THE HIDDEN POWER OF
ADOBE
PHOTOSHOP

MASTERING BLEND MODES
AND ADJUSTMENT LAYERS FOR PHOTOGRAPHY

SCOTT VALENTINE

FOREWORD BY MEREDITH PAYNE STOTZNER, PHOTOSHOP SR. PRODUCT MANAGER, ADOBE

The Hidden Power of Adobe Photoshop:
Mastering Blend Modes and Adjustment Layers for Photography

Scott Valentine

Adobe Press
www.adobepress.com

Copyright © 2021 by Scott Valentine. All Rights Reserved.

Adobe Press is an imprint of Pearson Education, Inc.
To report errors, please send a note to errata@peachpit.com

Notice of Rights

Notice of Liability

Trademarks

Executive Editor: Laura Norman
Development Editor: Victor Gavenda
Technical Editor: Rocky Berlier
Senior Production Editor: Tracey Croom
Copy Editor: Linda Laflamme
Proofreader: Becky Winter
Compositor: Kim Scott, Bumpy Design
Indexer: James Minkin
Cover Design: Mimi Heft
Cover Image: RAUSHAN MURSHID/Shutterstock with Scott Valentine
Interior Design: Kim Scott, Bumpy Design

ISBN-13: 978-0-13-661282-7
ISBN-10: 0-13-661282-2

1 2020

For Carla and Austin, who never give up and remind me to be my best self.
And for Echo and Summer, who remind me to get up from the desk and feed them.
Never underestimate the power of little reminders.

CONTENTS

FOREWORD

I have spent more than half my life in a relationship with Photoshop. It's a pretty healthy one, and we discover new things about each other even now. Like other couples we argue from time-to-time… you know how it is. But at the end of the day, we end up bringing out the best in each other.

It all started while I was studying for a degree in Imaging and Photographic Technology at Rochester Institute of Technology (RIT). My track had plenty of MATLAB, optics, and digital image processing, but I wanted to play in the pixels like they were finger paint. So I managed to get into the not-in-my-major class to use this awesome software called Photoshop—never imagining I'd spend my career at Adobe with the honor of representing Photoshop users.

I'd always considered myself creative, an artist. When I was 10 my dad got a free 35mm camera with his subscription to a magazine. I later used that same camera (covered in electrical tape to stop light leaks) in my high school photography class. That class was where I first began experimenting with imaging. I only had a standard lens, so I improvised macro shots with a magnifying glass in front of my 50mm. A classmate discovered reticulation by accident, but I liked the shattered look of the warped emulsion and replicated the process. I did a lot of creative experimentation before moving to the scientific side of imaging. Photoshop was the perfect medium for me to bring the two sides of my imaging experience together.

Scott Valentine also has a relationship with—and helps bring out the best in—Photoshop. He's been a key beta tester of the application and an advisor to the engineering team for more than a decade. Actually, as long as I can remember, Scott has been our partner.

One aspect that makes Scott unique and valuable to the team is that he is both artistic and intellectual. He makes his own beautiful creations to walk through the new Photoshop code and even creates test images to exercise and dissect features. The team has come to count on Scott's dexterity of science and art to help discuss and debate the direction of the application.

I'm pleased to see that this book, *The Hidden Power of Photoshop for Photographers*, stays true to Scott's balance of art and intellect to take readers on a journey of experimentation, discovery, and mastery. The symmetry of the conversational, approachable style of Scott's writing with his deeply inquisitive nature make this must-read material. I expect by the end, readers will be able to power their own tools the way the Photoshop team does.

—Meredith Stotzner,
Photoshop Product Manager, Adobe

PREFACE & ACKNOWLEDGEMENTS

When you spend enough time with someone or something, you start developing a relationship. Such is the case with this book, and it has not been the most pleasant, supportive relationship. We loved, we fought, we talked about trial separation and who would get the dogs… but in the end, we stuck together.

My wife and son were infinitely patient, the dogs less so. My first round of acknowledgement and thanks go to my family for knowing when not to ask "how's the book coming?" They showed amazing restraint and kept providing encouragement.

The reason you're reading this, however, is due entirely to the staff at Peachpit. Victor and Laura believed enough in this title and in me to keep at it long after they probably should have walked away. This pair of amazing professionals shifted between roles of friend and business partner seamlessly and smoothly, and I've learned a lot from them. These few words are not thanks enough for their efforts which started quite literally from the inception of this book and continued through it resting in your hands.

Longtime friend and Photoshop mentor Rocky gave his expertise for a fourth time, catching my errors and teaching me some new tricks along the way. Any technical faults in these pages exist because Rocky let me win an argument. He's the best that way!

I'd be remiss if I did not include Meredith Stotzner and Chris Main in this list, as well. Meredith, whose fabulous foreword makes me go "aw, shucks!" has taught Photoshop a thing or two about supporting creative visions and has a genuine love for the tool. Chris gives me space to write in front of a great big audience every month to talk about how Photoshop works, and I love that.

Thanks to everyone not named, as well—you've inspired and supported someone to be their best, so keep that up, ok?

PART I
INTRODUCTION

This is the start of the book. The cool stuff comes after this page, and includes little bits of wisdom I've collected over the years. Some of it was just dumb luck, a fair bit was absorbed from others, but an awful lot of it came from simply paying attention while making mistakes. I think this is an important thing to keep in mind as you peruse, browse, flip through, and otherwise consume the following information.

WELCOME

This introduction section, especially "Seeing Images as Data," exposes how I think about and approach Photoshop, and how I try to get it to give up its secrets.

PERSONAL NOTE

I'm an accidental artist. I love the act of creating, but I just don't feel like I have much of an inner spark that drives me to start a project and direct my skill towards any particular vision. However, I am exceedingly prone to finding inspiration while doing other things in the context of digital art, and most of my portfolio is made up of explorations of tools and techniques. Nearly everything I've created artistically comes from some kind of dabbling.

If you've ever bought craft or art supplies without any prior experience just to see if you enjoyed the process, you'll have an idea of how I approach Photoshop and digital art. Way back in the early days of the Internet, I found myself in a job that demanded I learn how to manipulate and create graphic elements, but I had no experience. I went online and found some fantastic communities that represented the best of creativity and willingness to share knowledge. I started out asking all kinds of questions, but soon enough I was helping others.

Every new question became a challenge for our small team to solve. I would spend hours sometimes trying to reverse engineer a particular effect or devising experiments to see how the various digital tools worked. Eventually, I realized I was more interested in learning how to control the tools than I was in the creative process. It also helped that I was fresh out of college with a physics degree but had not yet found a regular job.

So it's in my nature to explore and understand by breaking things down into bite-size chunks.

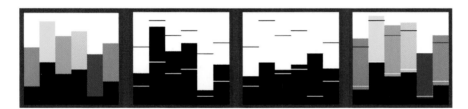

My teaching style is a direct result of my own path, and this book demonstrates the results of learning through discovery as well as through sharing. Many of the techniques you'll find here are in common use by professionals, but you won't often find them explained, applied out of context, or pushed to extremes. Throughout this work, I try to take the basic ideas and show you something familiar, then I build on the results to demonstrate the potential for pushing further into new territory.

Each recipe is designed to show you how the demonstrated features work, not just how to achieve a particular look or effect. Although you can stop at the basic achievements, your real goal should be to internalize how the tools behave under various conditions so you can not only solve problems more quickly, but also push creative boundaries without fighting with the things that are supposed to be helping you. Mastery of your tools is the key to supporting your own work.

Through experimentation, you'll develop a feel for what's going on behind the scenes. You don't have to know anything about math or digital image analysis. It doesn't matter if you understand (or don't know) the difference between Porter-Duff blending and gradient-domain processing. Experimentation leads to familiarity, and familiarity to mastery. Eventually, you shouldn't even think about your tools while using them to execute your vision. But it takes work and time.

In short,

Never let your tools get in the way of your art.

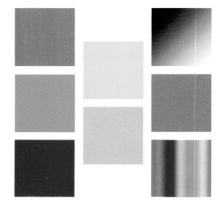

HOW TO APPROACH THIS MATERIAL

I wrote this book, and most of my teaching material, as a way to help you get familiar with the fundamental operation of the blending modes and adjustment layers in Photoshop. The techniques and descriptions contained in the following pages are meant to help you see these tools from both problem-solving and creative perspectives. With that in mind, you can look for specific solutions to common problems that you may encounter, but the real goal here is to give you an expanded and hopefully deeper understanding of how the tools actually work so that you can apply them to new situations.

As you move through the book, think about how you might expand a given technique, add to it in some way, or maybe just change the order of operations. How would you use different tools to accomplish the same end goal? How many different ways can you solve the problem? What I'd really like to see you do with this material is to use it as a foundation to build a solid understanding of Photoshop's tools and as a springboard for launching your own creative ideas.

With that goal in mind, the section "Creating the Workbench Files" in the "Project Examples" chapter will show you how to set up some of the experiment files, as well as what to look for in other images that might make them good candidates for certain tools or techniques. The experiment files are a great way to practice your problem-solving skills, but the real utility comes from abstracting the tools from your own artwork.

What does it mean to "abstract the tools?" One of the key challenges with developing facility with new tools in Photoshop is that we tend to be biased

towards what makes our work look good to us. If we apply some new technique or tool to one of our own photographs and the results don't meet our subjective standards, we are very likely to ignore and forget about that tool. That means we are preventing ourselves from learning how the tool actually works and potentially seeing how it might be useful in the future. Abstraction is a way of isolating the parts of a process to treat those parts individually. In this case, we need to isolate the tools and see how they behave by themselves, rather than focus on how we feel about their effects on a particular image.

By using files and images that you don't have a personal attachment to, such as the example images in this book, you can see the effects of tools and techniques with more objectivity. Filing those observable bits away can pay off when you encounter new challenges in the future. It's about exposing your mind to something new.

The majority of this book deals with using two core components in Photoshop: blending modes and adjustment layers. It presumes that you know how tools and layers generally work. While I do devote a few words to using other Photoshop features, such as brushes, selections, and filters, those techniques always rely on adjustments or blending in some way. In the case of the Stamped Portrait effect, Mixer Brushes and the Smudge tool are used after other features (filters, for example) have created a new starting point. In other examples, the use of tools is broadly described in support of the final effect.

My goal is to fully integrate your knowledge of blending and adjustments as part of your workflow, be that creative or utilitarian. So even though I don't talk a lot about filters, that doesn't mean you should avoid devoting time to mastering those as well. In fact, you should look for ways to make your work more enjoyable, whatever that means to you. If you find a panel that speeds up your workflow in a meaningful way, consider adding it to your kit. Plug-ins, filters, and other automation features all have their place, and nothing in this book should be taken to dissuade you from using any of them.

While giving a webinar once upon a time, I was really caught up in the demo and kind of left my viewers behind while I just improvised a problem-solving approach. After several minutes of my speedy delivery, someone raised their

virtual hand and asked me to go back and list all the steps I had taken so they could reproduce the process. Before I could respond, another educator in the audience (one whom I greatly respect) piped up with "Don't worry about the steps; pay attention to the possibilities and let your curiosity lead you."

That turned out to be a pretty powerful and thematic statement. Although I tend mostly to teach a blend of actual steps with comments on further exploration, I really love to teach about possibilities. That's the thing I most want to get across to people, but I recognize that it's a high demand for any given audience. I live in the space of ideas and potential, rather than the stepwise world of education. Both are necessary, and you can't really ignore either; it's just that I find more satisfaction in seeing others nurture the seed of "possible" into "real."

Over the years, I have developed a fondness for third-party tools that give me more control over my images, far more so than plug-ins that have lots of presets or come with canned effects. I like panels that expose or mix data in new ways, or hardware tools that open up more expression than you can get with a mouse. Here are some of the things I have centered on in the last several years as being critical to how I work in Photoshop.

WACOM GRAPHICS TABLETS

This single device revolutionized digital art more than anything since Photoshop first hit the market (in my humble opinion, of course). The ability to convert the motion of your hand into color and light is beyond useful and into truly liberating, making Photoshop almost a musical instrument. While Wacom is certainly at the top of the game, there are other options available at different price points. However, I will point out that to anyone in the industry, "Wacom" is part of the lingua franca of professional artists.

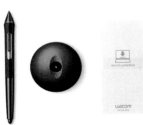

I have relied on the medium-sized tablets for years, and I currently rely on the Intuos Pro model. Many of my illustrator friends use one of the Cintiq lines, which let you work directly on a highly sensitive screen. In recent years, iPads and touch-screen tablets such as the Microsoft Surface have added this capability, enabling more mobile workflows.

MONOGRAM CREATIVE CONSOLE

For most of the year prior to starting this book, I used an external hardware interface from Monogram (previously Palette Gear). This is a modular system of buttons, dials, and sliders that can be assigned to virtually any control or function in Photoshop and many other desktop applications. Although the Wacom tablet gives you expressive control through a pen, Monogram gives you precision of tactile instruments that reduce the gap between your brain and asking Photoshop to do something.

The importance of this cannot be overstated. When you are working creatively or quickly, you do not want to break your line of sight to the screen. Reaching for keyboard shortcuts can certainly interrupt your flow. Having a configurable, assignable layout of hardware controls retains that visual connection without sacrificing any precision or expression.

RETOUCHING TOOLKIT

At its heart, the Retouching Toolkit (RTK) is just a set of software buttons that run some scripts to do things on your Layers panel. Sounds boring, right? Except the things it does on your Layers panel save you dozens of clicks and minutes of time setting up common professional tasks. Even better, you can configure the layout however you like and save different configurations for different kinds of work.

Again, nothing in RTK does anything that you cannot do for yourself. The value here is that the panel enables a faster, smoother, more consistent workflow. For example, I used to apply visualization layers only now and then if I found I was really struggling with some delicate retouching or compositing work. Since starting to use RTK, I apply an entire stack of visualization tools with one click, and I can see real improvement in my work along with less frustration and eyestrain. I'm also far more inclined to make solid "best practices" choices for layer organization and processing. Simply making these features easy to use has encouraged me to use them and nudged me into far better behaviors.

ERGONOMIC KEYBOARD

You can find lots of ergonomic keyboards on the market. I tried the minimalist keyboards, which are great for hammering out instant messages or a couple of emails. For anything longer, I need something with better key response and a layout that doesn't make my wrists and shoulders feel like I've been rowing a dinghy across the Atlantic Ocean. Even if you're not writing a lot, having a keyboard that promotes good industrial hygiene is definitely worth looking into.

ADJUSTABLE LIGHTING

Eyestrain is a real thing that leads to real headaches. Indirect lighting that can be adjusted for both brightness and warmth should be something you consider if you work more than a few hours at a time on your digital images. My setup is fired directly up to the ceiling and reduces shadows, and I've loaded

color-balanced, dimmable LEDs to help keep things as neutral as possible. Now and then I use a tungsten lamp behind my monitor to wash the wall with warm color to offset the typically cooler colors you get with email applications and social media.

Don't forget to just look away from the screen every few minutes.

YOUR BRAIN

As you get more in depth with the approaches, I'd like to ask you to think about using Photoshop to visualize the information in your pictures. Consider this (footnote: this comes originally from the 1934 play in verse *The Rock* by TS Eliot, and the DIKW initialism which you see after was made popular by Russell Ackoff). Its use here is not meant to imply formalism or other structure; I'm using it simply to introduce the notion of viewing Photoshop as a data viewer, or more correctly, an information display):

Where is the Life we have lost in living?

Where is the wisdom we have lost in knowledge?

Where is the knowledge we have lost in the information?

Put more simply and less poetically, there is a progression on which we build:

Data

Information

Knowledge

Wisdom

Art (My personal addition to this time-honored stack)

Data is a pixel in your electronic image. At the most basic level, a pixel is really just a value of electrical charge coupled with a position in a grid. The sensor on your digital camera knows that the pixel has a particular colored filter over it, so that gets stored as part of the translation process. But data by itself is meaningless. It needs something to relate to.

Information is data in context. Your raw image is a collection of data (pixels) presented in context of color and luminosity values that we perceive as a photograph and can digitally alter in software. Information is where we as humans generally start to think of how our photographs exist.

Knowledge is information plus insight. Just because the pixels are arranged a certain way does not mean there is any inherent meaning involved. When you as the photographer, or your client or other viewer, see the image, a relationship is created in the mind of the viewer that associates the information with meaning.

Wisdom is knowledge plus experience. Molding knowledge into wisdom is not an easy or comfortable task, and you can't really rush it. Wisdom is a unique perspective.

Art is using all of these elements as needed, when needed. Data, information, knowledge, and wisdom are really just concepts that we use to help us understand distinctions, and art is the way we express them.

How does this relate to Photoshop and photography? One way to view Photoshop is as a lens itself. You can ask much of Photoshop, and one of the most critical things you can ask as a photographer is to see your images differently. When you think of Photoshop as a lens, you get to choose what it shows you, *and that's kind of like a super power.* This will become more apparent in later conversations about isolating and manipulating the various characteristics of your images—color, tone, brightness, scale of features, composition, and so on.

A NOTE ON LANGUAGE

I tend to refer to brightness as *value* and colors as *tone*. These are not fixed terms, and you'll find that many sources use them interchangeably. Color Theory outlines the following terms:

- **Color:** A general term that may refer to any combination of hue, tint, shade, or tone.

- **Hue:** The dominant color family. In the additive model of screens emitting light, that is red, green, blue as primary, and yellow, cyan, and magenta as secondary.

- **Tint:** Any hue mixed with white

- **Shade:** Any hue mixed with black

- **Tone:** Any hue mixed with neutral gray

When I talk about tone in this book, I'm including both tint and shade. Adjusting tone in the context of digital art frequently simply means adjusting saturation, but sometimes it is used for making minor adjustments to hue. Yes, it's

kind of sloppy and inaccurate, and I have no good argument for defending my own bad habits here. To confuse matters even further, when digital artists use color grading that implies an overall cast to an image (say a slight blue haze in a landscape shot), you will also hear about tone as a description of the cast, even though other hues are present. It's simply a shorthand way to describe a dominant hue.

I also distinguish often between brightness and luminosity. *Brightness* typically refers to perception of individual colors, while *luminosity* is a reference to the absolute values in gray scale of each color channel. This is different than *luminance*, which is a description of the actual energy of light being reflected from a surface.

The reason for my choice here is that luminance is the raw lightness value without Photoshop interpretating a color. When Photoshop shows you a color, it is artificially changing the luminosity value based on a perceptual model of human vision. So luminance is more properly the power of reflected light coming from a surface, regardless of color. But because human vision is not uniformly sensitive to all colors, brightness is the converted color's appearance as corrected by Photoshop and luminosity is the grayscale representation of each primary color.

All of this boils down to a relatively simple axiom: How you think about the goal affects the path you choose. Having a broader vocabulary leads to better descriptions of those goals, and having a deep understanding of your tools opens new possibilities, new descriptions, and ultimately new goals.

HOW PHOTOSHOP "SEES" YOUR IMAGES

Digital image processing can be quite math intensive. After all, the computer is trying to figure out how to arrange zeros and ones in a way that makes sense to human vision. Fortunately, we have tools like Photoshop to help us poor humans understand what the computer is trying to say. But even the presentation of that data in Photoshop takes a little getting used to.

Without falling too far back into the basics of how Photoshop operates, take note that Photoshop presents color as a combination of *channels* that are each represented in grayscale, and that Photoshop uses the concept of *layers* to stack up image elements

and adjustments. These concepts are important to remember because adjustment layers in Photoshop frequently include the option of operating independently on each channel or on all of the channels cumulatively. However, blending modes are effective only when you use multiple layers together. Finally, the concept of a *layer stack* is that image elements get "stacked on top of each other" and elements at the bottom maybe hidden by layers above them. Imagine a stack of acetate or glass, where each sheet has a different image element; what you see looking down through the stack is the composite of all the sheets together. In this way, image information moves from the bottom of the layer stack to the top before finally being displayed on the Photoshop canvas.

Adjustment layers are really just data controls. They take information from your image, such as brightness and color, and give you specific controls that allow you to modify these characteristics. What's cool about these adjustment layers is that they give you different graphical ways to see and affect the data in your image. Sometimes simply having a different way to look at information affects how you perceive and manage it.

Probably one of the most popular and powerful adjustment layers is Curves. This adjustment allows you to see the relative brightness of all the pixels in your image and adjust them in a smooth, well-controlled fashion. Having this kind of manual control also allows you to be more involved with the editing process.

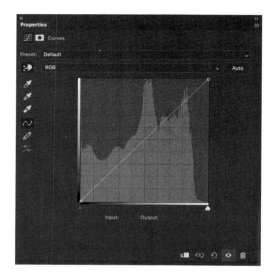

Curves (and Levels) are explored in more depth in the next section.

Blending modes on the other hand are mathematical functions. Like adjustment layers, they take input, do something with that input, and give a new output. However, rather than sliders, buttons, and lines to manipulate the image data, the controls are made up of the pixels you put on a given set of layers—the layer content. The color and brightness values in each layer are used as input for the unique equation of each blending mode.

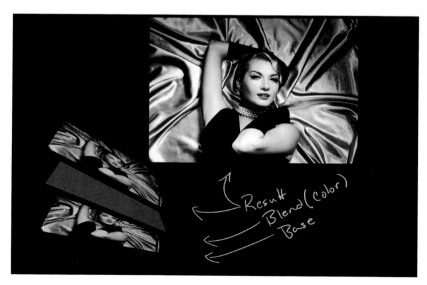

By default, Photoshop shows you images in a common Red, Green, Blue (RGB) color space. While other spaces are indeed important, this book sticks with RGB, as it is the most typical working space for digital artists. Many of the techniques shown in this book will work in CMYK, but because of various limitations, I recommend sticking with RGB through as much of your process as you can, converting and correcting CMYK or specialized outputs at the end. The reason for this is that RGB is specifically designed for displays that rely on mixing light rather than pigment.

Related to this topic, however, is something that you'll run into now and then: unexpected results. To a computer, all three RGB channels are "pure" and equal. Human vision does not agree. This gives rise to so-called "perceptual models" of color that try to correct any misalignment between computer screens and eyeballs. Many years ago, some very smart people came up with a method that associates the different wavelengths of light reflecting from objects to the relative perception in human vision. This model, called CIE (from the International Commission on Illumination, known in French as the Commission Internationale de l'Éclairage), gives rise to a set of values that are multiplied by "pure" RGB values to give a luminosity or apparent brightness value. The reason for this is so that we can perceive images on a computer screen in a way that simulates the real world in terms of color brightness.

Photoshop uses multipliers for each of the color channels to give them appropriate luminosity on the screen to approximate human perception:

- Red: 0.30

- Green: 0.59

- Blue: 0.11

To arrive at a display luminosity value, the gray level value on a channel is multiplied by the factor given above. These numbers quantify the relative sensitivity of human vision to each of these primary colors. Our eyes are generally more sensitive to green, then red, and finally blue. An example using pure white would look like this:

- R: 255 * 0.30 = 76.50

- G: 255 * 0.59 = 150.45

- B: 255 * 0.11 = 28.05

Adding the results together gives us a composite gray level of 255. The multipliers alone add up to 1, meaning 100%. So each multiplier is a fraction of

100%, or pure white. This fact is used in the blending mode math explained in the Reference section, and is useful in understanding why certain blending modes behave the way they do.

In the end, what you need to know is that Photoshop breaks your images down into components it can deal with using math, and that having some insight to how that math behaves gives you power over the tools.

SEEING IMAGES AS DATA

Now that we've talked about how Photoshop sees your images, let's try some tools to help you see your images as data. Most of this section deals with little experiments to show how various Photoshop features work, which means using some simplified files to remove distraction and make the changes created using those features more obvious. Although it's certainly not necessary, I find creating a measure of abstraction helps me gain better insight to exactly what's going on when I make changes to adjustments or blends. If nothing else, using a plain, simple file removes the bias we all tend to feel when evaluating changes against our own images. There is a tendency, when trying out new tools or techniques, to first decide whether we *like* a given result or not. More often than not, if we don't like the results we tend to abandon the pursuit and try something different.

That's fine when working creatively or under a deadline, but it doesn't really help us expand into new territory. However, looking at something in which we've invested no emotional content can make it easier for us to imagine new uses or chase down little bits of inspiration.

If you have an affinity for gray bars and plain color spectrums, then I may not have a solution for you. Just hope for the best, I suppose?

The Reference chapters later in this book describes some of the mechanics behind the blending modes and adjustment layers. This section is basically a rewording of the Photoshop Help files with a touch of opinion and suggestion sprinkled throughout. It gives a few of the more interesting and possibly mysterious tools a visual element, complementing what is sometimes pretty dry text. I highly encourage you to create your own demo files and tinker with them now and then when you want to see how something works (or doesn't, as the case may be). Let's begin!

STAYING AHEAD OF THE CURVES

Curves is perhaps the most used adjustment layer, and on its face, it is pretty simple. The Properties panel for a Curves adjustment later displays a line that represents the relationship between input (luminosity of the pixels in the layer below) and output (pixel luminosity fed to the layer above), and the result is a histogram of what is currently visible on the canvas to that point in the layer stack. The main (RGB) curve manages overall luminosity for all three channels. That's really it.

Because the line represents the relationship between input and output, adjustments to the line allow you to control luminosity changes parametrically. That is, you are not adjusting discrete luminosity values like an equalizer, but groups of values in context of each other. This tends to produce smoother results than say a graphic control, which would isolate specific luminosity values or ranges; having direct control over defined ranges can lead to discontinuities in your image, such as jagged edges between brightness values. Keeping transitions smooth and adjusting regions of brightness helps avoid visual artifacts.

GRAPHIC VS PARAMETRIC?

To make the comparison between graphic and parametric controls a little more clear, imagine a row of vertical sliders, each representing the brightness of a specific pixel in a line. If you wanted the line to have a smooth transition from one brightness to another, you would have to ensure each slider is moved precisely in relation to its neighbors, and you'd have to move each one separately. That is a graphic approach.

A parametric approach would be like having a rubber band attached to the tops of every slider so that when you raise one slider, its neighbors move proportionally because they're being pulled along. This is how the Curves adjustment behaves, changing ranges of values to preserve smooth transitions.

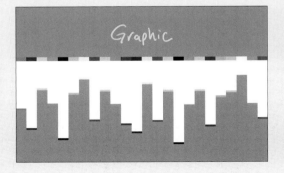

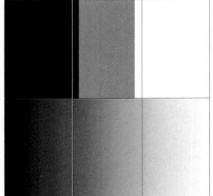

Here is a gradient that goes from black to white and that was treated to a Posterize adjustment to produce three gray bars. The lower half of the image is the original gradient for reference. The image also displays vertical guides that divide the image into three sections of equal widths. The reason the bars are not evenly aligned with the guides is that the default setting for the Smoothness slider in the Gradient Editor was cranked all the way up to 100% (this is meant to produce a more visually smooth transition, rather than a mathematically "correct" linear transition). Our first task is to even out the bars to align with the guides, ensuring an equal amount of gray between each vertical guide.

The Curves adjustment layer initially shows you the entire range of possible gray values available. The end points are aligned with absolute black and white, and the default straight line represents no change or translations to existing values. Put another way, every input gray value is left unchanged and exactly equals the output: If 50% gray exists in the image, the output will also be 50% gray.

As you manipulate the curve, inputs are remapped to new outputs. The horizontal axis represents input values, and the vertical shows output values. The histogram in the background shows you what luminosity information is coming into the Curves adjustment layer. Changing the curve does not affect the histogram's display.

When you drag a point along the curve upward, you are telling Photoshop to take that input value and give it a new, higher, output value. The nature of Curves means that moving one point takes other input values with it, meaning if you change 50% gray to now be 60% gray (10% lighter), all the gray values will be made a little bit brighter without you having to move all of them yourself. This is what *parametric* means in this context: Things are kept relative to each other. Black and white are anchored, however, so the change is scaled.

In the special case of moving the black or white points, you can affect the total dynamic range of your image. Moving the black point to the right along the bottom of the curve, for example, *remaps* the black point. If the darkest pixel in your image is really 20% gray, you can remap it to 0% gray (full black) by moving the black anchor point to that 20% gray value. All the levels of gray get shifted slightly darker. Similarly, if the brightest point is not quite pure white, you can fix that as well.

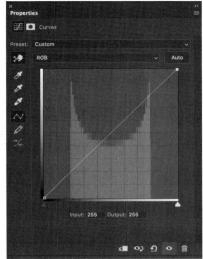

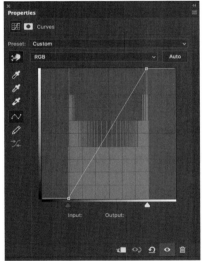

What happens if you move the black point at the left end of the curve vertically instead? Then the darkest point in your image gets mapped to a lighter value. If you have a solid black area in your image, you can remap it to any level of gray all the way to pure white. Note the histogram in this Curves panel shows a full range of values.

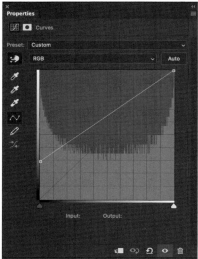

In fact, if you move the black and white endpoints to middle gray, your entire image becomes nothing more than a field of flat gray. All points are mapped to 50% gray, so there is no variation or detail left. In the Curves dialog box, gray values range from 0–255, so 50% gray is roughly 127.

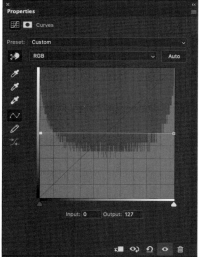

So how do we use this information to repair our gradient? The Posterize function divides up the range of luminosity values into chunks of equal value and distributes them across the entire available range of luminosity values. The number of chunks is set by the value of the Levels slider in the Posterize adjustment layer, and each chunk is shown in our test gradient file as a bar. Each bar's width represents how much of that range of gray values exist in the image, so there are fewer total areas in our test gradient that exist between 33% and 66% gray.

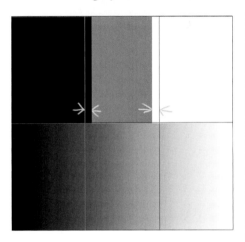
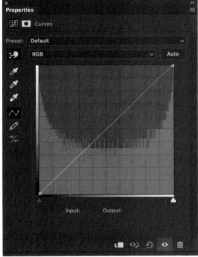

The challenge is to find a way to even out the bars, and there are two ways to do it. The first is to redefine the black and white points so that there are fewer deep shadows and bright highlights. To accomplish this, we can raise the black point and lower the white point, leaving the line flat between them. This effectively slices off the ends of dynamic range in the image and pushes everything towards middle gray, resulting in a more balanced histogram (but still not flat, which we'll talk about shortly).

The black point has moved from 0 to 24, and the white point from 255 to 231. The bars are perfectly even, but take a look at the smooth gradient below: We've lost pure black and white, which may not be acceptable in many situations when you are working on an overall image, but it can be very useful when working on selections and masks.

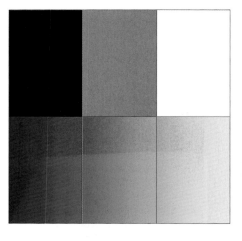

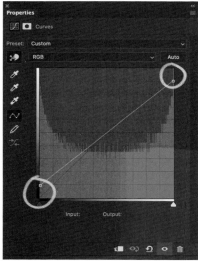

NOTE Later in the book, you'll find out that 50% gray becomes invisible with certain blending modes, such as Overlay. Changing the blending mode of the Curves adjustment to Overlay then makes this exact set up a nifty way to adjust midtone contrast. Tuck that bit of knowledge away for your own experiments a little later on.

If we push the adjustments even further, it should become clear that the result is an overall reduction in contrast, which is what we saw with the horizontal line above.

It seems natural to find a way to recover the middle values without affecting the black and white points. Rather than dragging these end points, we can leave them to their respective corners and instead focus on that middle area. Wherever you click the curve creates a control point. Control points are pinned and behave like pivot points. You can move the point all around, but when you add another control point near it, the line through that point rotates. We're going to make use of that fact right now.

In the middle of the graph, click to add a control point. With that point still active, either move it around until the Input and Output values at the bottom of the panel each read 127 or simply enter the values in the fields below the curve to set the center point. This pins the exact middle so we preserve our true 50% gray.

Now we can move the remaining areas around without moving the middle gray, black, or white points. Starting in the lower left of the curve, drag the curve upward to shift the gray values and compress them slightly. In the upper-right area, drag down to compress that range of values. This motion approximates what we did previously to lower contrast towards a flat 50% gray field, but because we've pinned critical values, we don't lose the full dynamic rage.

We have simply reassigned the quantity of gray values a tiny bit in order to achieve more balance.

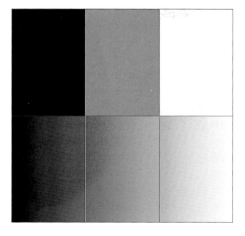
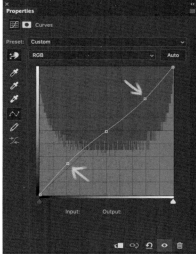

Notice that we didn't have to move the curve much, and precision in this case isn't as important as the general placement of points. This is a contrast reduction curve. We can make the opposite moves to create higher contrast.

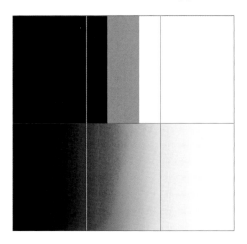
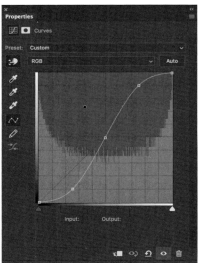

We can also move that vertical line left or right and shift the balance wherever we like.

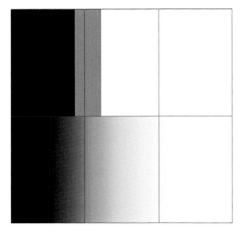 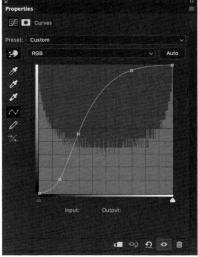

And just to take things to an extreme, we can create a nearly vertical curve.

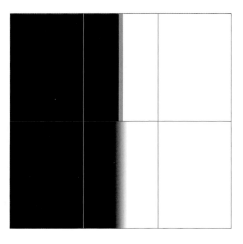

This example demonstrates that we have amazing control over the range of values available in an image. That includes some correction. Here's another graph where the middle gray value has shifted to the right significantly, but we still have pure white and black to maintain; you can see the original distribution of gray values in the histogram. The goal here is once again to balance out the bars, and because we already know that moving points up makes things brighter, while moving them down makes things darker, it seems like a good idea to reduce the mids.

If we simply drag the midpoint down we get pretty close, but not an exact match. That implies we need to change the shape of the curve slightly.

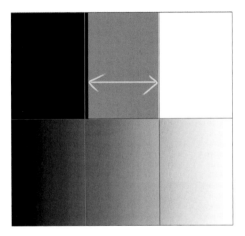
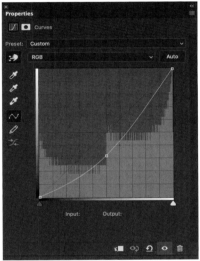

The solution in this case is to use two points, one on either side of the midpoint. This more or less uniformly lowers the middle tones, but expands the shadows and compresses highlights just a touch to make room for more middle values.

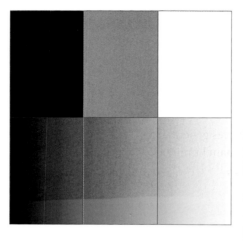

For fun, we can try out some other extreme curves settings and see their impact on the basic gradient. In this case, I've created part of a solarization curve that results in a gradient that appears to cycle on itself. I also increased the Posterization to show 5 bars.

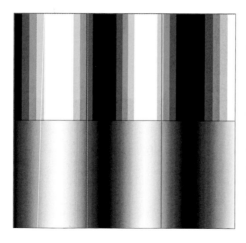

SEEING IN COLORS

To this point, we've used Curves to explore how gray values can be manipulated and adjusted. This knowledge translates directly to photographs in later sections of the book, where the exact function of a given feature may not be immediately obvious.

The situation gets a little more complicated when dealing with colors, but not too terribly much. It turns out that Curves generally treats all three RGB color channels the same when moving the main Luminosity curve, but it may still cause some color shifting. This leads us back to the previous section where we looked at how Photoshop weights each color. It's one thing to look at the weighting values, but it's another to see a direct demonstration.

This graphic is simply a black-to-white vertical gradient layered over a horizontal spectrum gradient. The colors in each gradient were created with the Gradient Editor tool using "pure" color values for each stop (read up on Gradient Maps adjustment layers in the "Gradient Zone Control" section of the "Color & Value" chapter). That means each color is displayed on your screen exactly how Photoshop expects you to perceive it, including weighting. The black-to-white gradient is then set to Lighter Color blending mode, which compares the luminosity value between the two layers at every pixel.

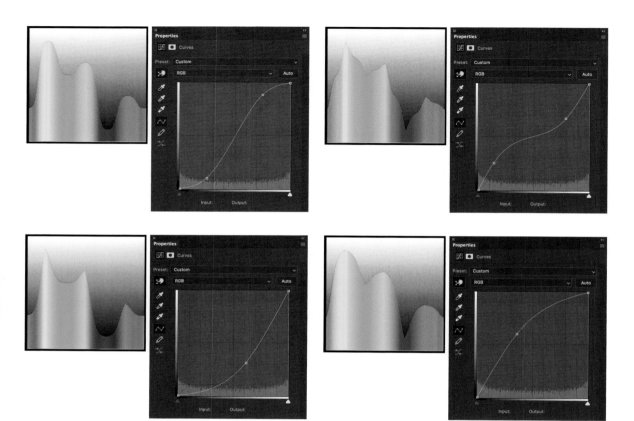

TIP At this point, you can also see those fully saturated, luminous colors represented on the Curves Properties panel–at least where they are on the curve, anyway. Reset the Curves adjustment to a flat line, and then click the Targeted Adjustment tool (looks like a finger with little up and down arrows). Then, click the wide solid bars each in turn. That will place a point on the curve corresponding to the luminosity of that color. Each one is in its own spot, but they're not evenly distributed.

The result is a very literal display of the weighting factors in play. What you see is the exact gray value that each color represents when composited and given the percent luminosity values listed in the previous section. What do you notice about the peaks? Did you expect them to be magenta, cyan, and yellow? The reason these colors have more luminosity is because they represent the combination of two channels; magenta is the additive result of red and blue, for example.

We can use this setup to explore some other effects, as well. Adding a Curves adjustment to the spectrum layer and tweaking just the luminosity curve as we did above, the height of the RGB and CMY peaks does not change, but the slopes in between do. That tells us the default Curves luminosity adjustment is acting directly on the RGB channels more or less equally. The brightness of each channel is being affected.

Remember that the channels are just grayscale representations of the primary additive colors. It may be easier to see this if we add a Posterize adjustment to the spectrum, too. This also illustrates how Posterize works: It divides up the gray values into evenly spaced chunks. Because each color is made up of gray values, each channel is split up as well. A setting of 3 levels in the Posterize adjustment results in 9 total bars: three for each of the three color channels. In this example, I'm using 8 levels to show more detail. The wider bars correspond to the primary and secondary colors.

Using Curves in particular, I recommend this setup as a way to explore the channel-specific curves that are discussed in Part 2, under "Color Grading" in the "Color & Value" chapter. When you adjust Curves with this view, the smaller bars will appear to rise and sink, but this is the same behavior we saw above with the smoother graph. The effect you're seeing is *quantization*, and if you were to imagine a line connecting the top center of each bar, you would recover the smooth appearance from the previous example. The bars are simply there to make visualization a little simpler.

SHADES OF GRAY

Let's throw a Black & White adjustment layer into the mix and remove the posterization for now.

This is the default conversion of color to grayscale. Once again, we see peaks on cyan, magenta, and yellow, but they're at very different luminosity

levels. Take a look at where the sliders are positioned and toggle the adjustment layer's visibility on and off to see the changes. Why do you think the Photoshop engineering team decided that should be the best conversion to start with?

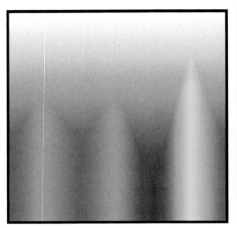

I can only tell you that I don't know. It may have to do with a certain kind of film they wanted to simulate, or they tried it out on a few test images and called it good. In the end, it doesn't really matter why. It looks fine, and it's easy enough to change. I created a preset called Neutral that creates a direct conversion that preserves luminosity.

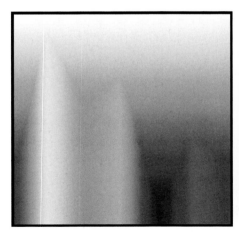

This lets me start from a literal conversion to grayscale, by which I mean a conversion that's a direct implication of a color's luminosity value rather than the somewhat "fudged" conversion that the engineers apply by default. This also has the added benefit of being a great starting point for using Black & White as a luminosity adjustment. Changing the Black & White layer's blending mode to Luminosity lets you change the apparent brightness of the primary and complementary colors without shifting their hues. Here's a comparison of the effect of Black & White with default and neutral conversions. The black targets are on peaks showing the original colors using the Neutral conversion, and the white targets are on peaks resulting from the default conversion. The arrows help demonstrate the direction of change.

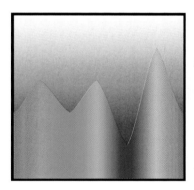 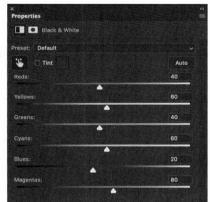 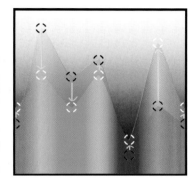

ONWARD, DEAR READER!

By now, you should have already decided if building experiment files is of interest to you or not. If they are, be sure to check out the section in Part 3 "Creating the Workbench Files" to get tips on making your own. The benefit lies in giving your eyeballs and brain a break from your own images and to explore the range of editing features available in Photoshop. There is really no limit to the kinds of files you can generate, but you should focus on creating files that let you control only one variable at a time, whatever that variable is. It can also be rewarding to figure out new ways to examine a particular tool or feature, which is often instructive in and of itself. That chapter also has some philosophical ideas on how to approach building workbench files for new situations.

All of this is meant to give you some ideas about exploration, whether for yourself or to use in teaching others. I absolutely love tinkering in Photoshop just to find the edges of capability and the beautiful failures that often result.

USEFUL INFORMATION

Before you can push off, you need something to push against.
Here is a quick review of some fundamental skills.

In order to make later techniques more approachable to users at all levels, this chapter provides an outline of the basics of working with layers in Photoshop. These are common activities and techniques that I consider essential for any Photoshop user at any level. In later parts of the book, if you come across a step or two that seems vague or assumes some prior knowledge that you lack, check back among these pages!

SKIPPING AHEAD

Even though this book is aimed at intermediate to advanced users, it often helps to ensure we are all using the same terms, ideas, and features. Feel free to jump ahead to Part II, "Techniques" if you're quite comfortable digging around in Photoshop. This chapter sets a baseline for general layer operations and controls. It will be here if you need it (and nobody will know if you had to sneak a look now and then).

More detailed information will be presented throughout the chapters as needed, and be sure to check out Part IV, "References" for individual discussions about the mechanics behind adjustment layers and blending modes—with a touch of opinion and suggestion sprinkled throughout.

LAYER OPERATIONS

At the heart of every technique in this book lie the interactions among image layers in Adobe Photoshop. This section lays out the fundamentals of working with layers.

ADDING ADJUSTMENT LAYERS

Part IV, "References" goes into deeper detail on adding adjustment layers to your document, but in the interest of getting you started quickly, let's go over a few basics now. Open the Adjustments panel from the Window menu, and take a look at the 16 icons that identify each of the adjustment layers. Click one of these icons to add your chosen adjustment layer above whatever layer is currently selected.

Photoshop also has the option to apply adjustments directly to layer content, which "bakes" the changes you make into the layer itself. While adjustment layers behave like pass-through filters (meaning, information comes in, is adjusted in real time, then output visually to the canvas), Adjustments apply permanent changes to the layer content. Most of the time, you should use adjustment layers to preserve the ability to change settings later on, but at times when you may have no choice but to apply an adjustment directly and permanently.

MASKING

When you first apply an adjustment layer, it comes with a layer pixel mask filled with white. By default, this means the adjustment affects everything below it; painting with gray or black on the mask hides the effect of the adjustment. Remember, white reveals and black conceals! Later in the book, you will see how to take advantage of selection techniques to create masks that can be applied to adjustment layers almost like magic.

You can also apply an adjustment to a mask directly, though you cannot use another adjustment layer. To work on an adjustment layer mask, hold Option (macOS)/Alt (Windows) and click the layer mask to see it on the canvas. Now

you can work on the mask visually as if you were painting on a black-and-white image. Here is an example of using the highlights from a photograph as a mask.

CLIPPING LAYERS

While Photoshop normally sends layer information upwards through the stack so that all layers can interact equally, there is a trick for constraining the interactions between two layers. This is called *clipping*, and it is accomplished by holding down the Option/Alt key and hovering your pointer at the boundary between two layers in the Layers panel. The pointer changes to indicate that clicking at the boundary unites the two layers in a clipping group.

The upper (clipped) layer in a clipping group is constrained by the bottom (base) layer. The most typical example of this is clipping an image layer into a text layer, filling the text with the image. But my favorite way to use it is for visualizing crops. Use The Claw keyboard shortcut (see the "Stamp Merge Visible (The Claw)" section below) to create a stamped copy of the layer stack, and then clip the copy to a layer with a blank rectangle. The rectangle can be transformed to whatever size you like, and trying different sizes will nondestructively show you how your image will look using various crops and aspect ratios.

CHANNELS

A few adjustment layers permit you to target a single color channel along with the composite of all three RGB channels. One adjustment layer, Channel Mixer, actually lets you swap information between channels. Direct access to each color channel provides a lot of flexibility in applying corrections and effects without requiring the use of multiple adjustment layers with masks to isolate the changes. Applying a Curves adjustment yields a particularly useful example, as you'll see in the "Instant Image Enhancement" section in Part II's "Dodge & Burn" chapter.

BLENDING CONTROLS

Blending refers to combining layers visually, whether with blending modes (sometimes called *blend modes*) or changing opacity and fill. In both situations, it helps to have a point of reference. The layer that is being adjusted in some way by a blending mode, opacity, or fill change is referred to as the *blend layer*. The layer immediately beneath the blend layer is typically referred to as the *base layer*. However, I also use a more general term that encompasses everything below the blend layer: "the backdrop." The backdrop is technically everything that is available to be combined with the blend layer.

The "Welcome" chapter explained the basic operation of blending modes and adjustment layers. The principal controls for these features are found near the top of the Layers panel: a menu for choosing blending modes and sliders for adjusting Opacity and Fill.

BLENDING MODES, OPACITY, AND FILL

As with normal layers, adjustment layers can use blending modes and respond to changes in Opacity and Fill. The results behave exactly as if you had duplicated a layer and changed the duplicate's blending mode—something I refer to as a "self blend" because you are blending a layer with itself. But you also get the advantage of having the controls of the adjustment layer itself. This is perhaps one of the more powerful "hacks" you can perform in Photoshop because you get the benefits and controls of each capability—a true super power!

This technique is scattered throughout the book, so keep your eyes open.

BLENDING OPTIONS

To access a wider range of blending controls, open the Layer Style dialog box (Layer > Layer Style > Blending Options or double-click an active layer in the Layers panel away from the thumbnail or the layer name). This dialog box contains more than layer styles. Confusingly, two areas bear the label "Blending Options." The area that concerns us is the central portion of the dialog box. At the top, the General Blending controls duplicate the Blend Mode menu and Opacity slider familiar from the Layers panel. Below that is the Advanced Blending area, which contains a Fill Opacity slider (duplicating the Fill slider on the Layers panel), and controls for channel knockouts (outside the scope of this book). In the bottom center of the dialog box you'll find the much-venerated Blend If controls.

BLEND IF

There are a handful of features in Photoshop that turn out to be insanely useful while appearing to be fairly simple. One of my favorite examples of this is the Blend If control in the Blending Options area of the Layer Style dialog box. It's amazingly useful, and knowledge of it is kind of a milestone that lets you know you've graduated to the next level of Photoshop mastery. You have probably seen or used it in a number of tutorials, especially intermediate to advanced lessons where blending shadows or highlights is called for. What you may not

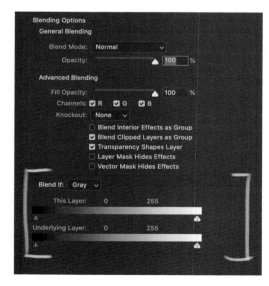

have seen before is how to turbocharge Blend If into a masking dynamo.

Let's start with a little review of how Blend If works. Basically, Blend If gives you a way to combine information between two layers based on the brightness values of one of those layers. There are two sets of sliders that control the blending for the current layer or the information on underlying layers. You can split either set of sliders by holding the Option or Alt key while dragging the edge of the slider.

The sliders are like boundaries for luminosity on each of the layers. Everything between the sliders is kept visible, while everything outside of the sliders becomes transparent (or more properly, blended with the lower layers). When you split a slider, you are creating a gradient from transparent to opaque. Using Blend If on an image made up of gradients should help clarify how it works. In this example, the gradient layer (Blend) is above a transparent layer (base or backdrop), and the white Blend If sliders for This Layer are set to 190/210.

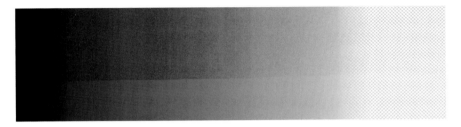

Note that the Blend If sliders let you choose what stays visible and what blends with the backdrop. Where a slider is split, the transition is a smooth gradient.

Blend If also works with color and includes a menu that allows you to choose each of the channels individually. Remember that channels are grayscale representations of how much color is in the final image, so the Blend If sliders act on the gray value of the channel itself. That means you can adjust each color channel independently, which gives you an approximate control of color in the blending. On the other hand, it does not give you complete control of arbitrary colors. In the end, you're still effectively limited to sliders for the Red, Green, and Blue channels when chosen from the Blend If menu. There is no specific color-to-transparency blending option that gives you any deeper or discrete control over blending hues or midtones that should be blended. In fact, the channel sliders for Blend If are only occasionally used in photographic contexts.

Let's look at a more dramatic example of how colors are affected by Blend If. This workbench image is a simple two-layer stack with the grayscale gradients on the lower layer, and the color gradient bars on the top layer. The top color bars start at black, go through a fully saturated color, then end with white to give them some brightness variation.

When I adjust the This Layer black slider to 127, the calculated luminosity of the color is blended (also called "knocked out" when it becomes effectively transparent) between 0 and 127.

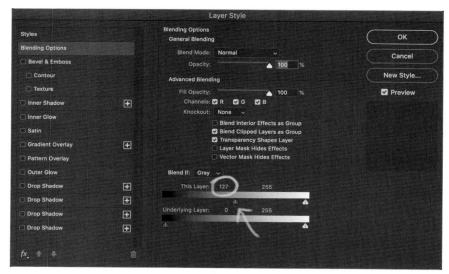

Compare this with setting the Underlying Layer black slider to 127, which now uses the lower layer's luminosity values to determine blending (which is called "punching through").

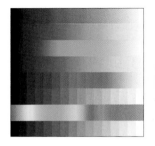

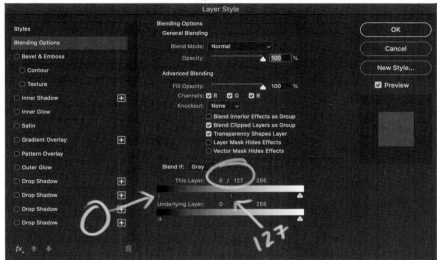

This should make it more clear that Blend If is evaluating channel information, and not specific colors.

But since we know something about how Photoshop gives us control over color, we can develop a few workarounds. It turns out that the Blend If sliders are insensitive to the layer's blending mode. That tells us that Blend If operates on the layer contents before any other blending occurs, giving you a way to preserve applied masks and blending effects regardless of blending mode. Let's place a white-to-black gradient over a filled color layer, and then adjust the Blend If settings for the gradient layer.

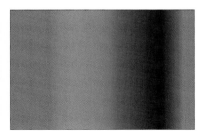

The third image is the result of using Blend If on the gradient layer (This Layer, Black: 17/49, White: 104/202).

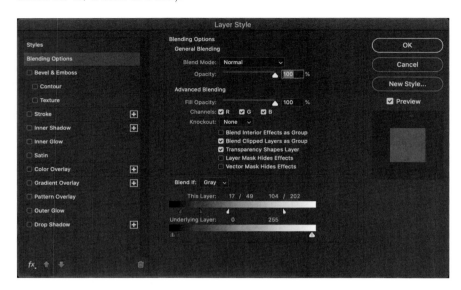

If we then change the blending mode of the gradient layer to Overlay, only the portion of the layer left visible by the Blend If adjustments blends with the backdrop color.

In this way, the Blend If results can be considered as if they were a mask created dynamically from the layer contents. Now let's put a Curves layer on top of the layer stack and increase contrast.

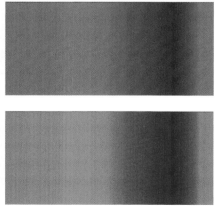

The Curves adjustment affects everything on the canvas, including the saturation of the color layer. Things change when we clip the Curves adjustment to the Gradient.

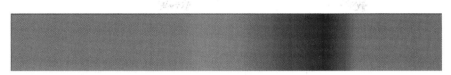

Notice that the gradient appears to have moved its position a bit as we saw in "Seeing Images as Data" in the "Welcome" chapter. But more importantly, the color is back to the original Overlay blending result. This is another way we can exploit Blend If as a dynamic masking tool. The clipped adjustment layer can be used to modify the Blend If results without affecting the blending mode results.

Going back to the color bars, let's apply a clipped Hue/Saturation adjustment layer to replace the Curves adjustment. For this example, the color bars layer uses something different in the Blend If section: only the Red channel's black slider is moved to 127. The other channels, including Gray, are not modified.

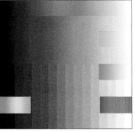

Notice that this is a very different result than setting the Gray channel black slider as we did previously. Finally, I set the Hue slider of the adjustment layer to −60.

The hues have indeed shifted, but the Blend If results have also changed! That reinforces the idea that colors presented on the screen have different luminosity values.

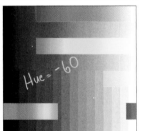

Honestly, I tend to file this one under "Stupid Photoshop Tricks" because there are many other ways to get similar results. The value of this demonstration is that it gives us some insight into not only Blend If, but into clipping as well. In particular, we now have a hint that clipping an adjustment layer that already has a blending mode allows us to change the way that layer interacts with layers beneath.

And that's another level of control.

There is an important caveat: This trick does not work on values controlled by the Underlying Layer sliders, because those rely on information in the backdrop or base layer; the clipped adjustment will not affect those so the Blend If results won't change.

So, one way to think about Blend If is as a comparison tool. Blend If lets you decide which values get shown on the canvas based on comparing luminosity values between the blend layer and the backdrop. If you're interested in checking this out in more detail, read up on the example files in Part III, "Projects."

"TRAPPING" BLEND IF TRANSPARENCY

In practice, Blend If is generally employed to recover shadow or highlight details when using adjustment layers or blending a copy of an image with itself for enhancement by using one of the methods in the "Instant Image Enhancement" section of the "Dodge & Burn" chapter and to tweak texture blending as you'll see in the "Effects" chapter (both are in Part II). But here's a fun trick that is kind of secret and still pretty useful. Did you know you can "trap" the transparent area that results from using the Blend If sliders? In this way, you are able to create masks and selections where Blend If allows lower layer information to show through the current layer.

Let's say I like the texture from this grainy wood and I want to use it with a picture of a creepy forest. I don't want the fence colors, though. There are a few ways to solve the problem, but this one will definitely win you some points with other Photoshop users simply for being clever. With the fence photo on a layer above the forest, set the Blend If sliders for This Layer so that something of the lower layers is visible. Add a blank layer immediately above the texture layer, then select both the blended and the blank layer.

With both layers selected in the Layers panel, press Command+E/Ctrl+E to merge them. The new layer now has the transparency blending "baked" in. Option/Alt-click the new layer to load the transparency as a selection, then open the Channels panel and click Save Selection as Channel.

Now you can load that new selection and create a Curves adjustment layer. In this example, I set the Curves layer to Overlay blending mode and gave it a little boost.

An alternative to creating and merging with a blank layer is to convert the blended layer to a Smart Object. This needs to be done after adjusting the blending sliders so that the transparency becomes part of the rendered layer. There are some advantages to using a Smart Object. First, it's a little faster than creating a blank layer, selecting, and merging. Second, and more importantly, the Smart Object method retains the ability to adjust the blending sliders. Merging the layers makes the blend permanent, and if you did not make a copy of your blend layer prior to merging, you'll have to reimport the image.

With Photoshop 2020, we now have the ability to unpack a Smart Object into its original layers, which means changes are extremely easy.

A more flexible version of this approach is shown in the section "Gradient Map Luminosity Selection" in the "Selections & Masking" chapter in Part II.

STAMP MERGE VISIBLE (THE CLAW)

NOTE Thanks to my keenly investigative editor, I learned the official name for this trick is Merge A Copy Of All Visible Layers. As Victor points out, this would hardly fit in a menu!

This is one of the earliest "hacks" I can recall learning about in Photoshop. There is no direct menu item for this trick (see Note), and you need all three modifier keys to make it work. Stamp Merge Visible is a way of taking a copy of everything you see on the canvas and making it into a single layer at the top of the visible layer stack–the stamped layer–but leaving all of the other layers intact.

It's incredibly useful for all kinds of purposes, but here's how you do it:

With everything visible that you want a copy of, press Opt+Shift+Cmd+E/Alt+Shift+Ctrl+E.

That's it. I like to call it *The Claw* because you have to contort your hand to get it all at once. Try putting your fingers on each of the keys and see what shape your hand ends up in–maybe practice it for your next horror costume.

You should be aware of a few tricks to using it. For example, I sometimes find it can fail if the active layer is not currently visible, especially if it's an adjustment layer. It's also possible to create a copy underneath other layers, and thus alter the final canvas view. The shortcut is supposed to stamp a copy to the top of the layer stack, but I always add a blank layer to the top of my stack, and then use The Claw on it directly. It's just habit at this point, but it also helps with organization.

You can use the stamped copy as a snapshot of sorts or as a way to compare before and after versions when you make a change to your image. I also like to use it when creating copies of my file for printing. Right-click the stamped layer in the panel, choose Duplicate Layer, then select Destination > Document > New. This creates a new document with the current document's settings, including size and color space.

Several techniques in this book rely on making stamped copies of your canvas, especially for effects and heavy manipulations. It's a great way to quickly build up variations, too–simply stamp a visible copy of one version, turn off visibility for the copy, make changes, and create another version. In the "Stamped Portrait" section in the "Effects" chapter in Part II, for example, you'll use The Claw to create something to paint on. The more you think about it, the more useful this trick becomes.

PART II
TECHNIQUES

The main part of this book shows hands-on examples, but these are not simply recipes; they are chosen and built so you can take your time thinking about how and why they work (and when they may not). Rather than work through the steps, actively participate in the process–this helps cement the concepts in your mind. You owe it to your art!

SELECTIONS & MASKING

Call it being picky, focused, detail oriented, or a control freak, but photographers and artists often want to change *that* thing right *there* and nothing else. Making selections relies on being able to tell Photoshop how to choose that thing right there. Guess what follows?

Photoshop enables both automatic and manual selection methods, and everything in between. Manual methods involve direct control by painting and using paths to create selections, so that Photoshop is not making any choices for you. The Select Subject feature, powered by Adobe Sensei artificial intelligence exemplifies the height of automation. Such fully automated tools look at information: the data of pixels and colors placed in the context of people and things in your photo. The "in between," semi-automated features, such as the Magic Wand tool and channel selections, look at data rather than information.

To make a semi-automated selection, you must have a way to describe what you want selected in a unique way. It could be a color or brightness range, level of transparency, or any combination. Some of the tools built into Photoshop, such as the Find Edges filter, even let you select transitions between regions. The point is, if you can describe something in terms that Photoshop understands, you can probably find a way to have it make a selection for you.

This chapter deals with a handful of ways to tell Photoshop what you want from your image. This is by no means a complete list of how to select absolutely everything, of course; what you should pick up is a few tricks that help you tell Photoshop what you want by giving you a kind of digital imaging vocabulary.

CHANNEL SELECTIONS

One of the most popular ways to get precise selections from your photographs uses one of the oldest features in Photoshop: channels. As you remember from "How Photoshop 'Sees' Your Images," channels represent the individual color components (typically red, green, and blue components, when speaking of images displayed on a screen) of your photograph, which are displayed in grayscale by default. The level of gray is roughly equivalent to the luminance of the given color. Because each color channel is represented as gray, we can use color channel information directly to create a special kind of channel called an alpha channel.

Alpha channels are essentially masks. More correctly, they are how layer transparency information is stored—instead of showing the brightness of a color, they show you the density of a mask, with white being transparent, and black being opaque (white reveals, black conceals with respect to the masked layer).

Rather than being tied to a specific layer, however, alpha channels can be used to store or develop more complex masks that can be loaded and used anywhere in your document as a selection.

For selections, alpha channels work a little differently. The white areas represent what is selected, and black areas are what is ignored. So, levels of gray between black and white are "sort of" selected. When you load a selection from an alpha channel that has a range of values, think of the selection as density of color where white or lighter grays will have greater density than darks or blacks. Creating a layer from copying an alpha-loaded selection with gray values results in transparency being applied to the copied pixels.

Notice the Blue channel of this portrait shows the model's hair as relatively dark. Try this: make a selection from the Blue channel, then choose Edit > Copy and Edit > Paste. This copies the selected pixels from the RGB channel and fills a new layer with them. In that new layer you'll find that the area of her hair is mostly transparent. Because that area of the Blue channel was dark, little data was copied so there was nothing to paste into the new layer.

Let's try a simple experiment that illustrates some of the selection techniques. (For details on creating this file, see "Building the Workbench Files" under "Project Examples.") Each of the three solid color bars represents a canonical color in RGB space, so when we look at the Channels panel, each of those colors will be solid white on one channel, and black on the other two. The gradient at the bottom represents a complete RGB spectrum at full saturation (that is, the gradient range passes through both primary and secondary colors, so the pattern is Red, Yellow, Green, Cyan, Blue, Magenta, and finishing again with Red).

Holding Command (macOS)/Ctrl (Windows) and clicking one of the channel thumbnails loads the luminosity of that channel as a selection. In this example, I clicked the Red channel to select it.

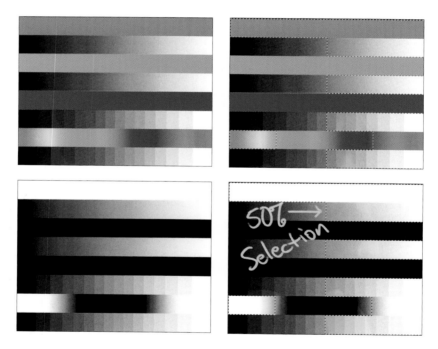

The selection area is noted by a pulsing, dashed line of so-called "marching ants," but that's not a hard boundary. The ants are simply marching along a line through the 50% point of the selected luminosity range. The entire channel is actually selected. Clicking the Save Selection As Channel button at the bottom of the panel (it looks like a white box with a dark circle) creates a new alpha channel.

The Channels panel display always represents what is currently visible on the canvas, regardless of layer transparency, masking, adjustments, and so on. So what you select in the above approach is based on what you actually see. We'll come back to this later.

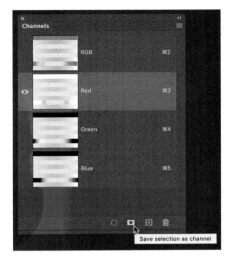

Notice that the non-primary colors are represented by gradients on each channel. That means if we want to load up something other than the primary RGB color channels, we have to do something beyond simply clicking one channel. It turns out that Photoshop selection techniques support three basic Boolean operations—addition, subtraction, and intersection. The first two are probably familiar to everyone, but intersection is not quite as common. It simply means the overlap between areas, but nothing else.

The intersection of these three color dots is white.

Once you have loaded a selection, you can apply one of the Boolean operations by clicking while holding down a combination of these modifier keys: Opt/Alt, Cmd/Ctrl, or Shift. Remember:

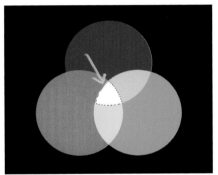

- Opt+Cmd/Alt+Ctrl **Subtracts**
- Shift+Cmd/Shift+Ctrl **Adds**
- Opt+Shift+Cmd/Alt+Shift+Ctrl **Intersects**

For example, in the Gradient Experiments file I selected the Red channel, then subtracted the Blue channel.

Here's the cheat sheet for selecting colors. For each color, begin by Cmd/Ctrl-clicking the first channel to select it:

- Red, subtract Green, intersect with Blue = Magenta
- Red, subtract Blue, intersect with Green = Yellow
- Green, subtract Red, intersect with Blue = Cyan
- Green, subtract Blue, intersect with Red = Yellow
- Blue, subtract Red, intersect with Green = Cyan
- Blue, subtract Green, intersect with Red = Magenta

Selecting the Magenta segment with only channel operations requires noting that Magenta is made up of Blue and Red, but no Green. So load either the Red or Blue channel, intersect with the one you didn't choose, and then subtract Green.

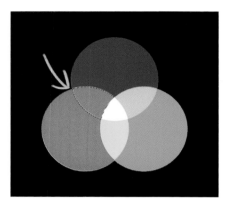

USING CALCULATIONS

Applying this to a photograph is exactly the same, but of course the selection result will be much more complicated. In this portrait, I want to isolate the blue jewels with a mask and change their color to green.

The Calculations dialog box is another option for making selections from channels, and has a lot more power than using the above Boolean operations, because it allows you to use blending modes as part of the process. Even better, it gives you a real-time preview of your results. The major limitation is that you can operate on only two channels at a time; as we'll see in a moment, Boolean selections still have a place in your workflow.

I loaded the Blue channel as a selection using the previously described methods, then subtracted both the Green and Red channels. At this point, the marching ants that denote the selected area vanish because they are visible only when the selected region is more than 50% opaque. However, the selection is still active–trust me!

I then made the RGB composite channel active and in the Layers panel copied the selection to a new layer as above. In order to see it, you may need to put a black- or white-filled layer between the copied result and the background layer. I named the filled layer **B – G – R** (blue minus green, minus red).

That is the beginning of our selection, but we need it as an alpha channel or active selection. Be certain to hide the additional layers you created once you have your alpha channel. The first result could use some refinement, so this is a great excuse to demonstrate Calculations. With Calculations, there is no

need to have an active selection or to have any particular layer active or visible. Choose Image > Calculations to see the dialog box.

Because the copied selection is already the result of the Blue channel minus both Red and Green, I want to further isolate the blue elements as much as possible. In the upper portion of the dialog box, under Source 1, I need to choose the copied layer (B-G-R) from the Layer menu, and then choose Blue from the Channel menu. In the Source 2 section of the dialog box, I choose the Background layer and its Red channel, then choose Divide from the Blending menu. Fortunately, Calculations gives us a preview of the results on the canvas.

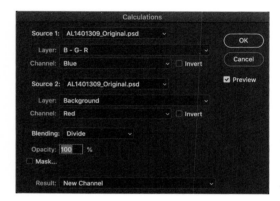

Notice that the result is the opposite of what we want: The jewels are black and everything else is white. At the bottom of the Calculations dialog is a menu for selecting the Result (New Channel, New Document, or Selection). Choosing New Channel is the best option in this case because we need to invert the mask and saving the selection as a channel makes that easy. Click OK to close Calculations, and the new channel appears in the Channels panel. To invert it, make the new channel active and press Cmd/Ctrl+I. Cmd/Ctrl-click the channel to load it as a selection.

I added a Curves adjustment so the active selection was applied immediately as a mask. The final move is to choose the Blue channel from the menu next to

the Auto button in the Curves Properties panel and drag the lights (right side) down to about 50 for Output. That removes most of the blue information, leaving the Green channel results visible.

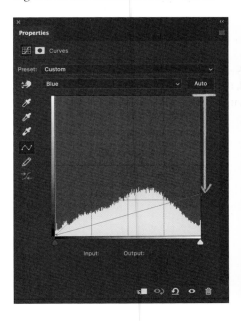

GRADIENT MAP LUMINOSITY SELECTION

You can never have enough selection method options in Photoshop. This one came about from my desire to create a fast, arbitrary luminosity mask (that is, a mask created by choosing specific luminosity values or ranges) without going through all the usual convoluted operations of making tons of small masks and merging them together. Although I love using luminosity masks for detail work and fine control over richly colored images, sometimes I just need a little slice of value range without too much fuss.

A *Gradient Map* is used to isolate a range of values in your image based on luminosity, and you can set up virtually any region and width pretty easily. As a bonus, you get near real-time results while you're tinkering, so you don't have to guess at which values are being included.

GRADIENT EDITING

If you are not experienced with Gradient Map adjustment layers, they are added either by choosing Layer > New Adjustment Layer > Gradient Map or by clicking the Create New button at the bottom of the Layers panel (it looks like a half-filled circle). After you add the Gradient Map adjustment layer, open the Properties panel (Window > Properties). You can click the downward pointing disclosure triangle to the right of the gradient displayed in the panel to open the Gradient Picker, which lets you choose a preset. Or, click the gradient itself to open the Gradient Editor, which displays both existing presets and a dialog box where you can create your own gradient. You can also save your newly created gradient as a preset and create a gradient group to save it in.

TIP For a variation on this technique, check out the section on Blend If sliders in the "Useful Information" chapter in Part I.

Start with a simple Gradient Map adjustment layer, and choose the Black, White gradient in the Basics group. Click the gradient sample to open the Gradient Editor, drag the white color stop to about the 50% location, and add a new color stop at the end. Make the new one black. You should have a black-white-black gradient so far.

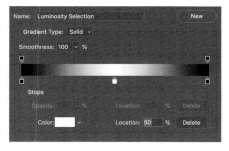

Bring both of the black stops towards the white stop, and watch the effect on your image. Adjusting the position of the three stops lets you isolate different ranges of luminosity values visually, rather than taking a more clinical or

math-based approach, which is how many plug-ins operate. Although those methods are powerful, the ability to see the changes to the selection immediately is also incredibly useful.

From here, you need to convert what you see into an alpha channel. Click OK in the Gradient Editor, open the Channels panel, and drag any of the channels down to the Create New Channel button. This automatically creates the alpha channel for you. Name it something relevant to your selection region, such as **Mid Shadows**.

Back in the Layers panel, turn off the Gradient Map visibility, then choose Select > Load Selection. Choose the channel you just created from the Channel menu.

Now, simply add an adjustment layer or a layer mask to an existing layer and the luminosity mask will be applied automatically. You can create any number of alpha channels the same way.

In this ship example, I wanted to both warm up the sky, and cool off the low shadow areas to create a duotone effect. Using the previous selection, I targeted first the shadow regions and applied a Curves adjustment to provide a misty blue cast. Using the gradient method allowed me to visually dial those areas in without making manual selections. I could also disregard the darkest shadows to allow them to retain just a little detail but otherwise achieve full black.

Warming up the sky required another pass with a different gradient for the highlight regions. Again, I did not want to include the extreme white areas because they would "blow out" to flat white, but keeping the texture in the

clouds was a little tricky. To sell the effect, the clouds also needed to retain just a touch of the original blue-gray. The adjusted gradient is not quite centered, so there is more feathering of the mask in the higher value regions. You can change the rate of transition by dragging the small diamond-shaped midpoint controls that appear next to a selected color stop.

I used the final selection to create a mask for a Color Lookup adjustment layer (CLUT), an adjustment layer I describe later in the "Color & Value" chapter.

Most luminosity selection methods have fairly uniform boundaries and specific ranges. Using a Gradient Map gives you quite a bit more freedom to select exactly what you need without having to mix and match or blend different masks together. It also lets you create only the masks that you need, while lots of plug-ins and automated methods give you tons of masks that you may not use and then have to delete.

Once you have the basic gradient map created, save it as a preset for easy recall. I named my starting point **Luminosity Selection**, because I typically start from the same mid-range. However, you could easily create a series of presets for specific ranges (more on that in a bit).

The stops, of course, can swap positions, too. If you want to select just the shadows, for example, simply drag the left black stop towards the middle a little, and then drag the white stop over it to the left edge.

Combine this technique with Boolean selections (see the "Channel Selections" section of this chapter) to carve out very specific areas of your image quickly. Remember to store the results as alpha channels with a good naming system so you can easily get your selections back.

HUE/SATURATION SELECTION

One of the secrets to making good selections is to understand that Photoshop can present you with alternative views of your image data. Some of the blending modes in Photoshop feel more utilitarian than others, and this technique involves the Difference blending mode—a tool most people associate with aligning image layers or detecting changes. When combined with a Hue/Saturation adjustment layer, however, Difference has the fantastic ability to isolate elements in your image.

The basic idea here is pretty easy to grasp: Make a slight change to some element of your picture, compare it with the original, and then extract the difference. In this case, we're going to change the color of something and create a mask from the result of that comparison. Don't lose sight of the fact that we're introducing a change, which could be just about anything we can target; it doesn't just have to be color, but the most useful techniques will involve features we can easily change with some level of automation.

NOTE When using the Targeted Adjustment tool with H/S, be aware that the color ramp selection settings are not persistent if you leave the adjustment layer; complete your selections before moving to the Levels adjustment or you will have to reselect the color area to refine your selection.

To start with, add a Hue/Saturation (H/S) adjustment layer above your image layer. Check out the color bars (the lines at the bottom of the Properties panel that look like spectra—from here on, I'll refer to them as *color ramps*): This is what we'll use to make the change, but we have to make a selection first. Click the adjustment layer's icon in the Layers panel so that you are not making a selection of the mask. This is a weird quirk in Photoshop: When you add the adjustment, the mask is automatically selected, so that if you try to use the Targeted Adjustment tool, you're sampling from the mask instead of the image.

Select the Targeted Adjustment tool in the Properties panel. Find a region you want to select whose color is distinct from its surroundings, and click. Don't scrub, drag, or anything else—just click in the area of interest to load the color that you want. Look at the color ramps back in the Properties panel and notice the indicators have changed.

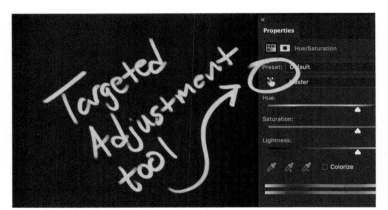
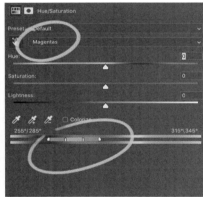

Also notice that the color ramps have updated to the closest primary base color from your selection. Now before we can make things work, change the H/S layer's blending mode to Difference. The canvas should go black because there is no difference—yet. Drag the Saturation slider in the Properties panel all the way to the left to desaturate the image.

What you end up with is probably very difficult to see in most circumstances. For the moment, you can see things better by adding a temporary Levels adjustment layer to the top of your stack for more contrast. You'll get rid of it in a moment, so think

of it just as a helper layer. In the H/S color ramps, drag the right-side control handle back and forth a little to see how it affects the results. By manipulating both sliders, you can refine the selection region to display more or less color variation.

At this point, don't worry about areas that you do not want to include; it's easy to remove them by painting black in the layer mask in the upcoming steps. The outer points are basically thresholds that clamp down on the color being affected, and the center slider is the most important or strongest color being selected. Adjusting all of them changes what will end up in the selection process.

Now the question is how to get from this odd view to a reasonable selection. Use The Claw (Opt+Shift+Cmd+E/Alt+Shift+Ctrl+E) to create a stamped copy of what is currently visible on the canvas, and name the layer **Mask Source**. On the Mask Source layer, first desaturate it using Shift+Cmd+U/Shift+Ctrl+U to completely desaturate the layer without opening the H/S dialog box. Click OK, and now turn off the Levels adjustment layer if you were using it. Making sure the Mask Source layer is active, press Cmd/Ctrl+M to open the Curves dialog box. Making changes here will apply the adjustment directly to your layer, so be sure to take care! Adjust the curve for maximum contrast without making pixelated edges.

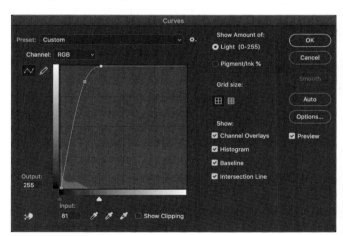

In many cases, you'll want to preserve the textures in your selection, so don't feel like you have to make everything completely white inside the area of interest. For more solid masking, use a slight Gaussian blur of around 1–3 pixels (this value will vary depending on the actual pixel size of your image), then use the Levels command to tighten up the edges. Check out the next section, "Tweaking Channels & Masks," to get details for enhancing the mask.

Once you have the contrast and density you want, clean up any unwanted areas by either painting over them with black or using the Lasso tool to select large areas and fill with black. To check the accuracy of your mask, change the Mask Source's blending mode to Multiply, which lets you see through the white regions of the layer (be sure to turn off any other adjustment layers you were using, especially the H/S). If you need to make refinements, this is the time to do it. Remember that Multiply makes white areas transparent in the current layer allowing color information from lower layers to show through.

When you have an acceptable selection area, set the blending mode back to Normal, and then open the Channels panel. Drag one of the channels to the New Channel icon to duplicate it. You have a shiny new alpha channel ready to go! Doing this will leave your new alpha channel selected in the Channels panel, so you will need to click back on the RGB composite channel before going back to work on your layers in the main document. Name your new alpha channel something appropriate for organization, such as Magenta Swatch.

To use your new alpha channel, simply Cmd/Ctrl-click its thumbnail to load it as a selection. You may optionally continue working on your channel before making a selection, or even use it with other techniques to create additional alpha channels. Remember that if you create a mask or add an adjustment layer with an active selection, that selection will be used as the layer's mask.

Use this technique for situations where you need some delicate selections while also having the advantage of somewhat uniform colors and good boundaries. It's more precise and flexible than the Magic Wand tool or other direct color selection methods, and really does not take much time. More to the point, this should give you some additional insight into creating so-called difference features that you can exploit for (slightly) automated selection tasks.

In this case, I used another Hue/Saturation adjustment layer (set to Normal blending mode) with my new selection to change the magenta areas to green.

TWEAKING CHANNELS & MASKS

Sometimes getting an amazing mask takes more than great selection techniques. As the previous sections illustrate, you may have to get in there and do some serious tweaking to get exactly what you want. Select Subject does some mind-blowing work, but it rarely provides a one-click solution. Let's take a look at a handful of ways to refine an already created mask by treating it like a regular Photoshop image layer.

Masks typically behave like any other pixel layer; they just operate solely in shades of gray. For the most part, working on a mask directly lets you see the results on the layer, but you cannot see the mask itself. There are situations that call for a different view, though, especially when the material being masked has a lot of visual clutter and confusion, or you want to carefully control the mask development. The first trick most people learn about, when moving to more advanced mask editing, is to hold Opt/Alt while clicking the mask thumbnail. That presents a view of the mask itself.

TIP When working on a layer mask directly, tap the backslash (\) key to toggle the layer mask display on and off. This changes the mask channel's visibility. The reason you may want to use this method is that you can see the mask as a translucent rubylith or red overlay, allowing you to see the mask edge without obscuring layer content.

Being able to see the mask directly gives you quite a bit of power and flexibility, and also it sometimes keeps you from missing important details that may otherwise be lost. This same view is available in the Channels panel when the masked layer is active and selected–Photoshop creates a temporary alpha channel that responds to the same tools as the layer mask. All of the layer-based tools available in Photoshop can be used on a mask or alpha channel, but these are destructive changes. How about a non-destructive workflow?

That requires promoting the mask or alpha channel to a regular layer.

Masks also get some love from the Properties panel, which includes Density and Feather sliders, as well as links to other features in the Refine section: Select And Mask, Color Range, and Invert. The Density slider is effectively an opacity slider and affects the entire mask all at once. I tend to use this feature when I want to blend layers as textures or make collage-style composites. The Feather slider acts on edges to soften them up, something that can come in very handy for replacing large image elements like backgrounds. Many otherwise beautiful composites have been ruined by harsh edges in a mask.

Both of these sliders are an incredible boon compared to previous versions of Photoshop because they allow non-destructive editing of some key characteristics of masks. If you ever tried to accomplish what these sliders do manually, you already know what kind of time savers they are.

The Refine buttons also have lots of potential, and while my intent in this book is to focus on blending modes and adjustment layers, you should not avoid the goodness packed into the other tools in Photoshop. In particular, the Color Range option lets you select either the image data or the mask itself to assist in refinement. Also, the Select And Mask tools are pretty great. I highly recommend you spend some time with those controls to get a feel for how they work, especially after going through the following material.

PROMOTE THE MASK

There are a couple of ways to promote a mask (that is, to convert a mask to a regular layer). View the mask as mentioned previously and use Cmd/Ctrl+A to select the entire mask, then copy with Cmd/Ctrl+C. Create a blank layer, and simply paste the material back in with Cmd/Ctrl+V. Boom, you have a mask on a regular layer (remember to turn off or remove the original mask so you can see your changes). This also works for copying an alpha channel to the layer stack. In this case, you will have an exact duplicate of your mask or channel. Set the new layer's blending mode to Multiply, which will cause anything that is not black to allow lower layer content to show through.

Another common approach is to load a mask or alpha channel directly as a selection using either a keyboard shortcut or menu command. For the shortcut, hold Cmd/Ctrl and click the layer mask or alpha channel. Alternatively, use the Select menu. With your masked layer active, choose Select > Load Selection and in the Channel menu, choose the option that gives your layer's name with "Mask" at the end. Both methods give identical results.

Once you have an active selection, create a blank layer and fill the selection with white: Press D to ensure your background color is white, then press Cmd+Delete/Ctrl+Backspace. If you feel the mask needs to be more dense, repeat the fill shortcut a few times. After filling, press Cmd/Ctrl+D to deselect. Below the newly filled layer, add another blank layer and fill that one with black by pressing Opt+Delete/Alt+Backspace.

MIND THE MODE OF THE GROUP

If you have not yet experienced changing the blending mode of a group, you should pay attention to the difference between the Pass Through and Normal modes. The default blending is Pass Through, which allows opacity, blending modes, adjustment layers, and so on within the group to act on layers that are beneath the group. That is, lower layers "pass through" the group as if they were part of the regular layer stack. Using Normal for the group blending mode treats everything in the group as a complete, composited image, so adjustment layers, for example, would apply only to layers already inside the group.

The technique being described here uses Multiply for the group, which also makes the two layers behave as a single, composite layer. The white fill layer becomes a "knockout" layer.

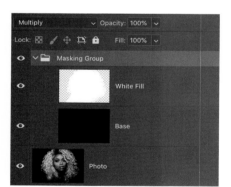

Remember that loading a selection treats gray values as partially selected, so white areas are fully selected, and black areas are not selected, with gray in between. When you fill in such a selection, the fill respects the transparency amount in the selection so while the color of the fill is technically white, it will be semi-transparent.

Group the filled selection and plain black layers, and set the group blending mode to Multiply. Now you can see the effects of the mask while working on a regular pixel layer.

It's an extra step, but I prefer this workflow of filling a selection because it provides greater flexibility as you work. It allows you to create additional layers, add multiple masks together, and to paint non-destructively. When the mask work is complete, you will need to set the group blending mode back to Normal, and then create an Alpha channel as described earlier. Instead of just making a direct flat copy of your mask, you may want to fill the

selected region with a solid color or gradient, or modify the selection with the Expand/Contract commands on the Select > Modify menu prior to filling. Further, you can opt to fill the selection to a blank layer, leaving the flat black layer as a base. These are more difficult to accomplish starting from a flat copy.

Let's now take a look at some nifty mask editing tricks that also demonstrate a little bit about how layers—and adjustment layers in particular—work inside of Photoshop.

LEVELS TWEAKING

Note that for this part of the example, we're looking at a single layer consisting of a white square surrounded by black. This will become important shortly. I have added guides to show the exact boundary of the original square. The square represents our starting mask, as if we had copied and pasted an alpha channel to a regular layer. I'll refer to this as a "mask layer" during this exercise.

Start by adding some blur to the layer, then add a Levels adjustment above the layer. Using a Gaussian blur of about 10 pixels is just fine for this demonstration. Now drag the right (white point) Levels control toward the left side of the display. The white square should grow a bit and extend beyond the guides.

Right away, this should give you some ideas about manipulating your masks. Of course, dragging the left control to the right has the opposite result, causing the square to shrink. And if you bring control points together, you can start to close in on a fairly sharp edge. Notice what it does to corners, however; they end up rounded. This is something you'll have to pay attention to in some circumstances, but for general work you'll use very small blur amounts in the range of 0.5 to 3 pixels, so the effect won't be a problem.

You can use this basic technique to smooth out rough, pixelated masks, especially those created by automated selection tools, such as the Magic Wand,

Object Selection tool, or Select Subject. Although those features can achieve awesome results in a few clicks, the masks often need just a little cleaning. Take careful note that Select Subject or Object Selection tool will attempt to create a solid fill. Just tuck that little insight away for future reference.

Levels adjustment has the added advantage of letting you place your edge boundary almost anywhere within the blurred region. To recover the original edge placement, drag both end points toward the middle.

There are lots of ways to apply this method, too. Let's say you're building a complicated mask with several parts, and you have just one section that needs some smoothing because it has a little pixelization. In the next example, I used the Blur tool to manually smooth out the pixelated area, then used the Lasso tool to make a selection around it, being sure to include some of the already smooth, crisp areas. With the selection active and calling up the Levels adjustment (not adding an adjustment layer) with Cmd/Ctrl+L, I tweaked the edge into shape. Because the smooth areas already have high contrast, they aren't affected and the blurred area blends right in.

Why was it important to note the figure is only a single layer earlier? It turns out that the way Photoshop handles layers has an impact here. Recall from "How Photoshop 'Sees' Your Images" that what you see on the canvas is a representation of all the visible pieces from each layer. There are situations where you can't immediately see a visible change between different ways of ordering layers, such as placing an adjustment layer inside a group versus outside of the group. This can cause some frustration, but it also gives me an opportunity to highlight the importance of knowing how your tools behave under different circumstances.

If I had placed the white square on a layer by itself, surrounded by transparency with the black background layer below it, the above experiments would have worked exactly the same unless we made a small change. If the Levels adjustment were instead clipped to the white square layer, it would have appeared as though the adjustment had no effect.

This happens because Levels (like all other adjustment or layer groups) operates as if everything below it is a single layer–everything coming in from below is added to its equation. Clipping the adjustment layer limits the input to only what is on the layer that it's clipped to. In this case, the fuzzy edges are blending with transparency, but Levels deals with actual pixels only and does not affect transparency at all. When we move the sliders, there is nothing to compare with, so the fuzzy edges don't change.

For Levels to behave like an edge refinement tool, it needs something for each pixel to be compared with, and that means either working on a flattened layer, working on a group, or not clipping the Levels adjustment to the white square layer. Let's illustrate this by adding a black circle to the middle of a white square, leaving a transparent region all around the square. The circle and square are on the same layer, and so the blur has been applied to both.

Applying a blur to the Square and Circle layer gives predictable results. The edges of the white square become soft and expand into the transparent regions, while the edge of the black circle blend with the white square. The blurred regions appear identical at this point.

Placing a Levels adjustment at the top of the stack and dragging the controls to the middle gives us what we expect–hard edges for both shapes (with rounded corners).

However, if we clip the Levels adjustment layer to the white square layer, check out the results.

The internally "captured" pixels of the fuzzy circle can be compared with their neighbors, so those get affected. The outside edges of the white square just sit there, happy and unchanged in isolation. Of course, if there were colors within the figure, or it were something other than flat black or white, Levels would have the usual effect, just as with the captured shape in the figure. In order for Levels to affect the edges of the white square, we either have to unclip it from the square layer, or group the black and white layers, and then apply Levels to the group.

Why should you care about this in context of masking? Because you can exploit blending modes to give you a view of your mask result in isolation while you are doing your refinements. Being able to see what does and doesn't work with the pieces of a mask as you work can save a lot of frustration.

MULTIPLY BLEND FOR GROUP MASKING

Let's look at a relatively simple example. This gull is easily selected with the Select > Subject command, which does an amazing job. But it leaves a tiny bit of halo around the bird, making it difficult to use in a composite.

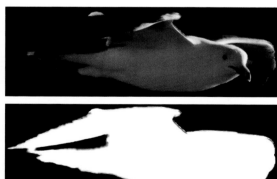

It's not too difficult to paint around, but that does take time and precision. A less labor-intensive approach is to set up the layers as shown.

Select Subject loaded the gull's outline pretty well, so I created a blank layer and filled the active selection with white. I then put a solid black-filled layer below the white selection. I grouped these two layers, and then set the group to Multiply blending mode. Black areas remain solid and opaque, but anything white allows lower layers to show through.

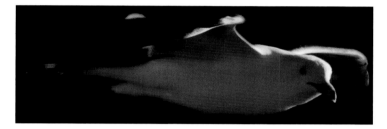

Now I can add a little Gaussian blur to the white layer, and then add a Levels adjustment layer above that. The amount of blur should be just sufficient to allow the boundary to be moved inward a little, typically 3 to 6 pixels. Notice that the Levels adjustment does not affect the gull itself, only the interaction between the white and black layer in the group. If I had placed the adjustment layer above the group, that would not be true: Anything showing through the mask would be altered.

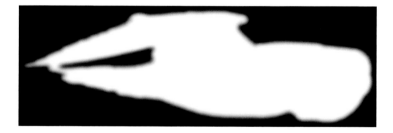

With this set up, I can freely adjust Levels to manipulate the boundary edge however I like. Although some bits under his wing and along his back need cleaning up, those are a lot smaller to deal with. After refining the mask, I set the group blending mode back to Normal, which shows me solid white and

black. A quick trip to the Channels panel and I can duplicate any of the visible channels to save my mask. From there, I just load it as usual for masking.

Of course, you can load any selection you like, and apply the same tricks to only active selections.

PAINTING WITH BLENDING MODES

Sometimes there is no getting around manual methods for masking. That means painting. But again, Photoshop lets you do some amazing things with just the basics. Channels are often a great starting point for masks, because they rely on the image data directly. With a little tweak of Curves and Levels, you can get some amazing details and subtlety with little effort.

While adjustments affect the entire layer at once, painting relies on you as the artist to make choices. The red channel from this portrait has a stunning amount of detail around the model's hair, so it's a great candidate to start with for lifting her out of the background. Duplicating it gives us an alpha channel to work with.

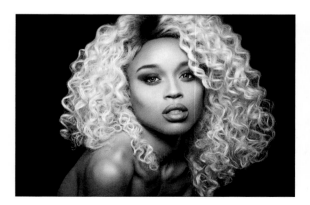

All by itself, it's nearly perfect, but does need some refinement. Grab a large, soft round brush and set the brush blend mode to Overlay. Lower the Opacity and Flow to around 25% each. When you're painting with black, solid white areas will be untouched, but areas darker than about 50% black will be burned down to total black. The low opacity and fill values let you sneak up on tricky areas a little more slowly.

I simply brushed over the curls area to increase contrast and smooth out edges. I also spent a little more time around the edges of the mask area to further darken the background before tackling the corners. To speed things up, I switched to Normal blending mode for the brush and painted directly in those areas, being careful to avoid the model's hair.

From here, it's easy enough to continue painting with white and normal blending mode in the interior of the mask to remove facial features. Using a gentle approach just takes a couple of minutes, but yields some amazing results.

NOTE When you are done with this technique, be sure to set the Brush blending mode back to Normal. Failing to do so may result in extreme frustration, and I do not need you throwing my own book at my head when your brush appears "broken" because you forgot about tool blending modes.

Photoshop being what it is, there are several ways to approach this challenge. After duplicating the channel, load it as a selection before painting. Try adjusting with Curves or Levels first, then brush with the selection still active. This can introduce some fringing, so this is a technique that's ideally suited for the group Multiply blending mode trick shown in the previous section. That way

you can see the results on the image as you paint and adjust. You can hide the selection's marching ants by turning off Extras under the View menu. Photoshop being what it is, there are several ways to approach this challenge. After duplicating the channel, load it as a selection before painting.

Remember that the goal of using masks is to make your life easier during the creative process. Look for ways to accomplish that goal using the data and tools available to you. This entire chapter is meant to illustrate various ways to do just that, not present a "best" workflow that is guaranteed to get results in every situation! In addition to the specific techniques listed previously, you should spend some time investigating other selection methods and perhaps even automating them.

If you do a lot of portrait retouching, for example, it may be worthwhile to dial in some methods that are specific to skin tone selection and create actions that set up layers to get you at least part of the way there. A quick web search turns up a few third-party plug-ins you can purchase that create some exquisitely fine luminosity masks with utterly absurd levels of control. Personally, I think it's money well spent if such tools help you express your vision more easily; but the true value can only be felt once you understand exactly what they're doing for you!

DODGE & BURN

Dodging and burning are cornerstone darkroom techniques, and there's no getting away from their benefits in the digital world. Fortunately, there is no end to the possible variations here.

When dealing with pixels, Photoshop allows many different ways to accomplish the crucial tasks of dodging and burning, the classic darkroom techniques of selectively lightening (dodging) or darkening (burning) individual areas of an image to regulate exposure. The specific method you choose should reflect both how you work and what level of control you desire. And, you should freely move between techniques as the work demands.

DODGE & BURN METHODS

The most basic approach to dodging and burning (or "D&B") in Photoshop is to use the dedicated Dodge and Burn tools, selected with the O shortcut key. If you use these tools directly on your photograph layer, however, they are destructive because they permanently change the pixels in your image. This might be best suited for making small refinements during a compositing project, for example.

The Dodge and Burn tools can also cause color shifting, as they are effectively operating with the Color Burn and Color Dodge blending modes. With the Protect Tones option enabled, the effect can be reduced, but this ultimately results in some desaturation. In this example portrait, the area under the model's eye has a "corrected" exposure value, but the color is almost completely missing from the highlight area.

Fortunately, both tools let you choose a tonal range (Highlights, Midtones, Shadows) as well as a relative power setting called Exposure. The controls for these appear in the context-sensitive options bar when one of the tools is currently active. Choose the appropriate range, and drop the Exposure setting to around 20% so you can sneak up on the corrections.

Working carefully over your image, you can exercise reasonable control but be warned: Except for using the Undo command, you can't completely recover the altered pixels back to their original state. Going too far with either of the tools typically causes unwanted artifacts, as well.

One way around these problems is to make your adjustments on a duplicate of your photograph layer. That way if something goes wrong, you can simply lower the opacity of the layer, use a layer mask, or replace the problem area

with a new selection from the original. The down side is that this approach adds to file size.

Other methods allow for a lot more flexibility and don't really have an impact on file size or performance, so the only compelling reason to continue to use destructive tools directly on your image layer is for speed in making minor corrections to small areas. Personally, I use these dedicated tools almost exclusively for working on masks, which is covered in the section, "Tweaking Channels & Masks."

OVERLAY

Let's start with a popular and time-tested method that uses a blank layer to hold your image corrections separate from the photo layer.

TIP To fill a layer and set its blending mode all in one action, press Shift+F5. This calls up the Fill dialog box with choices for types of fill (black, white, 50% gray, foreground, background, patterns, etc.), which blending mode to apply to the layer, and the layer opacity. Remember to use this on a blank layer or with an active selection.

Start by filling a blank layer with 50% gray and setting its blend mode to Overlay. The Overlay blending mode ignores 50% gray but selectively darkens or lightens based on the gray value of the blend layer. That means the 50% gray overlay layer is effectively invisible until you begin working on it. Using the Dodge and Burn tools on this intermediate layer is probably your best approach, if you feel most comfortable with these tools.

The only purpose of using a filled layer is to be able to use the actual Dodge and Burn tools. Another option that gives you more expressive control is to skip the fill step and paint directly on a blank layer set to Overlay blending. Use a standard brush set to low flow and low opacity values, and paint with shades of gray (50% gray will of course have no effect). This lets you build up the effect slowly, with more control to avoid harsh transitions in value. You can set foreground and background colors to the default black and white by pressing the D key, and then toggle between them with the X key.

As a bonus, paint with colors sampled from your image to adjust saturation at the same time. The Overlay blending mode is effectively the same as using

Multiply for darker areas, and Screen for lighter (see the "Blending Modes" chapter of Part IV, "References" for more details). Using this painting technique, it's possible to retain some of the richness that might be lost when painting with only black or white.

In this rogue's portrait, it was important to retain the slightly oversaturated look so painting with color as described helps increase the density of the darker tones while preserving and slightly increasing the saturation in the lighter tones.

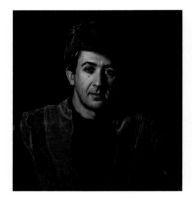

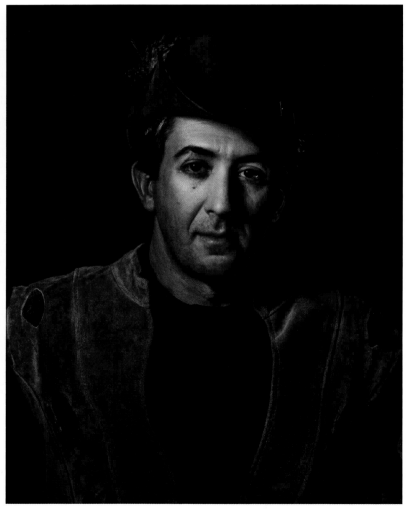

You still have to be careful when painting on this layer because extreme changes can have bizarre results and also create artifacts. While you can always go back and repaint certain areas, you might also end up introducing small artifacts without realizing it.

Just for fun, here's an example of how you can use the color-based technique for more than just styling. I treated these toy guns to a little color adjustment and then gave them a flat, masked texture layer. On top of that I added the Overlay D&B layer and manually painted with color, black, and white to create details and effects.

USING CURVES

My preferred starting technique for dodge and burn is to use a pair of Curves adjustment layers that are set up to limit the dodge and burn effect. This helps prevent some of the artifacting and extreme changes that are possible with the Overlay layer painting method. You also get the added benefit of separating the darkening and lightening effects to distinct layers.

To start with, create one Curves adjustment layer above your scene, and drag the center of the curve upwards to the point where the darkest parts of your image are as light as you think you'd ever want them to be. Name this layer **Dodge**. Fill the mask with black.

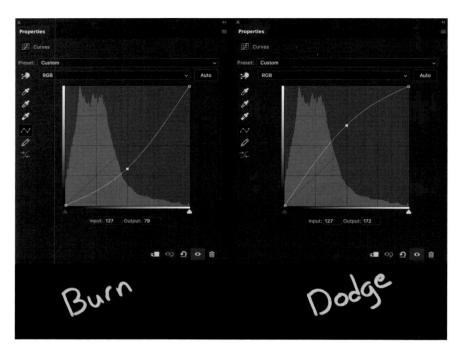

TIP Once you have used the Fill dialog box, the settings for blending mode, fill type, and opacity will be persistent while Photoshop is open. Pressing Shift+F5 or using Edit > Fill will show you the last settings you used.

Create another Curves adjustment layer above that, and drag its curve down so that the brightest areas are as dark as you want them to be. Name this one **Burn**, and also fill its mask with black.

For organization, group them together and name the group **Dodge & Burn** or whatever makes sense for your work.

From here, you will use the Brush tool to paint with white on the mask of each layer. Use a soft brush with low settings for Flow and Opacity just as with the previous method. This means you will be working on only one adjustment at a time.

There are several advantages to this particular approach. First, it gives you discrete control over the dodge and burn operations independently. If you need to adjust the opacity of either of the layers, you can do so without affecting all of your adjustments at once. Additionally, working with just one type of correction at a time helps you focus a little better on the global adjustments.

D&B BEST PRACTICES

As a general workflow recommendation, I suggest starting with large adjustments first, such as overall shaping and setting visual focus, such as lightening the face in a portrait, the foreground in a landscape, or creating soft vignette effects to guide the viewer's eye around the image. The next pass would be intermediate features, and then finally a detail pass.

This example shows the mask from the first (the "Big" pass) Burn layer.

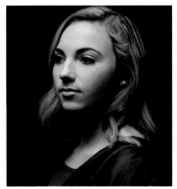

I also recommend using multiple D&B groups to keep them flexible and distinct. Using one pair of Curves each for large, medium, and small features gives you a lot of flexibility in balancing them later on. Each pair, and indeed each individual adjustment layer, can be modified without affecting the others. Of course, you can adjust the curves on each as well.

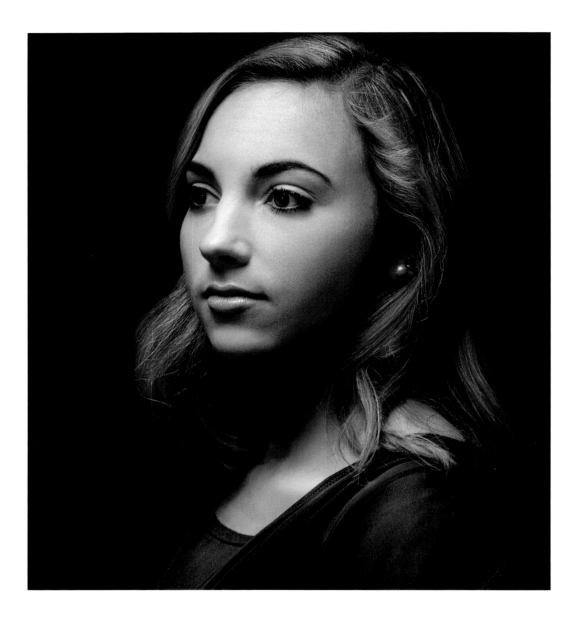

This same principle goes for working with the Overlay painting method: Use several layers rather than putting everything on one. For a more detailed workflow, look in Part III, "Project Examples." The Rembrandt Portrait shows off a couple of different dodge and burn techniques grouped together.

INSTANT IMAGE ENHANCEMENT

With all of the blending modes available in Photoshop, and the stunning array of techniques in which you can use them, it's sometimes easy to forget that they can be used directly for some basic image enhancement. The four most popular blending modes for this are:

- **Multiply**
- **Overlay**
- **Screen**
- **Soft Light**

Most of the time, you will hear advice on duplicating a photo layer and setting the duplicate to one of those four modes. Multiply darkens, Screen lightens, and Overlay and Soft Light increase contrast. Using this little trick is a great way to jump start lots of images, but let's explore some variations on this theme.

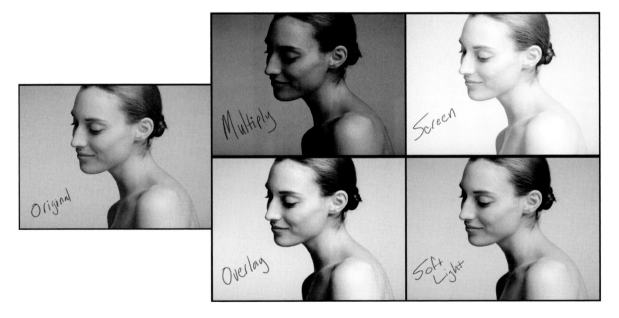

First, rather than duplicating the photo layer, you can generally use any adjustment layer instead. Without making any other changes, the adjustment layer behaves like a copy of the image, especially when it's clipped to the photo. This immediately gives you additional flexibility; not only do you get the exact same effect, including the ability to change opacity and advanced blending, you also get the features of the adjustment layer itself.

Adding a Curves adjustment set to Overlay gives a nice contrast, but you can take advantage of so much more. For example, I started by raising the left side of the curve to lighten up the muddy shadow regions and make everything a little less heavy.

Stepping through the channel curves lets me run some color work to shift the overall tone towards reds and purples. Each channel can be adjusted individually, so this is a good way to explore a lot of variations.

Finally, a little tweak in the Advanced Blending section of the Layer Style dialog box, using the Blend If section's Underlying Layer sliders, allowed me to smooth out the shadows a bit more. I finished by lowering the Opacity setting (in this case, to about 90%).

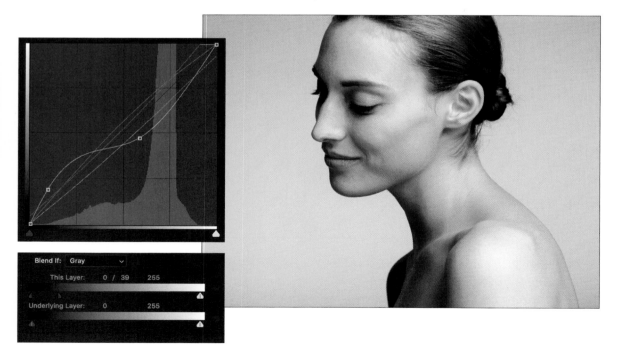

This represents a lot of the early heavy lifting that can be done with a single adjustment layer, all non-destructively.

You can use this general approach for correction or enhancement, or just to try out lots of different versions. This time, let's use Screen, which initially blows out the highlights quite a bit. Again, the composite curve gets some dramatic tugging to bring back the highlights, and then each individual channel is adjusted to end up with a gold tone (increase Red and Green, decrease Blue).

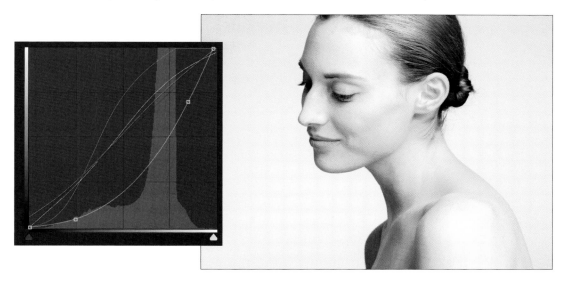

Each of the adjustment layers can behave this way, with the exception of Threshold, Inverse, and Posterize. These three will immediately apply their own effect. You can use Photo Filter if its Density slider is moved to zero, and the Color Lookup Table will be neutral until a lookup table is applied (once you choose one, however, there is no way to remove it completely without simply deleting the adjustment layer).

Choosing which adjustment layer to use for blending mode effects comes down to the usual question: What do you want to accomplish? For most purposes, I stick with a Curves layer simply because of its flexibility and power. Blending with other adjustments affects how they behave, so let's take a look at why you might consider certain blending modes for different adjustment layers.

Because, as you saw, the four most popular blending modes all have an immediate and independent effect, it makes sense to pair them with adjustments

that complement them in some way—either enhancing or mitigating their results. The Curves and Screen result is a good example of reducing the effect, or "pulling it back." Similarly, using Soft Light with a Color Lookup Table (using the Foggy Night preset) gives a gritty look.

In one final example, this single frame is reasonably well exposed but kind of boring. To enhance the contrast, I added a Curves adjustment layer set to Overlay blending mode, which had nice results in the midtones, but muddied the shadows and blew out the highlights.

To correct for this, I went to the Advanced Blending section in the Layer Style dialog box set Blend If to Gray, and split the Underlying Layer sliders.

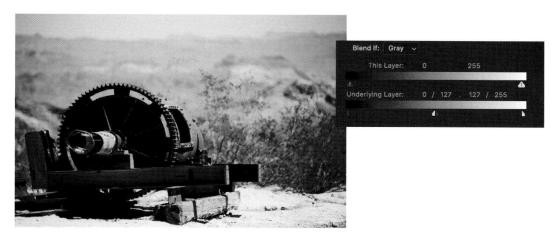

Splitting the sliders in this way allows the enhanced contrast to reach to the shadows and highlights more gradually, avoiding serious loss of detail.

HARD MIX CONTRAST

A more specialized application of using an adjustment layer to apply a blending mode takes advantage of the special nature of Hard Mix; it behaves differently when used with Fill compared to Opacity. See the "Blending Modes" chapter in Part IV, "References" for more details on why this is.

For images with low contrast, especially due to haze or extremely soft light, this trick can do some pretty amazing things. The shot below is from Coronado, California, showing some early morning fog. There's not much detail or contrast to work with.

Just adding a Curves adjustment set to Hard Mix, and lowering the Fill to about 60% gives a pretty dramatic change everywhere so there's at least some detail to work with.

If you've used the Clarity slider in Camera Raw or Lightroom, this effect will look familiar to you. By now, you should recognize a good opportunity to use Blend If to clean up the muddied shadows. Splitting the sliders and in this case, crossing the highlight and shadow regions recovers those muted blacks well.

NOTE Pay attention to the fact that the Blend If sliders can be crossed at any time, including when split as shown in the screenshot. It is worth a few moments of your time to explore this capability by setting the Fill value back to 100% and completely swapping the Black and White stops, splitting them arbitrarily and using extreme values. This gives you a sense of how flexible this ability really is.

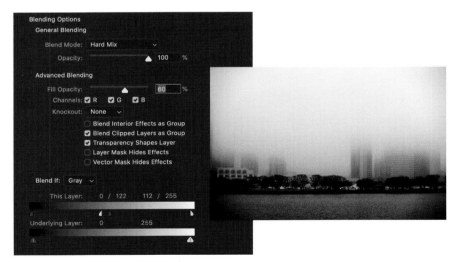

At this point, we can start to apply some of the usual techniques to adjust color and contrast in any way we like. Because we already have a Curves adjustment for free, let's exploit that by tweaking the individual channel curves a bit. I want a warmer, dreamy effect in this version. That requires a tiny boost in red and green, with blues dropping out. From the menu in the Curves Properties

panel, choose each of the channels in turn and apply minor changes. The thing to keep in mind, if you're not familiar working on each color channel individually, is that you're looking mostly for tonality in the first color you adjust, then sneak up on the colors you want with the remaining channels (more on this in a bit). The figures show what I ended up using.

The adjustments to each channel are pretty small, except the Blue channel where I wanted to retain some coolness in the deep shadow areas. I really enjoy this technique because it can recover some otherwise unusable images. And in this case, it only took one layer to do pretty much everything I wanted.

A more complicated picture is this lonely cactus in the northern New Mexico snow. It already has some bright areas and lots of tiny details with the snowflakes blowing about.

The photo was intentionally underexposed to preserve some texture in the snow patches, which means additional steps will be needed to avoid blowing out highlights. Also, the darks are perilously close to full black. That suggests we should attack the mids and low mids more than anything, and so this is a great spot to try out a few tricks. In the "Selections & Masking" chapter, I showed you a quick way to select ranges of values in an image using a Gradient Map.

With the Gradient Map visible, it's fairly easy to pick out the range we want to affect. In this case, it's the slightly brighter midtones. Close the Gradient Editor and in the Channels panel, make a selection from any of the channels, then turn off the Gradient Map adjustment layer. Create a Curves adjustment layer; the mask is automatically applied. Here's the result of setting the unchanged curves layer to Hard Mix at 40% Fill.

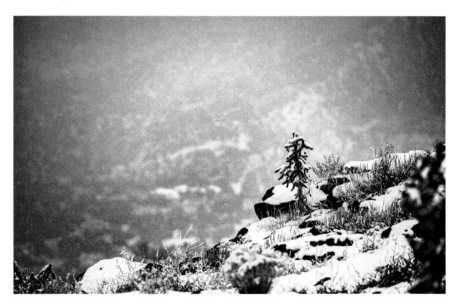

The brightest highlights in the snow and darkest shadows around the rocks are untouched, but the high mids are moderated. Let's talk a moment about why this is an advanced move. While I did not have a final vision in mind, I could describe some of the features I wanted in the results: Protect the ends of the dynamic range, and increase contrast and detail in the upper mids. Setting just those goals allowed me to use previously known skills to make an intelligent choice in creating the mask, namely by isolating the region of interest.

Further, we know that the Masks Properties panel comes with some extra goodies, such as Density and Feather adjustments, as well as the ability to access the Select And Mask workspace for refinement. Rather than hand painting the mask or trying to carefully combine multiple selections, the first pass got me close to an 80% solution, or more. The Feather and Density controls also allow me to exercise non-destructive creative decisions about the mask. I can even use Blend If should I wish.

The default transition between masked and not masked is a little harsh, and I would like just a touch more contrast in the areas I previously excluded. For this image (about 7400 px by 5000 px), a feathering setting of 36 px nicely blends those regions. I also dropped the Density setting to about 80%.

To finish this piece off, I added a Hue/Saturation adjustment to drop the saturation a bit, then added a Color Lookup adjustment using the Candlelight preset and lowered its Opacity setting to 45%.

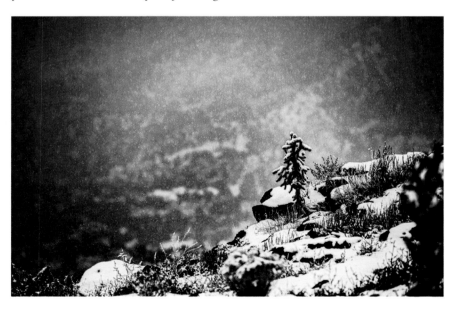

GRADUATED NEUTRAL DENSITY FILTER

Graduated Neutral Density (GND) filters are popular photographic tools that enable you to balance scenes with wide dynamic range. These glass filters attach to the front of a camera lens, and photographers typically use them for landscapes, sunsets, sunrises, and other scenes where the sky is far brighter than the land. A basic ND filter behaves effectively like sunglasses for your camera, reducing all incoming light (hopefully in equal amounts across the spectrum). A Graduated ND filter has a density ramp (a gradient) from clear to dark, allowing you to more easily balance exposure in a single frame by aligning the clear-to-dark transition with the appropriate areas of your scene. You can create GND filters in Photoshop to help balance your images in the same way. In addition, you can use them to create vignettes and other artistic looks. Just don't expect miracles: The following GND methods can't recover detail that is already lost in your original image, either by shadows that are too dark or highlights that are blown out.

The traditional digital approach for a sunset photo is pretty simple, assuming the sky is a bit too bright for the foreground. Create a blank layer, name it **GND**, press D to set the default foreground and background colors to black and white, and then grab the Gradient Tool (G). From the options bar, choose a linear gradient, and then drag from top to bottom while holding the Shift key. The Shift modifier ensures the gradient is dragged perfectly in the vertical (or horizontal or at 45 degrees, depending the direction you drag). Your result should be black at the top and white at the bottom.

Change the blending mode of the GND layer to Multiply to start. Notice the black areas bring down highlights, while the white areas of the gradient don't

have any effect on the image. Lower the Opacity of the GND layer until the values are more balanced. Unfortunately, I find that many images suffer from loss of saturation, and the result is something a little too muted for my taste.

Instead, I like to experiment with Color Burn and Overlay, depending on the dynamics and what I want out of the process. Color Burn can be really, really harsh, but fortunately it responds differently to Fill than it does to Opacity. For this particular image, lowering the Fill setting of the GND layer to about 55% gives a great result for the sky in this example.

In some situations, it may be better to actually duplicate the photo layer rather than applying a gradient. Duplicate the photo, and change the copy's blending mode to Multiply. Use the Gradient tool to add a layer mask to the copy, and this time let the sky show through while masking the foreground. Keep in mind that while a mask is selected, pressing D will load white to the foreground and black to the background, but also swaps the gradient colors if you're using Foreground To Background as a preset.

Both methods allow for all kinds of customization and tinkering. Duplicating the photo layer and using Multiply quickly burns the image overall, so be sure to keep an eye on artifacts in the darker areas. But any color regions will immediately start to pop. Similarly, Overlay will burn dark areas while dodging light areas—something to keep in mind if you are dealing with a low-contrast image, such as on a hazy, gray afternoon.

The next step in building on GNDs is to expand the idea to vignettes. While the technique is very similar, the intent is quite different. A GND is meant to manage dynamic range; vignettes are primarily meant to guide the viewer's eye around the photograph.

CREATIVE VIGNETTES

Vignettes use the same basic principles as the graduated neutral density techniques, but applying them is much more of a creative endeavor than a corrective one. As such, the possible variations open up quite dramatically. Honestly, anything you do to change the value around the perimeter of your image with the intent of drawing focus to your subject counts as a vignette. Of course, some methods are more popular than others.

To illustrate the concept, let's grab the Gradient tool and choose a Foreground To Transparent gradient with the Radial style. You may have to switch your foreground color to black, and in the options bar select the Transparency option. Also ensure Reverse is checked in the options. On a blank layer above your image, drag from center of the canvas to any edge. Name this layer **Vignette** for now.

Without blending modes applied to the Vignette layer, the result is predictably dark, but satisfies the basic description of a vignette. In fact, a solid, unblended look is more traditional to vintage film photography. On the Vignette layer, press Command+I (macOS)/Ctrl+I (Windows) to invert the black to white.

There is nothing that requires a vignette to be anything other than something to obscure the border of an image, and even that is not truly necessary. To that end, you can employ shape, color, and size in any way you as the artist see fit. Using the white vignette as on the previous page evokes old-style prints and can be useful in selling an idea of history in your work, especially with toning techniques like Sepia or Selenium (examples of which can be found in the "Color & Value" chapter).

Moving on to a more robust workflow, let's add a Gradient Fill adjustment layer at the top of the layer stack (you'll delete the Vignette layer later). When you first add a Gradient Fill adjustment layer to your document, the Gradient Fill dialog box pops up with a few controls. Choose Radial from the Style menu, then select the Reverse option (it may still be selected if you followed the previous technique). Finally, open the Gradient Editor by clicking the gradient swatch itself. Move the dialog box around so you can see the results of your changes immediately on the canvas.

NOTE If you have not used gradient presets before and are using Photoshop 2020, then you'll need to load the Photographic presets for some of the described looks. Choose Window > Gradients and open the panel options menu. Choose Legacy Gradients to load the presets you see in the text.

NOTE Why select Reverse? Because the color ramp in the Gradient Editor presumes the left edge is the center of a radial gradient, and we need the transparent region on the right to be in the center of the document instead. Most of the presets will place darker areas on the left and lighter on the right of the gradient ramp. Using the Reverse option keeps us from having to rebuild the gradients.

For this example, I'm using the Cyanotype preset from the Photographic Toning collection (see Note). Because the gradient layer needs to have a transparent region but the preset is 100% opaque, we can either use a mask on the Gradient Fill layer or build some transparency into the gradient itself. To be more flexible, let's create a new preset with its own transparency. The stops at the top of the gradient preview bar are for opacity. In this case, we want to

make the white region transparent; click on the Opacity stop above the right edge of the bar, then change the Opacity setting at the bottom of the window to 0%.

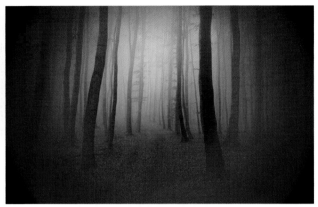

I find in many cases that I prefer to move each of the color stops to the left to control the size of the gradient. That way the colors from the original gradient are still included. Before I close the Gradient Editor, I want to save the new gradient as a preset. Choosing New lets me save the preset, and I can drag it to any collection in the editor window.

Closing the Gradient Editor window takes us back to the Gradient Fill box, where we can do some additional refinement by adjusting the Scale so that the effect is pushed out more towards the edges. There is one more thing we want to do before closing this dialog box.

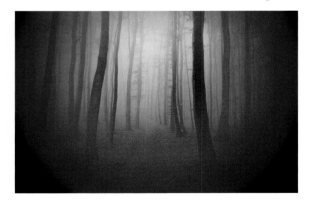

With the Gradient Fill box open, deselect "Align With Layer" so you can drag the gradient around on the screen. That way you aren't locked in to having the center of the vignette right in the middle of your image. Also try out the Angle settings to see the effect on the shape of the vignette; for radial gradients, this changes the shape from circular to oval. Drag the gradient where you like, and click OK to close the dialog box. If you need to reposition it, you'll have to open the Gradient Fill box again by double-clicking the adjustment layer icon.

With the gradient in place, you can change the opacity and blending to finish the effect. For this image, I chose to reduce the opacity to around 50%, and set the blending mode to Overlay to preserve the burning effect from the black areas.

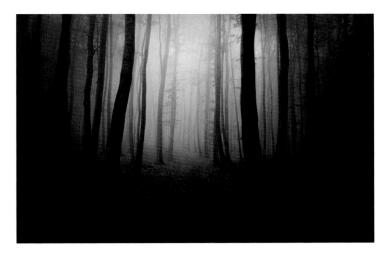

While this result looks pretty good, we can make it even more stylized by changing up the gradient a bit. Back in the Gradient Editor, I'll change the far-left Black color stop to a bright red (RGB: 255, 5, 50), then move the 100% Opacity stop to about the midway point. A few other color stop moves, and here's the new result.

Because I made changes to the previous preset, I can save a new one as well to the same collection. This also gives me an excuse to remind you of a great trick using Libraries. Starting in Photoshop 2020, you can see your new presets in the Gradients panel (Window > Gradients) and simply click one to load it into a Gradient Fill layer. The problem is that the radial style is not preserved, nor is the scaling. When you go to apply your saved preset, you'll have to make those settings changes. To get around this, you can drag your entire Gradient Fill layer to a Creative Cloud Library. Whenever you want to use it again, just drag it out to your Layers panel while holding Opt/Alt, and—boom!—instant stylized vignette.

Of course, you are not limited to gradients. It's entirely possible to create vignettes with painting techniques. Turn off or delete the previous vignette and fill layers, and add a fresh, blank layer. Select the Brush tool, grab a large soft brush, and lower the opacity to around 30%, and the flow to 10%. This will allow you to scrub and color in the effect a little more carefully.

Hold Opt/Alt to temporarily switch to the Color Sample tool, and click to select any color you'd like to try for the border. Release the modifier key and begin painting along the same edge you sampled from. Let the paint build up a little at a time, focusing on removing distracting details from the edges of your photo, or drawing focus towards the subject. This is a good technique to start with to ensure some harmony among the colors in your image, but you do have to choose carefully.

With the paint layer still active, try out some of the blending modes. Color is a good one for supporting a particular palette, building a theme across several images, or connecting the image to a viewing environment. Color Burn, as used in the Neutral Density Gradient, will provide a dramatic darkening effect.

Continue painting the other edges using the sampling method or using completely different colors as you go.

Remember: the point of adding vignettes is to enhance your photo by leading focus, and that means reducing visual clutter away from the subject.

REMOVING VIGNETTES

Now that we have spent some time adding vignettes, let's think about how to remove them. Shooting wide open on most lenses can give you some vignetting under the best of conditions, as will using a polarizer. When I first encountered this and tried removing them in Photoshop, I relied heavily on manually painting them out. As you may expect, that was neither easy nor particularly effective.

Here's a common situation with a simple vignette.

Let's remove it! On a blank layer above your photo (with no other effects or adjustments active), create a radial gradient that mimics the existing vignette to a reasonable extent. Start by choosing the Gradient tool (G) and the Foreground To Background preset. Hold Opt/ Alt while clicking on a representative dark area of the vignette, preferably in a fairly solid area. (You may find it helpful to instead use the Eyedropper tool (I) with a larger sample size to help average out the color.) Press X to swap the foreground and background, then Opt/Alt-click near the center of the image away from the subject to sample a representative color from that area. The gradient ramp in the options bar should have the lighter center color on the left, and the corner color on the right. Remember that you're selecting colors that you want to neutralize.

Using the Radial style, drag out from the center to the corners. For smooth vignettes, this should be pretty straightforward, but be aware that you may have to transform the gradient a bit in some cases.

Change the blending mode of the gradient layer to Divide. The background should be nearly completely white. Remember: anything divided by itself is 1, and in Photoshop that means white. Now we can mask the subject and lower the opacity of the gradient layer to blend everything.

Of course, this is a really simple example to demonstrate the idea. Things get a little more complicated when there is more texture and a bigger subject. Consider this image across San Diego Bay in California; I took it at the same time and location as the gull picture above.

In this case, the corners have clouds and some rich color, so we'll have to be a little more careful. Instead of sampling the sky near the center of the image, let's just leave it transparent. Select the Transparency box in the options bar, and click the gradient swatch to open the Gradient Editor. Ensure the darker corner color is on the right, with its Opacity stop set to 100%. The lighter color should be on the left, and its Opacity stop set to 0%.

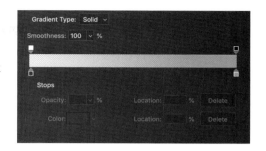

Again, drag out the gradient on a blank layer so that the corners are darkened.

It turns out that a few blend modes can work, so the important thing to remember is that you want to use the sampled color to lighten the area. Modes that lighten include Screen, Soft Light, and Linear Dodge (Add). In this case, because there is more texture and a slightly saturated color, Linear Dodge works really well, with about 60% opacity (and of course masking the buildings).

Something to watch for with Divide is desaturation in the blended areas. Moderating this result usually means adding back in some color on a new layer, or reducing opacity even further. Both can have some unintended results. For clear skies, it may be more useful to try a Luminosity blend, instead. This is effective when the actual hue is relatively constant across the area that you need to correct, but varies mostly in brightness. If your scene has any clouds or other elements, they'll have to be masked out. But let's skip ahead to a slightly more complex situation with Luminosity.

There's a strong vignette in this image, but no real way to isolate a color or single luminosity value to put into a gradient. In this case, I tend to use a simple black-to-white radial gradient knowing that I'll have to do some additional corrections. The gradient layer is of course set to Luminosity, but look how washed out everything is even at 20% opacity.

The solution is to toss in some Blend If goodness using the Underlying Layer slider, then mix with a little Curves and Hue/Saturation. This operation effectively equalizes the value variation from center to corner. You can think of it like another frequency, except at a very large scale compared to the image. To negate the frequency, you hit it with a little of the opposite frequency, the radial gradient. Because the larger frequency also affects the details, those will need to be brought back.

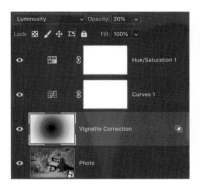

You may be wondering about the built-in vignette controls in Camera Raw. They're great! If you haven't discovered them before, now would be a great time to open an image in Camera Raw. Convert your layer to a Smart Object, then choose Filter > Camera Raw Filter. The vignette slider is under the Lens Corrections tab. There is a single slider that accomplishes some of what we've done above.

Even faster to use than Camera Raw is Lens Correction on the Filter menu. This is applied as a destructive filter, so either duplicate your photo layer or convert it to a Smart Object before using it. After choosing Lens Correction, you will need to open the Custom tab and look in the middle of the controls selection. The Vignette slider lets you choose to lighten or darken the corners, and the Midpoint slider adjusts the shape and transition of the correction (or effect if you choose to add a vignette).

While these built-in solutions are amazing, there are situations where they are just not enough. For example, the Vignette correction sliders won't help much with darkening only in one corner, which can happen with polarizers or shadows. It also won't help with smoothing out linear variations as may happen with a shadow in the foreground. Using the above techniques let you have direct, precise control over myriad situations that the Camera Raw and Lens Correction filters won't handle.

BRIGHT EYES

One of the secrets of retouching is enhancing small details that draw a viewer's attention. For faces, that means eyes! Adding a little brightness and shine to the subject's eyes will make them seem more lifelike to the viewer. This technique should be used with restraint, as overdoing it will be obvious, or at least disturbing.

The choice to use Soft Light here is a nod to that restraint. When I first started using this technique, I relied on Screen, which does not become useful until the opacity is lowered (multiply is the same way). That meant at some point I was not actually brightening the colors so much as adding white and desaturating. Soft Light is not nearly as strong as Screen, but has the advantage of preserving the saturation of the lighter colors.

On a blank layer above the photo, set the blending mode to Soft Light. Use a soft, round brush set to about 20% opacity and 30% flow, a little smaller than the iris (the colored part of the eye). Choose white as your foreground color and work gently around the lighter areas of the eyes, paying attention to and preserving much of the natural shading. The soft brush will also brighten a little of the skin around the eye, and that's fine so long as it's not overdone. The goal is subtle enhancement, not a glowing horror film effect.

Once the overall shaping is complete, decrease the brush size to about half that of the iris, then lower the opacity to about 10%. Look for where the image light is coming from and how it highlights the iris. There should be a lighter and darker area, and you will paint very carefully in that lighter region, creating a new highlight (avoid the pupil at this stage). If the effect is too much, undo it and lower the Flow setting to 10%. You should look for just the barest change here at first.

For softly lit portraits, this should probably be all you need for the highlights. You want to both enhance the shape of the eyeball and bring out the color without diluting it. Highlights over the iris are meant to show clarity as well as draw attention.

Now it's time to work in the darks just a bit. Switch the paint color to black and ensure the brush is small enough to deal with the edges of the iris. Gently brush over the dark edges to give them a little more presence. You can also use this over the pupils, but don't fill them in completely—a tiny variation in the blacks implies depth here.

The rims of the eyelid can also be painted over, especially at the outer edges of the subject's eyes. This same technique can be applied to eyelashes as well.

Bring a little of the color back in with a new blank layer set to Overlay blending mode. Sample a part of the eye color that is reasonably saturated but not too dark. Make a few small strokes outward from the pupil to the edge of the iris. This is a really subjective part of the technique, as it's easy to get wrong. The look you're going for is to disrupt the highlight just enough to

maintain realism, without creating artifacts or looking like the eyes have been colored in. Overlay will have the effect of darkening these areas most typically, unless the model has extremely bright irises already (such as you might encounter with colored contacts or some animals). Often, just a few dabs or tiny strokes will be sufficient.

Overlay is a bit stronger than Soft Light, and helps bring back some of the saturation of the colors you sample from the eye without losing detail or causing artifacts. Here is a little demonstration of using the various blending modes for this kind of dodge and burn.

Notice that Overlay (bottom pair of lines) has a stronger effect in the midtones when painting with black or white, while Soft Light is more uniform across the range from black to white. When you want to enhance what's there, choose one of these two blending modes.

In some cases, you can get a dramatic, vibrant change using a slightly different approach. Rather than gently painting in the highlights, this is kind of a brute force method of getting a glassy-eyed look.

On a blank layer set to Normal blending, use a hard, round brush the same size as the iris. Set the brush's Flow and Opacity options to 100%. Pick a neutral gray, around 55% brightness, and stamp a single dot over each eye. Add some noise for texture by choosing Filter > Noise > Add Noise, and choose Gaussian, about 15%–25%. Deselect Monochrome so you get some color variation.

Now change the layer blending mode to Divide.

Egad! It's horrible! Lower the Opacity—quick. Depending on the original eye, the opacity range could be anywhere from 10% up to 80%, so just try it out. Now add a layer mask and soften your round brush. Mask the edges and the pupil. Alternatively, switch the Brush blending mode in the options bar to Clear. This erases the paint on the canvas using the same brush, and you can avoid creating a mask. Also, if the speckled colors are too strong, use a Gaussian blur of about 1 pixel to soften the look.

Now we have a very bright, highlighted iris. Both methods can be made to give nice results. The painting method gives you control over position and shape of the highlights, while the selection method is very fast. There is no reason the two can't be combined, either. In general, Soft Light blending will be more precise and fit a wider variety of eye colors with little variation. The Divide method can be hit or miss, but gives really dramatic results very quickly.

COLOR & VALUE

If you want to start a lengthy discussion, maybe even a few arguments, strike up a conversation about color with photographers. Second only to the fervor over equipment, color inspires nearly religious devotion to certain tools and methods.

Where the "Dodge & Burn" chapter focused on contrast, this group of techniques deals with brightness and color as individual elements, as well as the relationship between gray and color.

COLOR GRADING

Because digital images are all about color, it makes sense that we want to master various ways to control color to different extents. You've already seen how to make some global and local tonal corrections with various dodge and burn methods, and later in this chapter you'll learn various detailed color techniques. Applying an overall color scheme to an image is typically referred to as *grading*.

This does not mean you simply create a single, dominant cast to the entire image, but it does mean that certain tonal values become dominant. You see this all the time in major motion pictures, where base color themes are used to help set emotion and feeling of a scene. Consider action movies that use orange and teal colors or horror films that tend towards dark blues.

That being said, there are quite a number of ways to bring color palettes to your work so it makes sense to think about the options available and how they impact both your workflow and vision.

SOLID COLOR FILL LAYER

The simplest approach is indeed to simply place a color layer over your final image. Use this technique to create a smooth, narrow tonality, especially when you want to focus on the graphic elements of the image. Although you can do this by filling a blank layer with color and using a blending mode, I recommend using a Solid Color fill layer instead. There are two common blending modes to put into play here: Color and Hue. With a dark blue solid color (RGB: 16, 27, 46) filling a layer, select one of these two modes to replace the colors in your photo layer. The following example uses Color blending mode first, then Hue.

The main difference between the two modes is what they actually affect. Color blending mode takes the color of the blend layer and merges it with the luminosity of the base layer. That means even shades of gray get a color value. Color in this case means both hue and saturation together. We will make use of this fact in some later techniques.

Meanwhile, the Hue blending mode replaces the actual hue only, using the luminosity and saturation of the underlying layer. Because shades of gray have no saturation by definition, they do not change at all. This also has the effect of giving less dramatic results.

Between the two of these modes, you would use Color to apply color to a black-and-white image. Hue would be most useful for making more subtle corrections and enhancements to color images, such as you might do with makeup and skin retouching.

In addition to lowering opacity, you can enhance this basic technique in a number of ways. For a duotone effect, for instance, add two Solid Color fill layers with both set to Color mode. Use one color layer for shadows and one color layer for highlights or midtones. In each color layer, use the Blend If sliders to constrain that layer's color to a particular range of values. In this example, darker values are given the same dark blue that was used in the Solid Color fill layer at the start of this section (blue shadows), and the middle values are given an orange (RGB: 187, 97, 24) tint (orange midtones).

HUE/SATURATION ADJUSTMENTS

For even more flexibility, let's use a Hue/Saturation adjustment layer instead of a Solid Color fill layer. The Hue/Saturation adjustment behaves similar to a solid-color fill when Colorize is selected. There is the added bonus of having a Lightness slider that behaves a little like a levels adjustment. Advanced blending (the Blend If sliders) may be used to affect specific lightness ranges. For the Shadows adjustment in this example, I used HSL: 257, 30, −2, and for the highlights HSL: 109, 71, 5. The values are given in HSL rather than RGB due to the nature of the Hue/Saturation adjustment controls.

Want a more precise approach? Add a couple of gray steps and reference chips to your image temporarily (see below). This way you can see the color shifts against a standard, making it easier to see where your duotones (or tritones) overlap. The purpose of the gray step wedge is to help you balance your Blend If adjustments so that you can more easily see where the shadows and highlights actually overlap.

In the previous image, the layer named 50% Baseline holds a small 50% gray square that is above the adjustments, so it is not affected. The layer acts as a reference point so you can compare changes against a neutral tone. The same gray is used below on the 50% Adjusted layer. Seeing these two chips next to each other helps you gauge the changes you are making to your image.

The Gradient steps are also just a range of gray values that help make changes easier to see in shadow and highlight areas. Learn about building these elements in "Creating the Workbench Files" in Part III, "Project Examples."

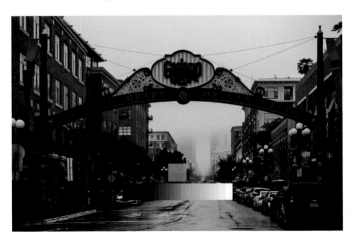

GRADIENT MAPS

Now that you understand the foundations of altering colors in an image, the next level of complexity is to apply a palette of replacement colors. In this way, you can more directly map specific tones across the entire dynamic range in an image. Remember back in the "Gradient Map Luminosity Selection" section of the "Selections & Masking" chapter when we looked at using Gradient Map adjustment layers to convert from color to gray values for black-and-white visualization? We can do the same thing for colorizing and grading. Adobe added a lot of amazing new gradient presets with the 2020 release of Photoshop. These are typically divided up into general color groups.

Let's apply a few Gradient Maps to my Gaslamp Quarter image just to see the effects. On a basic color image, the Gradient Map looks only at the composite luminosity value in order to map from tone to value to result color. That is, any given color you see on the screen is the result of the sum of brightness values in each channel, so Photoshop first generates a luminosity number for that color. Refer to "How Photoshop 'Sees' Your Image" in the "Welcome" chapter in Part I. Here are the Red_03 and Blue_30 presets applied to the starting image.

Remember that the color ramp in the Gradient Editor starts with blacks on the left and whites on the right, representing the input luminosity values. Color stops along the ramp translate from the luminosity level to the color on the

ramp, so for a photographic result, the darker colors should be on the left, and lighter on the right. The Photographic Toning gradient presets are built this way. You can find them under the Legacy Gradients folder in the Gradient Editor. (If you do not see them among your presets, load them by choosing Window > Gradients to open the Gradients panel, and from the panel menu in the upper right corner choose Legacy Gradients.) Gradient Maps can completely replace hue, saturation, and luminosity.

Applying a slightly modified Sepia-Cyan Gradient Map preset (Legacy Gradients > Photographic Toning) gives a pretty nice result right away (cyan in the shadows, sepia in the high mids). Adding a couple of stops could give us some control over the outputs, of course. But for fine control, we need some tools governing the inputs.

Let's place a Black & White adjustment layer beneath the Gradient Map. I want the burnt orange adobe earth to be lighter and take on more of the sepia tone. The adobe is comprised of yellow and red, so we need to increase the luminosity of those colors. (Photoshop may lack a "burnt orange" slider, but the B&W adjustment does have red and yellow sliders.)

By increasing the luminosity of the input colors, those colors get shifted to the brighter portion of the gradient ramp. The output takes on whatever color is assigned at that point. In other words, you can carefully choose the output by moderating the input luminosity. By changing the luminosity input value, you affect the translation output along the gradient ramp. This is a key concept for the Black & White Control Freak technique at the end of this chapter.

Gradient Maps also give you control over the transitions between color stops. If you find that the balance between shadow and highlight colors is not quite right but you want to preserve the specific color mapping, there is an additional feature you should know about. To adjust the gradient center point, drag the small diamond control that appears between two color stops; it lets you manage the balance or transition point between two adjacent stops.

This is really useful when your image has high-contrast regions, and the conversion seems to create an artificially hard edge.

So, Gradient Maps assign new colors and luminosity based on their composite input luminosity, while Hue/Saturation adjustment layers actually shift from a base color to a new color. Solid Color fill layers drive towards a specific tone. All of this takes some finesse and time to get exactly the right look. What if you need to do this same, complex conversion over and over to create a themed series? What if you just like the look and want to save it for future use? Enter color lookup tables!

COLOR LOOKUP TABLES

Color lookup tables (CLUTs), which you apply by using a Color Lookup adjustment layer, operate differently than Gradient Maps, Solid Color fills, or Hue adjustments; they take literal color and brightness values and assign a new color and brightness. To do so, they use a lookup table of values, and you can save them as presets that will help ensure consistency across multiple images. Anything not explicitly in the lookup is interpolated. This is a subtle but important concept. It allows you to independently control two colors with the same brightness value, or move the same color in different brightness areas to new colors altogether. Gradient Maps allow you only to "translate" a specific composite luminosity value; so two different colors with the same luminosity would become the same result color.

An actual table is used; so including more entries in the table gives more fidelity by virtue of having more data points to affect, and thus more control.

Applying CLUTs is pretty straightforward, and the Color Lookup adjustment layer in Photoshop includes a number of presets in various formats. Some represent classic film looks, and others are much more along the lines of special effects. After adding a Color Lookup adjustment layer, simply choose an option from the 3DLUT File menu. The table is applied as a pass-through replacement of colors and values, so has no direct controls. However, you can use blending modes, opacity, and advanced blending to moderate the effect. This cafe interior has been treated to three built-in lookup tables: Candlelight, Foggy Night, and Late Sunset.

Building your own CLUTs is a great way to get consistency and thematic focus in a project. It's actually pretty easy to do, and can be—Dare I say it?—fun.

In order to get a good, complete lookup table, you should start with an image that is representative of a body of work or series. Any colors not included in the original image won't be explicitly written to the table, so will have to be interpolated (in other words, a guess is made). If an entire collection of images that you wish to adjust has similar starting colors and values, then this really isn't a problem. Exporting your color table is pretty straightforward, because you can work on one of the images to your satisfaction and create a CLUT that will look consistent across all of the images in your collection. But let's talk about making your lookup table more useful for general cases.

I highly recommend that you plan your work up front. If you are developing a look for a series, start with a minimally processed image that reflects a reasonable starting point: something you expect to be similar to the majority of images you want to use with your CLUT. This image will be kind of a reference for other images, so that the rest of the series will give consistent results. Because color grading is usually the final pass for an image, earlier processing should be done in a way that is standard and repeatable for your workflow. Unlike a simple overlay, CLUTs will respond differently to color variations on the input side. That means if you apply the same lookup table to an image you have color balanced and also to one straight from your camera, the results will be different.

I also recommend that you create a flat copy of your reference image and build your color adjustments in a separate file.

In this separate file, use a copy of your flat reference image as the Background and add to it any adjustment layers you like for color control. When setting up an image to be used to create a new CLUT, you need to keep a few things in mind. First, only the background layer will be used to populate the inputs of the table. Second, masks are ignored. Third, opacity, including from Blend If and Fill adjustments, is respected in terms of effect on color and brightness, but not as opacity per se. In general, make the path from the original color to the result as direct as possible by avoiding any additional content layers. I recommend using *only* adjustment layers whenever possible, with a little sprinkling of blending modes if absolutely necessary. Although for some special cases you may want the color from one layer and the luminosity from another, you can by and large accomplish this through careful selection and control of adjustments.

There are some technical issues with color chart development for commercial and video output that I won't get into here because it gets too far out of scope for this book, and frankly, it is beyond my experience. If you have a critical need for accuracy, you will probably have to purchase a verified chart or reference card that comes with calibration certification, from a known production laboratory, such as an IT8 or ColorChecker chart. For most applications of CLUTs, however, a reference file built in the working color space is sufficient, so long as it includes a full grayscale range, primary RGB and CMY chips, and a sampling of target keys that are reasonably close to the gamut you intend to work with. Accurate color grading requires more than simply placing a lookup table at the end of the workflow, typically requiring appropriate color and luminance balance during capture or, at the very least, during the start of processing.

Basically, Photoshop builds the color lookup table by sampling the values at specific pixel locations on the background layer, and comparing those with what that same location shows on the final canvas view, which is the sum of all layers together. Then Photoshop applies an operation similar to Curves to make the translation. I say "similar to Curves" because as mentioned above, there is still interpolation going on, and Curves represents a smooth transition to fill in the gaps. Even with every possible color represented, not all colors are explicitly sampled for inclusion.

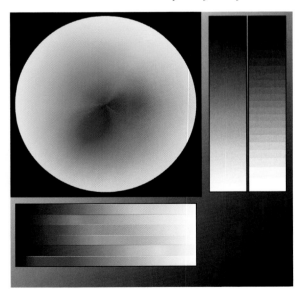

If you need to hit specific output values, say for a commercial project, you will need more precision. That requires using a reference image of some kind, one that includes the full range of hue, saturation, and luminosity values potentially expected. The most typical image includes both spectra and important color swatches. The reason for the spectra is to get as many colors as possible into the conversion process. The key colors are there for the most critical values so you can precisely sample and control the output for each target value.

Instructions for creating the components of this image yourself are in Part III, "Project Examples," in the section "Creating the Workbench Files." Note that this image is in 16-bit mode to reduce banding and to increase precision in the CLUT. This is a

basic chart that covers most RGB situations, and it is a good starting point to ensure your lookup table covers all the color and saturation bases.

For the most part, you'll want a range of at least 16 shades of gray, and 16 to 32 important color swatches (which I'll refer to as *keys*). Specific situations call for more specific charts, however. Skin tones, product colors, and branding elements are good examples of important key colors to include, as well as a range of saturation and brightness values surrounding the key colors. You can build these from known commercial charts or sample them from your own works. Spectra and gradients are helpful for visualization, but you should rely more heavily on the individual keys to make your adjustments. Apply the adjustments to your reference image and tweak as needed to get the desired final results for your key colors.

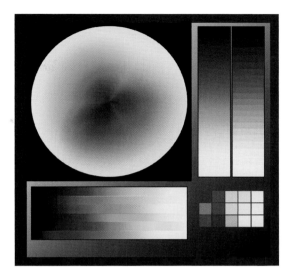

Okay, now that you have your stack of adjustment layers and fills, it's time to create the actual CLUT preset. This is surprisingly easy!

Choose File > Export > Color Lookup Tables. The dialog box that appears gives you a few options to add metadata, such as a description (which is not used as the name of the preset), copyright information, and whether to use lowercase file extensions. The options that really matter, however, are the quality and format choices.

The Grid Points value tells you something about the size of the table used. This can go up to 256, but for the most part I find 64 to be sufficient, even for 16-bit images. Choosing High from the Grid Points menu automatically sets the value to 64. Higher numbers result in greater precision, but they yield diminishing returns for still-image work and are typically more useful for high bit-depth images and high-resolution video. Also, higher quality levels mean larger file sizes.

Format is a tricky consideration, but for general use in RGB color space, select the 3DL and/or the CUBE formats. The 3DL format tends to be more universally adopted, while CUBE is used more for video. If you work in LAB color mode, you can also export in ICC Abstract format, which can be applied to any other color space. For more information on the various formats, see the "Adjustment Layers" chapter in Part IV, "References."

COLOR REPLACEMENT

Color replacement is a common task in product photography, but it can come up in lots of situations. The difficulty lies in making the effect look realistic, which requires good attention to detail, especially in preserving such aspects as surface finish, reflections, and realistic saturation levels.

First, we'll start with the technique of simply painting over the object with either Color or Hue blending mode. To do this, use the Brush tool in Normal blending mode on a blank layer that is set to Color. Color mode uses **both the hue and saturation** of the blend layer (the one you're painting on) and combines that with the luminosity of the base layer. Painting on a layer set to Hue mode preserves **both the saturation and luminosity** of the base layer. For either blending mode, you are looking for situations where the new color doesn't require any real shift in luminosity or value.

Color blending mode will tend to give more pronounced results because it changes the saturation level of visible colors. Because Hue preserves the saturation of the base layer, it can result in a more natural-looking color change. Hue does not work with desaturated images, however, because the blending mode retains the saturation of the lower layer; if there's no hue, there's nothing to saturate.

For this example, I selected this teen's sweater using the Hue/Saturation method from the "Selections & Masking" chapter, and then used that selection to create a mask for a Solid Color fill layer. Both versions use Color blending mode.

This method is quicker and more flexible than painting on a new, blank layer in terms of changing colors, but painting is more flexible when you need multiple colors, additional blending, or more expression, such as variations in stroke directions, textures, et cetera.

Of course, some situations will require more work, especially when dramatic changes are required. Before we get there, let's take a moment to consider an unusual (and admittedly extreme) result where Color blending mode appears to fail in spectacular fashion.

To demonstrate, I added a yellow square on its own layer over a blue one and set the yellow layer's blending mode to Color.

Recall from "How Photoshop 'Sees' Your Images" that Photoshop uses a visual perception model in showing you RGB colors. In the previous example, RGB Blue has a luminosity value of about 28, while the RGB Yellow luminosity is closer to 220. So the yellow hue doesn't show up well over such low luminosity. What we end up with is an undesirable dark yellow (RGB: 32, 32, 0). To recover the apparent brightness in yellow, we have to increase the luminosity of the *underlying* blue layer.

Try it out for yourself. In a new document with a transparent background, add a blank layer and create an RGB Blue (RGB: 0, 0, 255) square, then add another layer above and create an overlapping RGB Yellow (RGB: 255, 255, 0) square. Change the yellow layer's blending mode to Color to get the results above.

Starting from a blank layer gives you the opportunity to make an easy selection. Command-click (macOS)/Ctrl-click (Windows) the blue square's layer thumbnail, then use a Boolean Intersection (Shift+Cmd-click/Alt+Shift+Ctrl-click) with the yellow layer's thumbnail. This creates a selection of only where the two regions overlap.

With the selection still active, add a Hue/Saturation adjustment layer between the two color layers; the active selection becomes a mask for the layer.

Drag the Lightness slider to the right almost all the way (between +85 and +90) and watch the yellow come back to the selection area, as if there were no blending mode active at all.

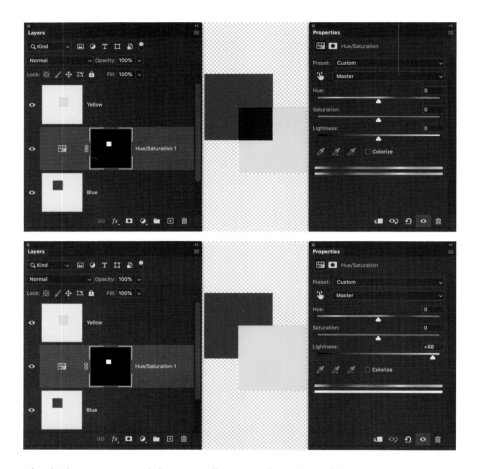

This little experimental diversion illustrates the utility of the next technique, and should drive home the idea that sometimes you need to apply a little "preconditioning" to get the effect you want. As a general rule, I like to desaturate the target area whenever possible, which gives me a little more latitude in using blending modes and also immediately reveals such issues as the low luminosity value of the blue square above. Desaturating to start with sets the luminosity range you're going to blend with.

Begin by creating a mask to limit the effect to only your intended color target area. I recommend a solid mask here rather than the more usual "proportional" mask that includes shading and so on (see the sidebar "Proportional Masks"). Replacing (or recoloring) the entire subject means we want both shadows and

highlights to be affected. If we wanted to simply add some color splashes to represent gelled lights, or perhaps a faux duotone effect, then the proportional, shaded mask would be most appropriate. By using a solid mask, the replacement color will apply to all regions, and we can use some of our prior tricks and techniques to vary the effect for realism. Save your mask to an alpha channel for easy use later on.

PROPORTIONAL MASKS

By "proportional," I mean a mask that includes the texture and detail of a subject, as you might create by duplicating a color channel directly. A proportional mask has shades of gray, as opposed to a solid mask that uses pure white in the subject area. Using a solid mask allows the color fill to react to the actual luminosity in the subject rather than being limited by the density of the mask. As you saw with the yellow and blue squares, lower luminosity is not a lack of color; gray values in the mask prevent the color from being applied to darker areas.

You have several options to desaturate your target area; the choice really comes down to preference. An easy method is to load your alpha channel as a selection, then create a Hue/Saturation adjustment layer and drag the Saturation slider all the way to −100. This approach allows you to vary the amount of desaturation, which can be used for graded effects where the replacement color is blended with the original color. The method I use most often is to apply the selected mask to a Solid Color fill layer, fill with 50% gray, and change the blending mode to Luminosity.

Once your desaturation layer is in place, add a Hue/Saturation adjustment layer and clip it to your desaturation layer (which I called **Gray Color Fill**). Clipping the Hue/Saturation adjustment allows it to affect only the output of the desaturation layer, which is already masked. This way, you're taking advantage of work you've already done and minimized duplication of masks.

With the layers ready to go, simply check the Colorize box and start moving the Hue slider. It should become immediately apparent that you can achieve quite a wide range of colors this way, and increasing Saturation and Lightness opens up more possibilities. But there's always room for improvement, right?

Tricky replacements or creating a wide variety of results requires more finesse. Knowing that Hue/Saturation is a good foundation, let's build on that. Add a Color Balance layer clipped to the Hue/Saturation adjustment. Color Balance will give you fine control and allows for independent changes to shadows, mids, and highs. Think of it as a surgical color adjustment.

For the final touch in this particular method, place a Curves adjustment layer just below the Hue/Saturation layer (you may have to clip all the adjustment layers again). This controls the contrast going into the color replacement, and is important for maintaining realism with some of the potential color changes. The exact adjustment depends on both the starting material and the color applied. A general rule of thumb is that darker (in terms of luminosity, not hue) and heavily saturated colors tend to require contrast reduction, while lighter, less saturated colors need a little contrast boost. Because each fabric behaves a little differently, you will need to evaluate what looks good to your eye.

At this point, everything works as it should: The desaturation layer provides the foundation and bounds the effects with a mask. Additional adjustment layers refine the contrast and apply the color replacement effect. But in the interest of improving the process for repeatability and flexibility, you can instead group the adjustment layers and copy the mask to the group folder (Hold Opt/Alt and drag the mask from the desaturation layer to the group folder).

The reason for organizing into a group is two-fold: First, it lets you use one mask for everything in the group itself; second, it makes things much easier to duplicate for additional color changes. If you need to show several variations, just duplicate the group and create a new color. (Remember to name your groups appropriately!)

TIP Placing everything into a group makes it easy to create a Library item from the stack. Duplicate the group and name it **Color Replacement**, then reset all the adjustments to their defaults and remove the layer mask. Next, open the Libraries panel and drag your group over. I have a custom library specifically for adjustment layer groups that I use frequently.

SPECIFIC COLOR TARGETS

Let's look at the stack in action to create a range of color variations on this dancer's outfit.

I have chosen five different color samples (the Swatches layer) that will be used on the silver fabric. These are on a separate layer at the top of the stack so they can be sampled without any accidental interference from the adjustment layers. Before making any changes to the color replacement layers, I made duplicates of the Color Group and named each group for a color sample.

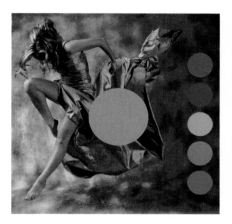

There are a few different ways to proceed, so I'm going to share the method that works for me with my slight colorblindness. Using this approach, I can almost entirely rely on numbers to work quickly and to make up for deficiencies in my eyesight. It will sound a little complicated at first, but stick with it!

To recap, the layer stack consists of my Color Group, a masked desaturation layer, and my color samples layer. The color samples in this case are meant to be targets for a 50% (neutral) gray sample, so that adjusting the Color Group causes the gray reference sample to become the same color as the sample.

Add the 50% gray reference sample (as a large dot) to a layer by itself, above the desaturation layer but below the Color Group. Place it within the mask area so that the Color Group affects it. Drag the Swatches layer to the reference bar's location so that the color sample you want to start with overlaps the reference bar a little. Alternatively, sample the color you want to use and paint a dot on a blank layer. This makes it easier to compare visually.

Once the layers are all in place, you need to do some workspace setup. Open the Info panel (Window > Info) and make sure you can see it easily while making adjustments. I like to place it near the Properties panel, which is where you'll make changes to the Hue/Saturation layer. Open the Info panel menu (in the upper-right corner), and choose Panel Options. Ensure that Always Show Composite Color Values is selected. This will make the Color Sampler values persistent so you don't have to memorize anything while making adjustments.

Back in the main document, select the Color Sampler tool. Click the color sample you want to match (it should be aligned with the gray reference bar) to place the first sample. Click again the gray bar to set the second sample. Notice the Info display now shows you the color from each sample as #1 and #2. They're probably displaying RGB values at the moment, but the Hue/Saturation adjustment reads out in HSL. Next to each sample readout, open the menu (by the Eyedropper icon) to choose HSB Color. There is no HSL option, and Lightness is not the same as Brightness, but we can live with it. For the moment, look at the Info panel and note that the #2 sample reads 0 for Hue, 0 for Saturation, and 50% for Brightness.

Now you are *finally* ready to get your colors matched up! Select the Hue/Saturation adjustment layer, and check that the Colorize option is selected. Using the #1 sample readout from the Info panel, enter the Hue and Saturation values into the appropriate Hue/Saturation fields (leave Lightness alone for now). Check out the values for the #2 sample in the Info panel. They should have changed, including the Brightness value. However, they may not match the values of the #1 dropper, and the reference bar is not likely to exactly match the target color. Not yet, anyway.

That's okay, because the goal is to get close enough to finish with other, more precise tools. From here, the trick is to adjust the sliders so that the Color Sample #2 display begins to match the #1 values. Start with the Lightness slider, watching the Info panel display instead of the values in its own dialog box. Compare the #2 Color Sample Brightness value with that of the #1 sample, and drag the Hue/Saturation Lightness slider in the direction of the needed change.

Dialing in the results requires a very technical approach referred to as "twiddling the knobs." Except, replace "knobs" with "sliders" and you get the idea. Adjust the sliders in the Hue/Saturation property box while watching the values in the Info panel. It's likely that you won't be able to dial in the perfect values, because most adjustments to one slider result in some wobble in the other values.

When you feel you are as close as you can get, or you get tired of twiddling the knobs, open the Curves adjustment and make some visual changes if necessary. For this deep blue color, I wanted more shine, so I increased the contrast a tiny bit to bring up the highlights. Adjusting the Curve by keeping the line passing through the middle of the Curves graph helps keep the reference color from shifting, but it still may drift a little.

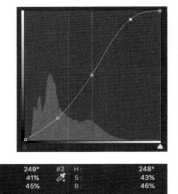

#1	H:	249°	#2	H:	248°
	S:	41%		S:	43%
	B:	45%		B:	46%

The final pieces are to use Color Balance for any leftover details, but also to manipulate the highlights and shadows independently. Some materials will look more natural if the highlights are slightly shifted or give a hint of reflection. Although this can move your target value, it can add more realism to the piece. In this example, I gave the Highlights a little extra yellow, which required more adjustments to other regions, including going back to the Hue/Saturation layer.

When using this approach, you'll need to be patient and probably go through a few iterations on each control to get precisely the right match. After a few attempts, it gets a lot easier, but it's not unusual to get a perfect match to the gray reference block and still need to make some changes for sake of aesthetics. The point here is that the amount of precision is entirely up to you; while you can get an exact conversion, it may not be pleasing to the eye.

Moving to the next target color, simply turn off the Color Group, move the Swatches layer so the chosen color is again next to the 50% gray reference block, and repeat the above process.

In the "Color Matching" section coming up, I will describe an alternate method. And after all of this, you may be wondering: Why not simply use a Solid Color fill layer for each of the sample colors? The short answer is that you should certainly try it out. It's the fastest way to change colors on an object or in an image. Having multiple approaches gives you far more flexibility, though. There are plenty of situations where you will want options, such as sitting with a client who needs to see some variations. Trying to replace Solid Color fill layers takes only a couple of steps, but using the Hue slider you can see changes on the fly much more easily.

REMOVE COLOR CAST

A *color cast* generally is present when too much of a dominant color appears across an entire image. This can happen with poor color balance settings as a result of an odd light source or reflection, as well as due to aging of photographic print substrates. Fortunately, in the digital world we can take advantage of the additive nature of color and light to easily remove color cast.

The trick is to add more of the offending color's inverse. That is, we want to neutralize the offending color by adding a little of the opposite color. It's a great technique for correcting special environmental pictures, such as under water scenes, "mood lighting" in a restaurant, or aerial haze (that overall blue cast to landscape pictures as features get further away from the camera).

There are a handful of approaches you can take to solving this issue. The first one involves addressing an overall cast that affects an entire image (or major portions, such as you'll see demonstrated shortly). It's meant to be a global

adjustment that can be applied quickly with reasonably good results, but it may not give you everything you need, so don't stop if just the one technique isn't sufficient.

The second approach involves a much more detailed view of specific areas, such as shadows, midtones, and highlights, but it relies on the same principle of adding the inverted color. It can be even more focused on specific problem areas, as might occur with reflections from solid surfaces.

Start by duplicating the image layer and running an Average Blur filter on it (Filter > Blur > Average). You should get a solid color that represents the overall dominant cast in your image. Name this layer **Color Cast**. Invert the color itself by pressing Cmd/Ctrl+I with the layer selected. That is the complementary color that you'll add to neutralize the cast.

On the Color Cast layer, set the blending mode to Color, and reduce the layer opacity. You'll have to adjust for the relative change in brightness between the cast and correction colors. The exact opacity value will be different for every image. If the effect is still too strong, try changing to the Hue blending mode. For the canyon image, I used 50% opacity because there is such a strong cast. Quite often you'll find that very low values are sufficient, typically around 10% to 20%. In this case, I want to remove only the cast associated with distance, so a simple gradient on the mask allows the correction to be applied only to the top half of the photo.

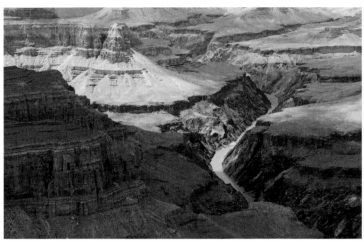

Sometimes the color correction is just not enough, though. This specific landscape example is still not quite punchy, so let's add a couple of adjustment layers. Below the Color Cast layer, add a Curves adjustment layer and boost the contrast with a basic S curve. After that, add a Hue/Saturation layer above the Color Cast layer, and clip them. Remember that the Blur > Average command literally took the average value of every pixel in the image, which may not be a perfect representation of what you need to manage. Because the Color Cast layer is already at low opacity, the clipped Hue/Saturation layer can be moved quite dramatically with minimal effect; here, I've moved the Hue slider to −68, and the Saturation slider to +65.

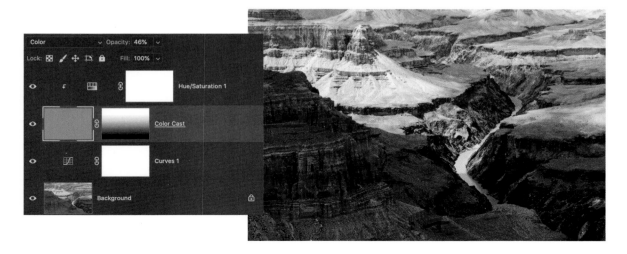

Some extreme cases require a little more boost. In this nighttime shot, there is very little useful color information along with large areas of black, so using a simple, averaged color fill layer is insufficient; the image produced is dull and mostly monotone. To deal with images like this, use a duplicate of the Color Cast layer set to Color Burn blending mode. Add and adjust the Color Cast layer as well as possible first, then duplicate that layer and move it below the Color Cast layer and change to Color Burn mode. In some cases, it may not be necessary to lower the opacity of the latter at all. Typically, however, this will result in a much darker image so once you deal with the color, move on to other contrast and detail techniques.

If you find that you only need the color cast correction applied to shadows or highlights, double click the Color Cast layer to open the Layer Style dialog box and in the Blend If section adjust the This Layer sliders to control blending in the highlights or shadows. Hold Option/Alt while dragging part of a slider to split it for a smoother transition. In this image of tulips, the two color correction layers (Color Cast and Color Burn) were grouped, and then the group was masked. I applied the mask selectively to the flowers and partially to the background as a creative choice to visually isolate the tulips.

You can apply localized (or more targeted) corrections by first selecting problem areas and copying the selection to a new layer, then running the Average Blur filter. This will create an area of solid color on the new layer; combining a few different selections on the same layer gives you a kind of palette of correction colors to work with. The selection matters so you get a good starting point to appropriately apply your color corrections.

Each time you make a copy and blur it, you'll have to select the image layer again–otherwise you will be making your selections from the newly copied layer rather than from your photo.

To adjust color casts in shadows, try using the Magic Wand tool set to a fairly low Tolerance (below 16) and deselecting Contiguous in the Options bar (this allows the Magic Wand to select all similar values across the entire image). Also be sure to read "Gradient Map Luminosity Selection" in the "Selections & Masking" chapter for another quick way to isolate problem areas.

Once you have a reasonable selection of the areas that need correction, press Cmd/Ctrl+J to copy the selection to a new layer. Now run the rest of the basic steps above: Average Blur, invert, lower opacity. Note that this technique does not fill the entire layer, and you may find that you need to apply a little Gaussian blur to the edges of the filled region to avoid some odd or harsh transitions.

Other kinds of color issues should be dealt with using painting methods. For portraits, for example, check out the "Frequency Separation" section in Part III, "Project Examples," as well as the previous "Color Replacement" section.

It's important to keep in mind that the goal of this particular correction is to obtain a somewhat neutral result that you can build on with later adjustments. It's not meant to give you a final product, just to scrape off the majority of a large color problem in your photo. Once you have a good starting point, consider making a stamped copy of the result (see "The Claw" in the "Useful Information" chapter in Part I) to do any detail corrections such as healing or clone stamping. To prepare images for compositing, use the Color Matching technique (next), or apply a Color Grading method to get your pieces in a more uniform state.

COLOR MATCHING

Lifting a color scheme from a set of images is a great way to try out various looks in other images. It can be challenging to get good results without a lot of work, though. Fortunately, there is a quick method that lets you use virtually any starting image you like, whether a photo, a painting, or an illustration.

Let's give this gray forest the green tint from this processed image:

The first thing to do is to place, paste, or drag the green version to the target document that you want to change. The source image can be low resolution, or you can resize it. You just need to be able to see the brightest and darkest regions.

This trick works best with images that have similar dynamic and tonal range. In this case, the lighting is pretty consistent between the two, so it's a good bet that the result will make the two different images appear to be shot and processed as part of the same series.

Add a Curves adjustment layer between the source and target images.

From here, you need to pay attention to one small detail: the adjustment layer thumbnail. By default, the mask of the adjustment layer is selected, which means the sampling step you are about to do will attempt to sample from the blank mask. Those results are not very impressive. Ensure the actual adjustment layer icon itself is selected, then hold down Opt/Alt and click the Auto button in the Properties panel. This opens the Auto Color Correction Options dialog box.

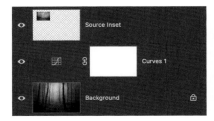

From the dialog box, select the Find Dark & Light Colors option. This enables the Color Picker section under Target Colors & Clipping. Move the dialog box so you can see the source image, then click the Shadows swatch. In the source image, click the darkest region you can find. It doesn't have to be black, and in most cases will be more interesting if it isn't. Finish out the Midtones and Highlights the same way (if Snap Neutral Midtones is not selected, do so at this time). Your goal is to select representative colors that you want in your photo, so use some discretion in making your choices. Close the dialog box when you're done, and click No when Photoshop asks if you want to save the new target colors as defaults.

Depending on your selection prowess, you should have a reasonably good match between the two photos. I find I usually need a little tweak of the main RGB curve, or some other finishing touches, but this is a great time saver.

NOTE If your eyedropper isn't picking up colors from your source image, make certain the adjustment layer's icon is selected and not the mask. Also be sure to place the source image above the curves layer so it doesn't get adjusted along with the target.

Applying this technique to portraits simply means stacking up a few things you already know how to do, including masking and blending. In this case, I want to use the palette from Luini and Solario's *Saint Mary Magdalene* (shown here under Creative Commons Zero license from The Walters Art Museum). Rather than sampling from the entire image, I am going to constrain the effects to skin tones.

Because the effect will be limited to the model's skin only, start with a quick selection that excludes the jewels, dress, and background but retains her hair. With the selection active, Photoshop will automatically create a mask when you add a Curves adjustment layer. Following the same technique as earlier and masking out the eyes gives an odd, unnatural result.

Blending modes to the rescue! Choose Color blending mode for the Curves layer, and things settle right down.

What if you want to keep the settings for other portraits? Because you are making selections from a specific source, it may be difficult to reproduce exactly the same values, so there are a handful of ways to deal with this.

The first is simply to drag the Curves adjustment to your Libraries panel and save it directly. This is probably the quickest solution, and it will preserve any additional changes you've made to the Curves.

The next approach is to temporarily include some gray reference values in your image below the Curves layer. These can be color squares or a smooth gradient, so long as the reference values are on a layer by themselves. I tend to prefer a gradient because it can be difficult to gauge just exactly how a particular tone will translate to a solid color and a smooth gradient allows me to sample nearby tones easily. Once you have used the Auto Color Correction Options dialog box to make the color match adjustment, the grayscale gradient will take on the sampled colors. You can save the new color gradient layer to your Library by stamping a merged copy of your photo to a new layer, then selecting the gradient (Cmd/Ctrl-click the gradient layer thumbnail) and copying that selection to another new layer. Drag the new colored gradient to your library. This gives you a continuous tone sample. When you've saved the gradient, you can delete those temporary layers.

One method that is overlooked quite a bit is saving colors directly from the Color Picker box to a library. Load a sample as the Foreground color by selecting it with the Eyedropper tool, then with the Libraries panel open to your project library, click

the Add Content button at the bottom and choose Foreground Color. Repeat for other colors you want to save. Once the samples are in your library, you can then use them to create color samples in other documents.

CHOOSING WHICH METHOD

Why would you save color samples or gradients instead of the adjusted Curve? While dragging the Curves adjustment to your library is really easy, it doesn't give you an immediate visual indication about the colors used, so you have to rely on good naming conventions (which you should follow, anyway). Using something more visual makes it easier to quickly identify the colors you want to use. Of course, there are other drawbacks to using the colors, because you have to follow the same selection steps outlined above. And in the case of using specific colors, you have to load them by clicking the swatch in the Library panel, then paint or fill an area of a blank layer, and *then* make your selections.

The decision is really based on your own workflow. If you use your libraries for specific projects, you may need only one color matching tool so Curves is a natural choice. On the other hand, if you use libraries to keep a range of presets for general purposes, having the visual element makes more sense and potentially offers more flexibility, in particular when saving the gradient rather than individual colors.

Using curves is a quick way to transfer a palette or theme from one work to another, but it doesn't work as well for matching tones in composite work. For that, we need a little more control and some help with visualization. Here's a composited image where the model is much cooler than the background.

Although we could jump in immediately with standard color correction techniques, it sometimes gets difficult to see subtle changes. Using a little blending mode and adjustment layer magic, we can highlight the differences and give our eyes a break. At the top of the layer stack, add a 50% gray layer set to Luminosity blending mode. This reveals the color without brightness changes. Then, add a Levels adjustment layer above the fill layer, and set the black and white points close to the middle to enhance contrast. Don't move the midpoint. There will be a significant amount of artifacts visible because of the extreme adjustment. All you need to focus on is the actual color variations.

Group those two helper layers together, and name the group **Viz**. This way you can turn it on and off easily. For this image, use a Selective Color adjustment clipped to the model layer. This ensures any changes are restricted only to the model. Also choose the Absolute option rather than Relative.

Selective Color behaves like an ink mixing tool. For each of the colors represented in its menu, there are sliders that allow you to adjust the ratio of pigments that contribute using the Cyan, Magenta, Yellow, and Black sliders (the standard colors that you would find in a typical printer). Before you start fiddling with the sliders, take a look at the difference in colors between the model and background.

In particular, darks and shadows in the model photo are dramatically more cyan than the middle and foreground darks. There is also a hint of cyan and blue in the skin highlights. The sky is, of course, blue and cyan, but the majority of available light is coming from artificial sources and is very warm, mostly magenta and yellow in this view. I typically recommend starting with the Neutrals, but in this case the shadows are really affected by the color cast so start by choosing Blacks from the Colors menu.

For me, this is an iterative process, meaning I tend to go back and forth through the Neutral, Black, and White adjustments a few times. While we are not adjusting brightness here, it does help to compare areas of similar value when matching tone. Because her dress and hair have large dark areas, we'll compare these to the shadow areas in the middle of the background. You should not be attempting precise tonal matching so much as aiming for "reasonably close." Quite often this color matching step is just part of the path, so you'll have time for dodging and burning or additional overall color work later on.

With the Blacks in the "close enough" region, go after the Whites next to knock down the highlights and remove a little of the cyan. Finally, the Neutrals need just a little reduction across the board. What you want is for the visualization to look like things are at least more balanced, not perfectly matched.

It is important to toggle the Viz layer while you are working to ensure you're not pushing things too far or missing the key values. You can always reduce the opacity of the Selective Color layer, too. Another option is to use the Color Balance adjustment layer instead of Selective Color, which may be faster in some situations, although it gives you slightly less fine control. On the other hand, Color Balance is better at preserving brightness, and a little more intuitive because it shows you the complementary colors on the same slider—depending on how you think about color, this may make more sense to you.

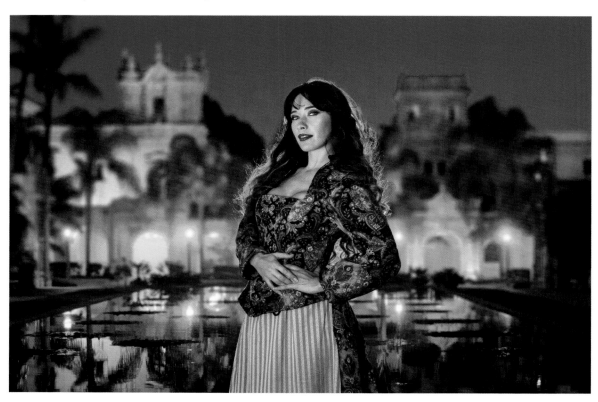

GRADIENT ZONE CONTROL

Way back in "Gradient Map Luminosity Selection," you learned how to use Gradient Maps to carve out tonal ranges visually with ease. Using the same idea more broadly, you can also tweak those tonal ranges when using Luminosity blending mode, turning that basic technique into a zone control powerhouse. Let's recap a bit.

Gradient Maps are kind of a cousin to color lookup tables (CLUTs), in that they selectively remap luminosity levels to specific colors, while CLUTs remap colors to colors. Knowing that each color you see on the Photoshop canvas is some combination of color channels and that each channel represents a specific color's luminosity contribution, you can imagine how a given input brightness value gets transformed into a new value in a gradient.

The bar (or *ramp*) in the Gradient Editor represents a visual map of output values based on composite luminosity (i.e., combining all three channels). Left is zero luminosity where no channels have any information (black), and the right is 100% luminosity where all channels are fully contributing (white). While you can't see the input value, the Location text box lets you choose whole percentage values on the scale.

Each position along the gradient bar represents an absolute luminosity value, not the actual range of your image. Adding color stops tells Photoshop what you want that absolute luminosity value to translate to in terms of color and brightness. For example, placing a bright blue color stop at the 50% location will cause all selected areas of your image with 50% total luminosity to be converted to bright blue.

In this way, each color stop gets mapped to a discrete luminosity value. When mapped to the standard Black To White gradient preset, the result is a straight black-and-white conversion that is based on the composite luminosity. In images where there is no pure black or white, there is nothing for the linear gradient to convert at the extreme ends. In the simple case of a black-to-white gradient with one stop in the middle (set to 50% gray), a Gradient Map adjustment layer set to Luminosity blending mode then behaves like a levels adjustment: It drags the black and white points towards the middle, causing a kind of expansion of dynamic range.

Put in slightly different terms, moving a black slider to the right of its original position causes more shadows to become completely black, while moving a white slider to the left causes more highlights to become completely white.

In these three examples, I created a plain black-to-white gradient using the Gradient tool, and then applied the Gradient Map described above. Note the positions of the control points and how they remap the gray values in the plain gradient.

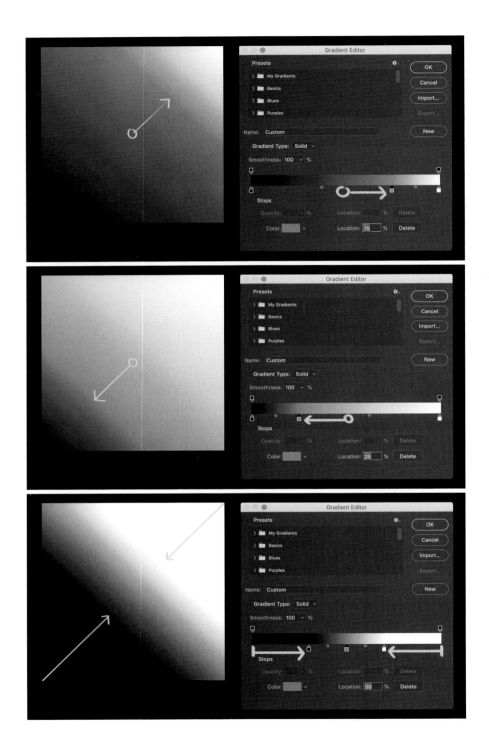

Unlike with a Levels adjustment, however, you can add more stops to the ramp. If you are careful about assigning gray values that match the percent Location values—that is, at the 25% Location stop you assign a 25% gray color—then you have fine control over translating specific ranges of luminosity input to specific output ranges.

This image demonstrates an approximation of Ansel Adams' famous Zone system: Each stop represents the boundary of a gray value *zone*. The regions in between each stop can be compressed or expanded, changing the relationship of the zones to one another. In this way, you can get some seriously detailed control over the entire tonal range of an image. Incidentally, this method was shown to me by this book's technical editor, Rocky Berlier. Kind of a genius trick, wouldn't you say?

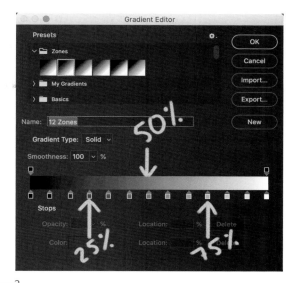

But the fun does not stop there! Setting the Gradient Map adjustment layer's blending to Luminosity, you also gain tonal control over a color image. It's like Levels on steroids hopped up on caffeine after a bowl of Super Frosted Sugar Bombs—but with a very, very steady hand.

ERGONOMICS

When making fine adjustments to stops on a gradient ramp, you may find your fingers and wrist getting fatigued from all the gripping and small motion. This can happen whether you're using a tablet or mouse or trackpad. I highly recommend looking into some ergonomic solutions, such as using a mouse wheel or precision mode on a Wacom tablet, or you could even invest in a dedicated hardware device like a Monogram Console or Loupedeck. See the "Introduction" for more details on hardware for working with Photoshop.

The trick to setting this up is simply to start with the basic Black To White gradient (*not* the Foreground To Background preset!), then add stops along the bar. For each stop, assign the location value, then open the stop's color panel and assign the B value in the HSB group (the values for H and S should be 0). The location percentage and the B value percentage should match this list:

0% 8% 17% 25% 33% 42% 50% 58% 67% 75% 83% 92% 100%

You'll note that this makes 13 total stops, so you'll have to add 11 stops between the end points. Because Photoshop doesn't allow fractional values in this dialog, you have to make do with approximations. This particular set isn't written in stone, but it does give you the most even distribution while hitting the 50% mark. It also ensures you have 12 individual zones of luminosity. You could easily just create 10% value stops and get most of the same control.

After you create this gradient, I highly recommend saving it as a preset in the Gradients menu. Give it a snappy name like **Way Cool B&W Thing** or **Rocky's Most Awesome Zone Gradient**. Or maybe just **Zone Control**. Be boring. It's okay. Now you can use it whenever you need to without recreating the entire sequence.

Applying this method is pretty straightforward, so let's look at two examples. The first is a simple refinement for increased local contrast.

This wall is reasonably well exposed and balanced, so it just needs some minor range corrections. With a few tiny tweaks to the gradient color stops, I got some better definition in a few areas that were previously indistinct. The change is not dramatic, but having access to precise value ranges let me adjust overall contrast pretty easily. In this case, I used Luminosity blending mode with the Gradient Map to avoid applying any color. I simply wanted to adjust the balance of values in certain ranges.

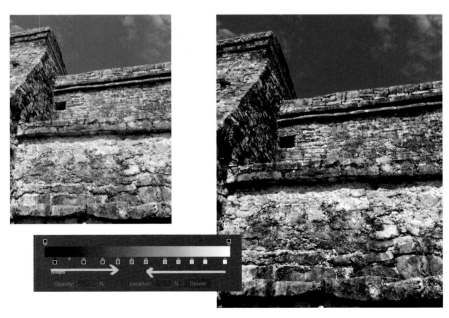

As you can see from the adjusted gradient map, not much has changed. I moved the black and white stops toward the middle slightly, separating the shadow detail just a little. Remember that moving a dark slider to the right of its original position causes a darkening, while dragging a light slider to the left adds luminosity. Having several stops allowed me to put boundaries on the adjustment with more local control than I could have gotten with Curves.

That being said, this technique really pairs well with other adjustments in a suite of corrections or enhancements. I tend to place this zone map at the end of other corrections.

This flower is quite a bit underexposed to keep detail in the petals, but that means the rest of the image is a little muddy. First, I added a Levels adjustment to compress the dynamic range, then I followed up with a slight overall contrast enhancement with Curves. Once that foundation was set, adding the Zone gradient map gave me fine control over the last bits of detail. I threw a vignette on top for good measure.

There are many ways to approach this zone system, but in the end my recommendation is to eyeball the results rather than going for precise numeric values for density and value. This gradient gives you control over the relationships between tonal values and ranges. The approach has many advantages, but first a warning: Getting too dramatic with the individual sliders often results in either very compressed tones or banding in what should be smooth areas of your image. Don't forget that you are selectively compressing and expanding tonal ranges, not just changing discrete values.

In general, I like to use this gradient for making small contrast adjustments to separate details that are otherwise very close in tone, such as with clouds in a bright sky. It's also a great way to shift tonality overall by nudging each of the sliders in the same direction.

You're not limited to the slider assignments listed above. Remember how all of this resembles levels on steroids? Using fewer stops allows you to make larger changes in different regions. This building from Balboa Park in San Diego just needed a little contrast boost in the mids, so I placed stops at the 25%, 50%, and 75% points (with corresponding gray values), and shifted the midtone stops to the left to make the overall image brighter.

In fact, it turns out that having a handful of presets is really useful. Although the examples above deal with the Luminosity blending mode, these same gradients can be used for effective and impactful black-and-white conversion. As you are about to see with the B&W Control Freak method and saw previously under Color Grading, Gradient Maps are effective at applying fine tonal variations to an image.

B&W CONTROL FREAK

This is one of my favorite black-and-white conversion techniques because it doesn't rely on plug-ins or external software, and you can retain tons of control easily. It's also pretty flexible in that you don't have to use all of the elements. The trick is that this technique allows color tools to be used for grayscale conversion, putting you in charge of virtually every available element.

This northern New Mexico mesa is hiding some interesting detail in those narrow tonal ranges. A basic, direct conversion using a linear black-to-white gradient doesn't do it justice, nor does the default conversion from adding a Black & White adjustment layer, shown here.

Fortunately, we know that Photoshop views color as a combination of channel luminosity values, so we can use that to control which colors get converted to which shade of gray. Early in the book, I explained that two different colors can map to the same gray value because they share the same luminosity, even while differing in hue and saturation. The secret sauce here is that we are going to manipulate hue and saturation as an input to the gray conversion.

The technique starts with a Black & White adjustment layer, where you set the major *blocking* or conversion from major colors to gray. Because the conversion process is entirely subject to your own creative vision, I'm going to talk more about the choices I made for this particular image, with almost no focus on actual values or settings. The point is to walk you through my thought process in creating the final piece, so you can use a similar approach in your work.

What struck me about this image is the variation in tone in an otherwise narrow color range. For processing, I wanted to try to draw out those variations along with the texture. That meant dropping the sky to black and really exploiting tiny differences in color. On the B&W adjustment layer, I dropped the Blue slider until the sky was almost completely gone, then nudged the Cyan slider down to finish it.

From there, it was just a matter of playing with the different sliders available to get the heavy lifting out of the way, what I called blocking above. I knew the sliders would not have the level of fidelity required to really separate things out, but they were useful for setting the major tonal regions and establishing the overall dynamic range.

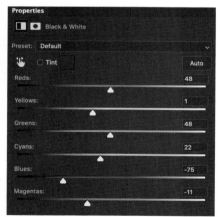

Starting with neutral values helps me establish the obvious visual elements more easily and provides a kind of reference point when it comes time to deal with the shadows and highlights. In general, photographers tend to use neutral values as a baseline against which we define shadow and highlight rather than simply assigning specific levels of luminosity. When the bulk of information is in the central third to half of the available tonal range, it makes sense as a rule of thumb to start there.

However, smashing rules (and sometimes thumbs) are necessary in the pursuit of art. When you look at your own image for conversion, consider working on the areas with the most important information first. These are foundational areas that you want to nail down, and then bring in other areas (e.g., value and color) to support the foundations and frame them. This is a broad approach to adjusting your art regardless, not just for conversion to black and white.

To adjust the exact hues going into the conversion, we need something with extremely fine color controls just below the Black & White adjustment layer. Selective Color provides this control by splitting out the primary and secondary colors into mixes of pigment: cyan, magenta, yellow, and black. When using Selective Color, I tend to start with the neutrals and work my way out to shadows and highlights.

The Yellow slider helped to enhance the contrast on the center spire's horizontal layers, while Magenta brought up the shadows enough to reveal some nice detail.

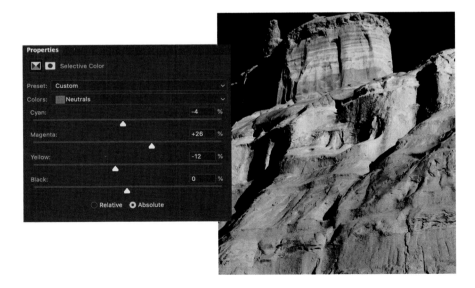

Already this has become more dynamic with minimal slider moves. Tackling the whites next, the middle layer of sediment required a boost in Magenta with a little reduction in both Yellow and Cyan sliders. And finally, working on the blacks took even smaller adjustments. The shadow areas had a strong magenta cast to them, so for more refinement I chose Magenta from the menu and lowered the Yellow slider quite a bit. This brought more detail to the shadows without having to affect the other regions.

At this point, a conversion with the B&W Control Freak technique will be almost complete. But we have more options and room for improvement! Adding a Color Balance layer below the other two gives you a chance to make some global adjustments that affect how the different areas of color relate to each other. This treatment is very subtle, as it affects the balance between complementary colors: As you add to one, you are taking away from the other. Prior to this, we have been addressing individual colors, so this is a chance to manage the relationships with some precision.

Going on from here is mostly a matter of personal preference for detail, but this is the basic set of controls in place. Remember that the flow of information is upward through the layer stack, but we worked downward from the top. Think of each additional adjustment layer as refinement just like you would do if adding dodge and burn layers to the top of a portrait retouching file.

I finished off my mesa with a modified Sepia Gradient Map (in the Gradient Editor, Legacy Gradients > Photographic Toning > Sepia Midtones).

Speaking of adding to the top, we can certainly add some dodge and burn adjustments. In the "Dodge & Burn" chapter we looked at a few methods, but I'd like to add another version here: the Exposure adjustment layer. You can use any method you like, and to be honest I'm including this variation for the sake of proving the point that anything you can do in Photoshop can be done a number of different ways. Because I wanted only to add some shadows, I used only one Exposure layer with Exposure set to about −1.5 stops with a full black mask, and then manually painted a few shadows for contour.

So the final layer stack includes five different adjustments, each of which is non-destructive and provides meaningful, responsive controls in slightly different ways. It starts with blocking out the major conversions from color to gray using a Black & White adjustment layer, then refines the contribution of colors to luminosity at the color component level with Selective Color. The relationship between colors is managed with a Color Balance layer. Finally, tonal adjustments are completed with a Gradient Map, and it's all about the details with a dodge and burn layer that uses Exposure.

I have this stack with default settings as a group in my CC Library, so I can simply drag it out to a working document. There is no end to the possibility here. Even the gradient map gives you some ability to tweak a little more. I called this technique Control Freak for a reason!

HELPER LAYERS

If you have ever found yourself squinting at your work, or staring for minutes on end trying to find "the thing" that may need your attention, I have a real treat for you. This chapter is brief, but I wish I had learned these techniques much earlier to avoid literal headaches and eye strain, as well as to simplify various kinds of image corrections and adjustments.

Helper layers are temporary layers that you put in place to change the look of your image while you're working but do not include in the final piece. Helper layers have two key uses. The first is to enhance certain aspects of your work so they're more visible, typically exaggerated to the point of absurdity. These usually take the form of extreme contrast or feature isolation, which removes distracting elements and lets you focus your attention. Just as important, the second use is to jar your perception of your work. When used to enhance or alter perception, helpers not only let you change the context of your work, they also reduce fatigue introduced by staring at details for too long. Sometimes these two uses overlap, as when inverting or desaturating an image.

The most typical (and effective) use of these helper layers is to place them in a group at the top of your working layer stack. Occasionally they can be paired with specific layers or groups for things like composites and some color work, but for the most part they should be left at the top for easy access and removal.

Depending on the type of correction or enhancement, you may find it necessary to frequently toggle these helper layers as a quick check rather than leaving them on while working. Keep your Layers panel open when using helpers and pay attention to your selected layers to avoid working on the wrong content. As an added precaution, consider locking the entire group—this lets you change visibility of the elements and the group without allowing parameter changes or painting on masks.

A LAYER BY ANY OTHER NAME...

I highly recommend naming your layers for organization, but there's a twist when it comes to helper layers. Name them according to the results you see or how you use them, not to echo the names of the blending mode or adjustment layer involved. In the second example, the Color blending mode is used with a gray layer, but the result is a view of the luminosity of your image. Likewise, using the Luminosity blending mode gives you a view of the color. As you apply the following helper layers to your work, use names that tell you what the layer is meant to show you (which are conveniently provided at the beginning of each description).

Finally, pay attention to the tools you're using on your correction layers. Some of them, such as the Clone Stamp tool, have options for which layer content they use and target. If you leave the default setting of All Layers in force and work on a healing layer while a helper layer is visible, you will end up affecting everything currently visible on the canvas (including your helper layer) rather than only the content you actually want. Instead, ensure you're using either Current Layer or Current Layer & Below if you work with a helper layer visible.

INVERT

One of the first helpers that you can easily apply is the simple Invert adjustment layer. Using this adjustment layer lets you see your image slightly differently, and it may help you pick out a variety of otherwise hidden or obscured details. While this particular adjustment layer doesn't appear to be that useful for artistic or technical senses, it illustrates the notion of having a quick change in what you're seeing as a way to help refresh your eyes.

There are no controls, and the effect is basically a color negative of your image, inverting both color and luminosity at the same time. You will most likely use Invert along with other helper layers, especially as a quick toggle to look for glaring problems. Also consider pairing Invert with Canvas Flip and Rotation (commands on the Edit > Transform submenu) to check composition and graphic balance.

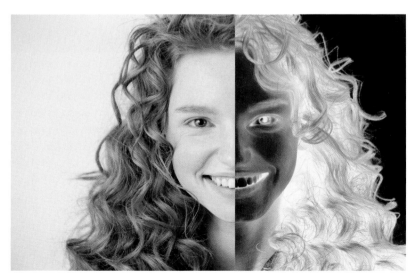

LUMINOSITY

You can remove color temporarily by adding a solid black layer set to Color blending mode as a helper layer. Why would you want to? Recall that two colors may have similar luminosity values, so desaturating everything to gray values gives you a better sense of graphical composition and also helps you evaluate the relative brightness of various colors. This is especially helpful for working with vignettes and when dodging and burning for contour development and shaping. Use this technique zoomed out to retain a contextual view of your work.

If you prefer to stick with adjustment layers, you can substitute a Solid Color fill layer, also set to black, white, or any other desaturated gray. Because Color blending mode replaces the color from backdrop layers with the current blend layer, the result is the same no matter what gray value you use.

Combine the desaturation layer with inversion for a more flexible inversion adjustment, but instead of an Invert layer, use either a Curves or Levels layer below the filled gray layer. Using one of these adjustments gives you control over contrast as well. To use Curves, drag each end of the curve to its opposite vertical position: The left control point should be at the top, while the right control point should be at the bottom.

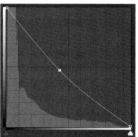

To get an inverted Levels adjustment, drag the Output sliders to their opposite ends. The Output sliders are below the Input sliders, which themselves are immediately below the histogram. Simply swap the black-point and white-point sliders.

I prefer using Levels to Curves here because I find it easier to create ultra-high-contrast regions by setting the Levels adjustment layer to Hard Mix. You will be able to see contrast areas by "sweeping" the Input midpoint slider back and forth. This is another visualization trick that helps with composition. By isolating different ranges, it's easier to pick out unbalanced areas or features that may distract a viewer's eye.

SOLARIZE

A solarize curve is great for exaggerating extreme contrast to pick out transitions that may otherwise be invisible. Especially useful when working on smoothing out color and shading, this helper layer is best used as a quick toggle because the transitions can be misleading.

On a new Curves adjustment layer, set four additional control points and drag them to resemble this extreme configuration.

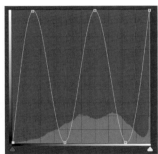

Once you have created your curve, you can save it as a preset by clicking the panel options menu in the upper right of the Properties panel, then choosing Save Curves Preset. In the image example, I used the Solarize curve to help me see where to smooth out tonal variations in the model's skin.

Add a Luminosity helper above the Solarize layer (as described in the preceding section) to help see where to use dodge and burn techniques (see the "Dodge & Burn" chapter). You can check on your progress by toggling the Solarize helper layer on and off. Note that the transitions between color and value regions you see are not intuitive because of the shape of the curve. For example, if you attempt to dodge and burn when this curve is active, you may be doing the opposite of what you expect because you will be seeing the

transition regions move around while you work. Instead, turn it on briefly to identify areas that need work, then turn it off and start on whatever correction layer you have chosen to use. While still working on the same correction layer, you can turn the Solarize curve back on to complete that region. It takes a little getting used to, but once you get the hang of working with the Solarize curve turned on, it becomes easy and quick to do very detailed corrections.

COLOR, HUE

Similar to removing color to see luminosity, you can also remove luminosity to see color separately from value (or brightness). The advantage here is to isolate tones to look for areas that may have subtle inconsistencies, such as frequently happens with makeup coverage. Add a 50% gray layer to your image and set its blending mode to Luminosity. The results themselves may be difficult to see, so add a Levels adjustment to increase contrast. Start by moving the black-point slider to 100 and the white-point slider to 155, leaving the midpoint slider alone. If the effect is too harsh, either lower the opacity of the Levels layer or adjust the black- and white-point sliders until everything balances well enough visually. Remember that the goal is to help you see things more clearly, not to achieve a particular look or special effect.

To isolate the hues in an image, add a blank layer set to Saturation blending mode, then fill with any fully saturated color. So long as it's fully saturated, it will replace the saturation of the underlying image—open the Color Picker and set both the B (Brightness) and S (Saturation) values to 100. It's common to choose a primary color, such as Red (RGB: 255, 0, 0), but it really doesn't matter.

Notice that every hue is fully saturated, but luminosity is preserved. This helps you look for inconsistencies in tone across smooth areas, but you can also use the technique with a Color Balance adjustment layer if you place a color swatch in the layer stack for reference.

The swatch must be above the color correction layers, but below the visualization layers. You don't want to adjust the reference along with your image! This helper is great for checking makeup, product colors, and matching composites.

THRESHOLD

Admittedly, this is one of the helpers I use very rarely, and mostly to identify elements at the extreme edges of the histogram. A Threshold adjustment layer has a single control that lets you set a hard transition point at a given luminosity value. Everything below the threshold turns black, and everything above becomes white. Use this for visualizing extreme highlights or "hotspots" by dragging the slider to the right, and solid black areas of your image by dragging to the left.

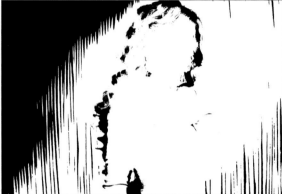

I prefer to see the region of interest in white, so I typically leave the slider to the right and instead use an Invert helper layer above the Threshold layer when considering shadows and black regions.

There is a more flexible use, however, and that is to set the Threshold adjustment layer to Multiply or Screen (turn off the Invert layer). Using the Multiply blend mode lets the white areas of the Threshold result blend with the canvas contents, so you can see your image dynamically masked in this way–remember that the blended areas are Highlights when using Multiply. If you want to use the mask for controlling an adjustment or other layer, you have a couple of options.

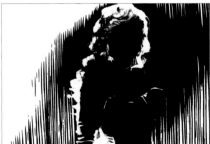

Option 1: While Multiply is still blending the Threshold layer, use the Magic Wand tool with Tolerance set to 2 and Contiguous, then click in the black area. Then choose Select > Inverse or use the keyboard shortcut Shift+Command+I (macOS)/Shift+Ctrl+I (Windows) to invert the selection. Create either a new layer or an adjustment layer to have the selection automatically applied to a mask, and then use the Feather slider to smooth the pixelated edges.

TIP If you do not plan to create a mask, you can also choose the Overlay blending mode to see highlights in white and shadows in black at the same time.

Option 2: Set the blending mode back to Normal, and save a new alpha channel, which you can then manipulate as you please and use later as a mask or selection template. This is my preferred method.

If you want to use Screen on the Threshold layer to show only shadows, you have to use a little wizardry. Add a filled layer filled with solid black above the Threshold and Invert adjustments (turn Invert off), and open the Layer Style dialog box. In the Blend If section, move the black slider for Underlying Layer to the right so it reads 250. Now the shadows show through. Fortunately, you can now switch between Multiply and Screen on the Threshold layer to show highlights or shadows quickly. Group these together along with the Invert layer for organization. Remember to use Invert only for the strict black-and-white display and choosing a selection area.

SATURATION MASK

Saturation can be a really difficult characteristic to see in a photograph, especially where skin tones are concerned. A classic favorite for creating a saturation view is to use the Selective Color adjustment layer. For every color in the Colors menu, move the Black slider all the way left to –100. For each of the Whites, Neutrals, and Blacks options, move the slider all the way to the right at +100.

Selective color treats your RGB image as if it were a collection of pigments (subtractive color model). Because each printed color is made of a combination of cyan, magenta, yellow, and black pigments, the sliders control the mix or density of each virtual pigment. By removing black from each color, you are allowing "pure" pigment coloration for each of the tones, red through magenta. The gray values get maximum density of black to give those values maximum density.

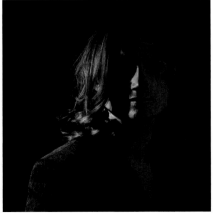

The resulting view is grayscale, with white representing more saturation. Now add an Invert adjustment layer above the Selective Color layer, and set the blending mode of *both* adjustment layers to Luminosity. Group these two layers together so you can toggle them off and on easily. This inversion step lets you see the colors against white, which looks more natural.

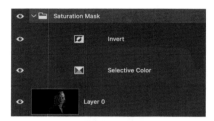

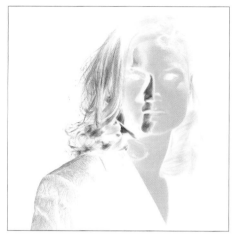

Use this saturation view above other color correction adjustments, such as Hue/Saturation or Color Balance.

BONUS TIP If you find these helper layers useful, gather them all together into a layer group called Helpers, set them to the appropriate starting values (such as with the Saturation Mask), and delete the masks. Ensure visibility is turned on for the group, but off for the individual helper layers. Open your Libraries panel and create a special Adjustments library, then drag the group over as a new item.

When you need your helpers, just right-click the library item and choose "Place Layers" to have the entire group plopped into your layer stack, ready to go. This is much easier than creating and managing presets for every adjustment.

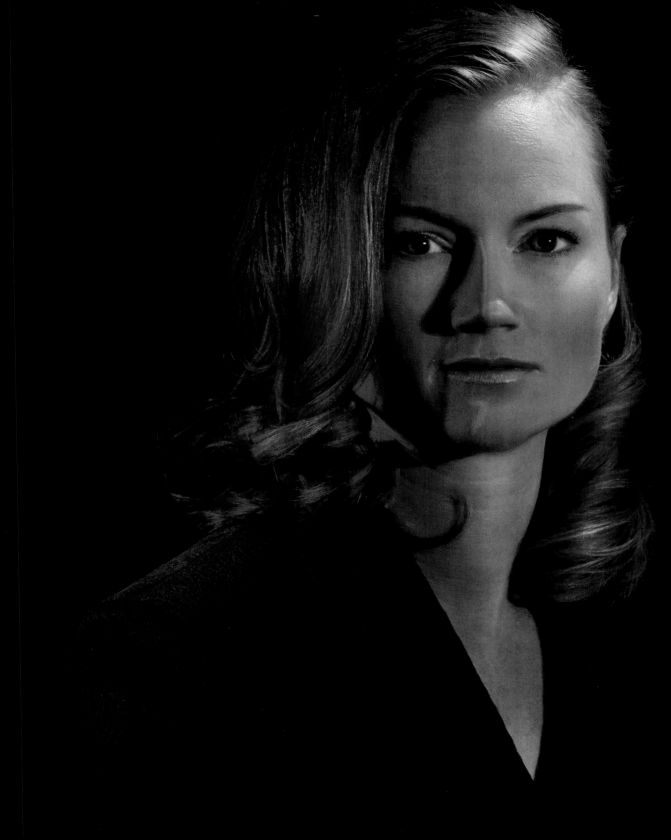

EFFECTS

It's time to take a little break from photo corrections and have some fun with textures and effects.

Playing around with effects is something I have done since my first forays into Photoshop, and I still enjoy the process. It really comes down to a directed kind of experimentation, and I find it also helps develop a sense of how filters behave. Although the filters in Photoshop are getting pretty long in the tooth and have some frustrating limitations, they still offer the creative artist a reasonable amount of flexibility.

In places, this chapter certainly wanders beyond the theme of blending modes and adjustment layers, but keep in mind that the purpose of this book is to enable deeper understanding of the tools. Seeing tools and techniques used in context helps solidify their place in larger workflows. Hopefully some of these example effects will spark your own creative explorations!

ORTON EFFECT

The Orton effect has been around for quite some time in the digital imaging world, but traces back to the era of traditional darkroom techniques (and one Michael Orton), when implementing it required quite a bit of skill in manipulating film negatives. Fortunately, Photoshop allows us to achieve the effect fairly quickly and with lots of ability to control variations. The look itself provides a dreamy appearance, which is great for fantasy subjects and still lifes. It tends to work best with images that already have some fairly bright highlights and possibly even rays of light running through them. Dusty trails, cloudy landscapes, and shiny objects all look great with this effect, as do portraits (just be careful not to slide into the cheesiness of glamour portraits from the late '80s).

Let's start with an old-school version of the technique, which is what I learned nearly 20 years ago. Duplicate your photo layer and apply a large dose of Gaussian blur, perhaps 15–50 pixels depending on the actual pixel dimensions of your photo. You want to end up with regions of dark, midtones, and light in

large enough patches, but not so much that the scene elements can no longer be identified. See the example for a rough guide to the initial results. This will result in a soft glow around your subject in later steps. When you're happy with the blur, duplicate the blurred layer again. Name the top layer **Blur 50% Desaturate Screen** and the middle layer **Blur 50% Multiply**.

Turn off the Blur 50% Desaturate Screen layer for a moment, and set the Blur 50% Multiply layer's blending mode to Multiply. This darkens everything up and creates a lot of muddy shadows, which we will take care of shortly. Back on the Blur 50% Desaturate Screen layer, make it visible and set its blending mode to Screen. Then desaturate the layer (press Shift+Command+U (macOS)/ Shift+Ctrl+U (Windows) to desaturate). The initial result is kind of an indistinct mess, but remember that this is simply an intermediate step.

To get the final effect, dial down the opacity of each layer to about 50% to start, and if necessary use some Blend If magic from the "Useful Information" chapter in Part I to selectively blend shadows and highlights. The most typical result is a dreamy, soft glow around bright highlights and reflections.

The basic look is pretty easy to obtain, but can we improve on this? It turns out that if you are willing to give up the flexibility of having individual layers to tweak, you can get a different and possibly more pleasing result using just one duplicate layer and a dash of Apply Image.

Back in the original photo, make a duplicate as before, but this time choose Image > Apply Image and, in the Apply Image dialog box, set Blending to Linear Burn. Choose either Merged or Background for the source. We are using different blending modes for a different look—and to show that choice of blending mode is a little subjective. You should experiment with various looks!

Now that we have baked in the darkening result of Linear Burn, add the large Gaussian blur and then change the layer blending mode to Screen. The result is not extreme like the first version, so there is less need for mitigating the look.

But let's go a step further and recover some of the highlights. Add a layer mask to the blurred layer, and with the mask active, again choose Apply Image and Linear Burn. This time choose the Background layer, and check the Invert box. Doing so uses the image itself to create the mask so the details in the highlight regions are preserved, but the edges of the highlights still have a nice, soft glow.

Take a moment and think about how this effect works. It starts with blending the original image with itself using Linear Burn; that burns down the overall tone, and then you blur the result. The blur acts to create the glow area, so the size of the blur matters to the end result's impact. The final Screen blending acts to negate some of the Linear Burn result, but allows some of the blur to blend with highlight areas. In the end, the effect should be only slightly brighter than the original, owing to how Screen adds the highlight and light midtones together.

That suggests some interesting variations, such as changing the type of blur, adding adjustments along the way, and using different blending modes. Here's an example using the same basic steps on a very different portrait image, but immediately after the Gaussian Blur, I used Levels (Cmd/Ctrl+L) to increase the contrast of the blur result. Instead of Screen, I used Soft Light, and I added a clipped Hue/Saturation layer to the result to reduce the saturation a little, between –25 and –50. Notice that the much darker areas show off the highlight and color tones.

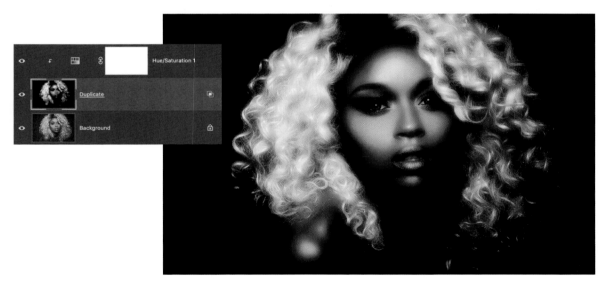

You can also add textures by filtering immediately after the blur step. In this example, I ran the Clouds filter (Render > Clouds) after blurring, and then used the Fade command (Edit > Fade Clouds) with Soft Light chosen from the Mode menu in the Fade dialog box to blend the cloud diffusion back into the blurred result. The final step is simply setting the blending mode to Screen. Notice the

hazy, textured glow around the white areas that almost look like mist. As my editor points out, this is an example of the "cheesy late-'80s" glow!

Naturally, you can try different blending mode combinations, as well. Rather than Linear Burn, try Multiply like in the original version. For something really funky, start with Hard Mix and a Distort filter, or a Path Blur filter. The point is that the effect gives rise to a technique that reaches beyond the original intent.

RAIN AND ATMOSPHERE

I like to find ways to use Photoshop filters to organically generate various textures in a procedural manner. That simply means following a prescribed set of steps to build up a final effect, but taking advantage of randomness where possible. This turns out to be quite a lot of fun, and you can spend hours on end tweaking different settings and parameters to come up with various effects. More in context of this book, however, we can use the effort like an experiment to gain familiarity with digital tools and to exercise some problem-solving skills.

Generating rain, snow, and other atmospheric effects is a staple illustration trick. Rain in photographs consists of hazy streaks usually with no color and varying levels of brightness. Most tutorials start with adding noise to a black layer, adding some Motion Blur, then setting the layer blending mode to something like Screen, Soft Light, Linear Light, or Vivid Light.

Noise is pretty uniformly applied across the entire canvas, and consists of pixels that don't scale to the size of features in the image. That means as your image gets higher in resolution, the "rain" drops get smaller. Plus, noise tends to end up looking like it's distributed fairly uniformly. Let's start experimenting by increasing the droplet size.

One approach is to use a Gaussian Blur to smear the noise together, and then find ways to make blobs of different sizes. This rarely seems to give satisfying results, though. Being a bit of a control freak, I like a more definite approach.

Enter the Crystallize filter (Filter > Pixelate > Crystallize). Crystallize comes with a single slider to control "cell" size, or size of the crystals. The filter generates little solid-color polygons by grouping together pixels within the cell-size radius, then averaging the RGB value and returning a single color. When started from a noise-filled layer, the quasi-random pixels create cells you can use as a basis for various precipitation effects. Plus, the cells have hard edges, which tends to look better when you later apply the Motion Blur filter.

Here's the result of filling a layer with solid black, adding about 20% Gaussian Monochromatic noise (Filter > Noise > Add Noise), and then using Crystallize set to 10 px setting (we'll get to the recipe in just a moment, so don't worry about following any steps just yet). The canvas size is about 2900 px wide by 3500 px tall.

Now that we have some control over the seeds for the raindrops, we can go ahead and apply the usual Motion Blur filter, using an angle of about −85 to produce rainfall that is not quite vertical, and a Distance value of 100 px.

There is a relationship between noise we generated and the results of the Crystallize filter. In particular, less noise results in darker crystals, as there are fewer white pixels contributing to each cell. Adding more noise to a black layer means adding more "not black" pixels (that is, there are more randomly generated pixels, so more of the original black layer content is obscured), and that results in brighter crystal cells with more chance of getting solid white.

To achieve a good effect with depth, you need to generate several layers of rain. Rather than running through the filter process every time, start by filling a layer with solid black and then converting it to a Smart Object (Filter > Convert for Smart Filters). Now when you adjust the various filters, you can simply create a stamped copy of the variation.

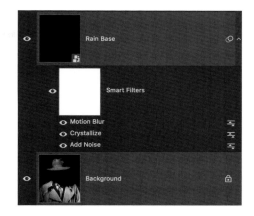

On the Smart Object layer (name it **Rain Base**), add the following filters and settings in order:

- Add Noise: Amount 20%, Gaussian, Monochromatic

- Crystallize: Cell Size 10 px

- Motion Blur: Angle −85°, Distance 100 px

AT THE EDGE OF THE WORLD

Most of the rendered results will have some odd behavior at the edges, so you'll probably have to use Transform to scale up your rain layer a bit larger than the canvas size. Some instructions have you increase the canvas size to allow for more empty area around your image, then crop back down, but I find this is easy to forget in the end. In many cases, you may also want to slightly rotate or move your atmosphere effects around, so you're going to be transforming, anyway. Because of the nature of the effects, you won't suffer any distortion, loss of resolution, or jagged edges unless you get extreme with the transform.

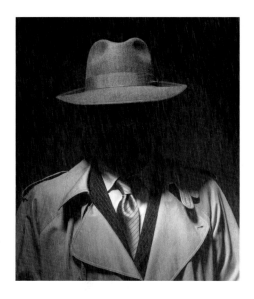

Use The Claw shortcut (Opt+Shift+Cmd+E/Alt+Shift+Ctrl+E) to create a stamped copy (like a snapshot) of the rendered rain on a black background. Turn off the Smart Object visibility, and set the copied layer to Screen (or other mode that suits your base image) blending mode. Name this **Rain 1**. The first round is just to get your bearings on how the effect looks with the subject, so feel free to explore various settings. My philosophical approach here is to start by creating a rain layer that looks good with the subject immediately, so it is typically a little more sparse.

At the moment, the rain itself looks good, but it isn't really interacting with the subject. After exploring some of the other blending modes, I settled on Overlay, which in this case gave a

NOTE A frequent concern with this effect is low contrast. Once it's rendered, you can easily increase the contrast using a Levels adjustment applied directly to the layer. Press Cmd/Ctrl + L to bring up the Levels dialog box, and make necessary adjustments. This is purely subjective, but I suggest erring on the side of too bright because you can much more easily reduce the effect by lowering opacity or fill later on. Remember that applying an adjustment directly to a layer is destructive!

really dramatic lighting result as well. This also took splitting the Black Underlying Layers in the Blend If area of the Layer Style dialog to bring back some of the shadow areas.

Now the hat and coat look wet from the rain. Turn off the Rain 1 layer, turn on the Rain Base Smart Object, and then adjust the filters to produce longer streaks. Add a little additional noise, slightly larger Crystallize setting, and longer motion blur (with a little extra tilt). Repeat the capture process to add your new rain, and call this layer **Rain Texture**.

The reason I'm not giving you specific settings here is because this effect is all about tweaking. If you don't like the result, scrap the layer and synthesize something new. Think of the Rain Texture layer as the middle ground in your atmosphere, while the Rain 1 result is the foreground. Aim for something that will fill in the space and sell the idea that water is falling everywhere in the scene. For this middle texture, I used Linear Dodge (Add) blending mode with Fill set to 40%, and then applied a little masking in front of the subject's face.

Here's the current progress with both rain layers turned on.

In real life, rain that is further away will tend to cause less motion blur than rain that is close to the camera. It is common to see at least a few raindrops with less blur, so let's add one more layer that sells this little detail. To get this

effect, reduce the Motion Blur Distance setting to about half or less of the original blur, and cut the Noise Amount setting by half (to about 10%). Make a stamped copy, and call this one **Rain Drops**.

Set the Rain Drops layer to Lighten blending mode. If the rain is further away, it wouldn't be in front of the subject, so apply a layer mask to prevent the effect from falling on the subject.

Group together the layers you generated from Rain Base, and name the group **Rain**.

Now, let's explore some additional controls for this effect. It is easy to reduce the brightness of the rain by lowering layer opacity, but we can add another trick into the mix to adjust the apparent amount of rain, as well. Before making a stamped duplicate of the base effect, add a Levels adjustment layer above the Smart Object and clip it to the Smart Object. The adjustment layer gives you a way to change the contrast of the filtered Smart Object result, which in turn changes the apparent number of raindrops (or the "density" of rain). Start by adjusting the midpoint slider and observing the effect on the middle gray values. If additional contrast is needed, move the black or white point sliders towards the middle. Use this in addition to varying the amount of noise and the cell size in Crystallize.

Because you are using a Smart Object, you can preview the effect over the subject (and other rain layers) by setting the Smart Object blending mode to Screen. This trick gives you a chance to compare various settings before creating a snapshot layer. When you get a look you want to keep, set the Smart Object blending mode back to Normal before making your stamped copy. The Levels adjustment layer is clipped to the Smart Object, so it will no longer have an effect on the layer stack.

Creating multiple versions of atmospheric effects lets you create more depth in an image, so the Smart Object approach is really a great timesaver. For a rain scene with a large depth of field, you may want to create two or three different versions, changing up the motion blur direction and length, and maybe even the amount of noise or crystal size.

Here is a variation that tends more towards wet snow or sleet. There are four layers of precipitation here, with the far background becoming almost uniformly light gray, while big, wet chunks of snow are in the foreground.

As a final note for this technique, you can also use it to generate brushes for painting rain into a scene. This is really useful when you need to create splashes, for example, or want to only show a little rain here and there.

STAMPED PORTRAIT

This effect came about as a result of trying to find a good use for the Threshold adjustment layer. It's also an exercise in putting whatever tools you want to unusual uses. The secret to this technique is taking a minimalist approach to building up the starting image like a piece of graphic art rather than a photograph. Pay attention to composition and balance as you go, and how density of texture and line thickness impact the overall balance.

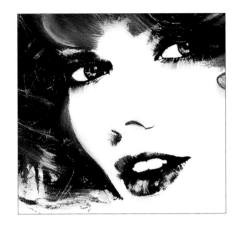

The Threshold adjustment layer evaluates the cumulative brightness of each channel and makes everything at that level or brighter into white, while everything else is solid black. Here's what it looks like when Threshold is applied to a linear gradient. Moving the slider back and forth changes the cutoff (threshold) value. It's easy to see why Adobe called it "threshold." That's pretty much all there is to this particular adjustment. For discussion on how Photoshop calculates the brightness, refer to the end of the section "How Photoshop 'Sees' Your Images" in Part I.

For the expressive portion of this effect, you'll use various brushes to smear the pixels around a bit. This requires having some texture rather than solid areas, and the hard black/white transition of tiny pixels and edges is a great medium for blending. So you want to work towards texture as a kind of density. This helps preserve the illusion of depth, as well, and prevents having to deal with solid filled areas.

In order to get what we want out of Threshold, we need to feed it carefully by controlling what colors and values go into it. We are going to exploit our knowledge of how Photoshop converts color to luminosity values and place a few controls beneath the Threshold layer.

If you are using a photo that has lots of visual elements, first try to reduce visual clutter so you can more easily see how the Threshold technique works. You can do this by masking your photo layer, or by placing a white-filled layer above your photo and setting it to Screen blending, then paint with black on the white layer to reveal the subject.

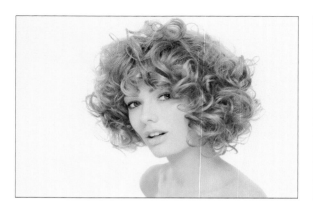

Place the Threshold adjustment layer above your photo and tweak the Threshold Level slider to get close to the result you want. If there is simply too much range to get a balance, focus on one element at a time (such as hair in this example) then add everything together before painting. This result is pretty good, but to refine it add a Black & White adjustment layer below the Threshold layer. Remember that this adjustment converts color to gray values, so you can modify the brightness of individual colors for Threshold.

Let's say I want even more control, and the color tools aren't cutting it. We can add more adjustments below the Threshold and Black & White adjustment layers, in similar fashion to the Black & White Control Freak recipe from Part II. A more direct approach is to simply paint on an Overlay layer to control contrast exactly where we want it; add a layer below the Threshold layer

and fill with 50% gray, then set to Overlay blending. This is one of the same approaches used for dodge and burn at the beginning of "Dodge & Burn" in Part II. Use a large, soft round brush set to about 10% flow and gently paint with black and white on the gray Overlay layer to choose the details you want preserved or obscured. I went for more texture in her hair and some detail in her eyes.

The only thing missing here is a hint of shoulder, but painting with Overlay in such a low-contrast area is kind of painful, so we need a cheat. With the Photo layer selected, choose Select > Subject. This loads up an outline selection that you can paint in on another layer with black.

Remember that you're just setting yourself up to start a painting, so you can always add or subtract later on. Don't worry too much about what you should or shouldn't show at this stage. From here, you have a choice of using either the Smudge tool or Mixer Brush (or both—I won't tell). When I first started using this technique, I preferred the Smudge tool for its simplicity. The more I worked with this effect, however, the more I began to prefer the options and flexibility of the Mixer Brush.

Once you have the starting point you want, create a merged flat copy at the top of the layer stack, then lock it so it doesn't get changed. Name it **Base**, and then add a blank layer above that. This is where you'll start painting.

SMUDGE TOOL

Select the Smudge tool from the toolbar, and open the Brushes panel. Smudge works just like the Brush tool in that you can choose a brush tip and dynamic characteristics. I recommend choosing one of the bristle style brushes, especially the Flat Fan for faces because it has some wispy qualities that lend a more organic look to the process. To set up your brush, open the Brush Settings panel and select Brush Tip Shape from the list of options on the left side of the panel. The right side of the panel displays a number of brush tip presets; click the Flat Fan preset to select it.

In the options bar, set Strength to between 25% and 50% to start and ensure that Sample All Layers is selected. "Sample All Layers" is what will let you sample from what's visible on the canvas and paint the smudged result to the blank layer, giving you a way to recover through erasing or masking. It also gives you a way to selectively turn on or adjust certain layers temporarily for more sampling control.

This technique is best used with a pressure sensitive stylus, such as a Wacom tablet.

On the blank layer, begin smudging. The amount of drag (how far digital paint is smudged) for each stroke depends on the Strength setting, so be sure to make judicious use of that control while working. This part is all about expression, so take some time to practice with various brushes and sizes. The Smudge tool is best suited for the first pass of blocking in areas you want to affect, but be warned that it can often result in blurry regions, so use it sparingly. Just get the digital ink roughly where you want it without obscuring details too much.

For more expression and a painter-like experience, add another blank layer and grab the Mixer Brush!

MIXER BRUSH TOOL

I enjoy using the Flat Fan brush with a texture such as Raw Linen under the Artistic Brushes Canvas set. To try it, set up the Mixer Brush as follows:

- Bristle brush: Wet 100%, Load 1%, Mix 100%, Flow 100%

- Load the brush after each stroke: Not selected

- Clean the brush after each stroke: Selected

- Sample All Layers: Selected (if you are painting to a new layer)

- Brush Smoothing: 10% (optional)

The Mixer Brush will take advantage of both the black and white pixels, so remember that you can also blend the white pixels into black areas to help with detail. As you work, consider adding new blank layers so you have a set of snapshots to work with. Sometimes you may need to experiment with a few different techniques to get what you want, and it can be helpful to have a range for comparison.

Using various brushes, you can tease out all kinds of strokes and effects. While I prefer the bristle brushes for smudging, try experimenting with regular brushes meant for hair or smoke. The Flat Round Mixer Brush is great for dense, solid details, while the Fan with something like a canvas texture can add a lot of character where there are few strokes to work with.

Remember, this effect is all about expressiveness, so tweak the technique as necessary. For example, you can always go back and add dabs of paint with a regular brush, then blend that in with the Smudge or Mixer Brush. I prefer a smooth look to most of the areas, with just a tiny bit of the original aliased grit or noise, so to get that in some areas, use the Sharpen tool to remove just a little of the edge softness here and there. Depending on what look you want, you could also take a look at the Rain recipe and add a little texture to your piece. The stark, inky look gives you a fantastic base for all kinds of additional elements.

This is just one of several ways to get this effect, but I enjoy this process of manual painting because it feels more involved and organic. Try taking it in crazy directions, or start with a different technique. This would pair nicely with the Dissolve Painting approach discussed next!

DISSOLVE PORTRAIT

This effect was a lot of fun to develop as I had set myself a challenge to use the Dissolve blending mode, which most people tend to ignore. The Dissolve blending mode is quirky in that it uses a map of pixels on your canvas to determine opacity levels. Each time you start up Photoshop each pixel is assigned a specific value randomly. When you use the Dissolve blending mode and lower the opacity, Photoshop compares the opacity level to the value randomly assigned to each pixel. As the opacity level reaches that number, any pixel with that particular value becomes completely transparent.

But something different happens when using the Dissolve blending mode with brushes. In order for the blending mode to take effect, you need to use a brush that is not completely solid. Brushes that work best tend to have a soft edge and low flow. This allows the effect to be built up. However, unlike the layer-based blending mode, the tool-based blending mode is not assigned pixel values based on specific location on the canvas. Instead each pixel's value is randomly generated as it is painted, which allows the effect to be built up in a manner similar to airbrushing.

This also means that brushing with the Dissolve blending mode can have a more random and scattered effect but it is still easily controlled. The newsprint or grainy airbrushed look relies on active selections from your image to keep things in order, as if you were painting by using a stencil (or if you have air-brushing experience, using frisket). There are many ways that you can select the different regions of your image, but I like to use automated approaches whenever possible. One great way to explore this effect is to simplify your portrait and use channels as selections. When you load the selections, they will automatically have shading built in.

This effect is best applied to images with minimal detail or where you can easily isolate key areas that you want to paint. Anything that you don't want included in the final result can be masked out or deleted, or you can simply not paint those areas or features.

With your portrait layer loaded into Photoshop add a blank layer above the image layer. Now, select the Brush tool and load up a soft round brush that is relatively large. If you're using a digitizing tablet such as a Wacom Intuos, be sure to set the pressure sensitivity for opacity but not size. In the options bar, set the brush blending mode to Dissolve and lower Opacity to around 30%.

Above the photo layer, add a layer filled with white (or a Solid Color fill layer set to white), then another blank layer above that. For the moment, turn off the white layer so you can see the background image.

Open the Channels panel, and select the Magic Wand tool from the Tools panel. In the options bar again, set Tolerance fairly low, such as 8 to 16, and deselect Contiguous. This will limit the total range that you select with the Magic Wand. Click one of the color channel thumbnails to make it visible, then click the canvas to load a narrow range of tones, such as middle values. I've chosen the Green channel and clicked just under the model's hairline. Because the selection is based on density, you need to invert the selection (Select > Inverse) to paint into the areas you've chosen.

With the selection still active, click the Composite channel, and then return to the Layers panel to pick your starting color. For my example, I used black to start. Select a soft, round brush as described earlier and start painting gently on the top blank layer where the selection is active. You should begin to see some detail show up almost immediately. Because of the low Flow setting, you should be able to work back-and-forth as if you were coloring in the

region. This is another way that you can keep control over the density of pixels painted on the canvas.

Remember that you do not have to fill in all of the selected areas. To include color in your images you have two major options: The first is to select your color and paint directly on the canvas; alternatively, add a new blank layer set to Color blending mode and paint over those regions with a regular brush. Remember that Color blending mode will not affect areas that are already solid black, so you may need to go back to your painted layer and use a very low flow and low opacity eraser to lighten those areas that you want to color.

Another thing to keep in mind is that because you are painting with actual pixels, the grain size is fixed. In order to get finer grains, start with a larger canvas (at least 3000 px × 3000 px). This will allow you to have much finer grains and much more variation in the apparent density, and you can always scale down as necessary.

If you want greater variation, instead of painting with pure black, paint with 50% gray. This will allow you to use dodge and burn layers, as well as apply one of the color grading methods outlined in other recipes.

PART III
PROJECTS

Knowing is one thing; doing is another.

PROJECT EXAMPLES

To truly take advantage of hidden powers, they must be exercised in context. Part III shows some brief examples of bringing techniques together and choosing various approaches.

CREATING THE WORKBENCH FILES

This section is for the intrepid digital explorers who love to tinker with bits and ones and zeroes. Although I have provided instructions for a couple of basic experiment files, you should always be ready to create your own specific experiments to test various properties and characteristics of whatever tool, feature, or technique you want to better understand. Often, understanding comes through building a better vocabulary, and in the Photoshop world that vocabulary is more likely to be visual and conceptual than a new set of words.

What makes a good experiment file is the ability to let you control the variables involved, and to reduce the distractions and attachment we have to our own work. Using files that reduce the environment to colors, brightness, shapes, and so forth helps us leave behind any attachment we have to working on our photos. For example, if you are just trying out blending modes with a photograph, you are likely to judge an effect based on whether you like the results in the moment. If you come across something that is unappealing, you are probably going to just move on and leave that blending mode behind and not bother trying it again in the future.

Such is the fate of Hard Mix and Dissolve, two blending modes typically ignored or used for singular effects. In the following pages, I hope you find a little of the fascination I feel when experimenting—and that leads to a discovery or two!

GRADIENT EXPERIMENTS FILE

Remember that my intent with this book is not to show you the fastest, coolest way to edit photos, but to expose the tools and features in a way that helps you build a stronger foundation for your own work. Building and using these files is a way for you to push beyond what I've shown in the previous pages. If you have favorite techniques, plug-ins, or other tools I haven't described, try them out with these files or build something new.

Each individual experiment file should be built in its own document. I prefer to use a document of 2000 px by 2000 px in 16-bit RGB, with a resolution of 300 px/inch, and either a white or transparent background.

BASIC COLOR BARS

The first file is something I've used for years to see how blending modes behave over basic colors and luminosity values. Ensure that your working space is set up for your normal workflow, including such settings as gamma, color profiles, and so on. If you haven't changed any of this before, it's likely you don't have to do anything more, but you can learn about the basics on the following site: helpx.adobe.com. Search for "Color settings Photoshop" and browse the results.

In your new experiment document, select the Gradient tool and then open the Gradients panel (Window > Gradients). Create a new preset group by clicking the Create New Group button at the bottom of the panel (it looks like a folder) and name the group **Utility Grads**.

TIP The New button does not start you off with a clean, basic gradient. Only click the New button **after** you have set up the gradient you want to save **and** you have entered a name in the Name field.

Press D to load the default foreground and background colors (black and white, respectively), then from the Gradients panel open the Basics folder and select the Foreground To Background gradient–this will now of course be black to white. If you have a layer active in the Layers panel, clicking a gradient preset will either add a new Gradient Adjustment layer if the layer has content, or convert a blank layer to a Gradient Adjustment. Name the layer **B-W 0% Smooth**.

Double-click the icon on the Gradient Map layer to open the Gradient Fill dialog box, and set the Angle to 0°. Then click the Gradient swatch to open the Gradient Editor dialog box. Foreground To Background should already be loaded in the Name field.

In the editor area below the presets, find the Smoothness setting and enter **0** (zero). Smoothness interpolates luminosity values to look more uniform to your eye using a Gaussian distribution; setting the value to zero gives a linear transition between color stops. This will be important when using the Posterize adjustment later on.

Give your modified gradient a new name such as **B-W 0% Smooth**, and then click New to save it (see Tip). Drag the new preset to the Utility Grads group. As you create new utility gradients (such as the black-white-black gradient we created in the "Gradient Map Luminosity Selection" section of the "Selections & Masking" chapter in Part II), place them here for easy use and organization. Click OK in the Gradient Editor and Gradient Fill dialog boxes to close them.

NOTE I have changed the default cyan-colored guides to magenta for better visibility. You can set the guide color in Preferences (Photoshop > Preferences in macOS, Edit > Preferences in Windows) in the Guides, Grid and Slices category.

Back in your document, create a blank layer to work on and add a new guide layout (View > New Guide Layout) with one column and eight rows, ensuring that Gutter and all other numerical settings are blank or 0.

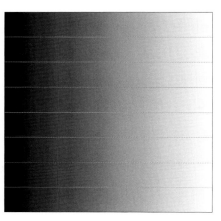

Switch to the Rectangular Marquee tool, then create a selection from the top horizontal row. If you have not previously done so, ensure snapping is on (View > Snap). Click the foreground color swatch in the Tools panel and choose RGB red (RGB: 255, 0, 0). Fill the selection area on your blank layer with the red foreground color by tapping Option+Delete/Alt+Backspace.

Skip a row, then repeat the process for green (RGB: 0, 255, 0) on row 3 and blue (RGB: 0, 0, 255) on row 5.

For row 7, you need to create a color spectrum. In the Gradient Editor, make a new gradient preset with the settings shown in the following table. In addition, set Brightness and Saturation to 100% and Smoothness to 0%. You can start from any preset you like so long as it uses 100% Opacity; it's probably easiest to choose a simple preset so you can add each stop individually.

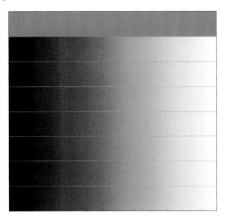

LOCATION	COLOR	
0	Red	(255, 0, 0)
16	Yellow	(255, 255, 0)
32	Green	(0, 255, 0)
48	Cyan	(0, 255, 255)
65	Blue	(0, 0, 255)
82	Magenta	(255, 0, 255)
100	Red	(255, 0, 0)

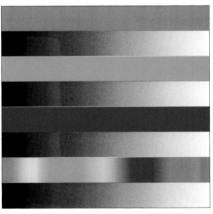

This new gradient gives you a spectrum that will repeat if you use it with the Radial gradient, and gives a full account of the primary and secondary RGB colors. Save your new preset (I called mine **Spectrum - RyGcBmR**), and use the Gradient tool to drag from left to right across row 7, the next-to-last row on your blank layer.

Name the layer with your color bars **Blend**, and then duplicate it naming the duplicate **Reference**. Use the Move tool to drag the Reference layer downward (hold Shift to constrain the movement) until it snaps to fill the even-numbered rows in Blend. Click the Lock All button with the Reference layer active to prevent it from being changed. You'll use this to compare the results of experimenting on the Blend layer so differences are easier to see.

Your layer stack should now look like this.

Turn off the visibility of the Blend and Reference layers for now, and add a blank layer between the B-W 0% Smooth layer (the gradient) and Blend layer. Switch to the Gradient tool and load the B-W 0% Smooth preset. Hold the M key to temporarily load the Marquee tool, then drag to select row 7. Release M, and drag from the bottom edge of the row 7 to the top edge so the selection gets a uniform black-to-white gradient. Repeat for the row 8. Here's what the newly created gradient layer should look like.

The reason for this is because the last two rows are spectra from left to right, so a horizontal gradient won't evenly interact with every color when we start changing blending modes. Having the black-to-white gradient vertical here ensures that each of the colors gets to blend with every level of gray.

To use this file as an experimental workbench, make the Reference and Blend layers visible again and change the blending mode of the latter. Watch how the colors behave based on how they blend with the gray layers below. You can also clip adjustment layers to the Blend layer which gives you control over the brightness, saturation, and hue of the Blend layer colors depending on which adjustment you choose. Because the adjustment layer itself does not apply a blending mode to the Blend layer, you'll still have to choose a blending mode and/or change the opacity and fill in order to see a blended effect.

Although this particular set up doesn't seem too exciting, it's kind of like a "Hello, World!" programming project meant only to demonstrate *that* something works, leaving the *how* to future efforts. It allows you to see how the fundamental RGB colors behave when blended with different values of gray. One fun variation is to place some kind of color control layer between the Blend layer and the black-and-white gradient base layer. Try a Solid Color Fill layer set to Color blending, a Color Lookup adjustment layer, or even a Gradient Map layer.

More complex and useful project files can be built from these principles. Before moving on, though, take a look through the various blending modes, including the Special 8 that respond differently to the Fill slider (the Special 8 blending modes respond differently to the Fill slider than the Opacity slider. Read about them in the "Blending Modes" chapter of Part IV, "References"). As you see changes (or no change), try to describe to yourself why the result makes sense. For example, the previous image is the result of the Lighter Color blending mode.

Remembering that Photoshop assigns a weighting value to luminosity that approximates human visual perception, then it should be clear that there is some point along a black-to-white gradient where the gray value is brighter than the color. The point where the solid horizontal color bars stop is exactly where the gray value and the luminosity of the color are identical. The spectrum along the bottom shows the same effect for every RGB color at full brightness and saturation.

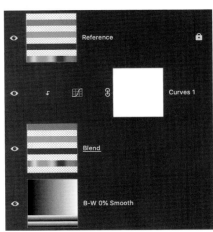

You can test the idea using a Curves adjustment layer clipped to the Blend layer.

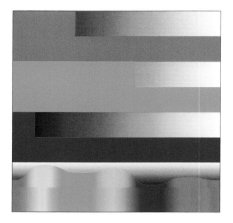

Changing the RGB curve changes the relative brightness. Check out the result of a typical contrast S curve, such as the Increase Contrast (RGB) preset in the Curves Properties panel. What changed and what is the same?

Did you notice that the "pure" primary and secondary colors did not change at all? The intermediate, mixed colors did change. This result tells you that in order to adjust contrast in an image, some colors have to change. If, instead, you return the curve to its default setting and then choose the Blue channel and drag its right-side control down to the bottom of the graph, you'll see that the blue bar does shrink until it's gone, and the blue region of the spectrum turns black.

You can also reset the Curve and then explore how self-blends work by using blending modes on the Curves layer while leaving the Blend layer set to Lighter Color. Use Multiply for the Curves layer.

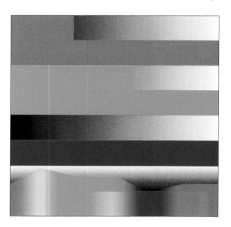
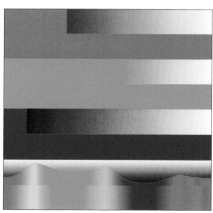

Notice the depression in the intermediate areas? Again, the color bars haven't moved. Once you've built this experiment file, see if you can approximate some of the blending mode results with various combinations of adjustment layers.

You can also try adding images or other gradients between the various layers. Use an Invert adjustment layer, also clipped to the Blend layer. Just play and see what you can discover, but always think about the results you see and ask yourself "why?"

Want to explore the difference between Fill and Opacity? Set the Blend layer to Hard Mix and turn off visibility of the adjustment layers. I have some thoughts on why these behaviors are different in the "Blending Modes" chapter in Part IV, "Reference".

Let's move on to using the experiment file to create a preset. Set all blending modes back to Normal, all opacity and blending values to 100%, ensure no selections are active, and turn off any adjustment layers. Add a Black & White adjustment layer above the Blend layer and set its blending mode to Luminosity. This is the default black-and-white conversion that Photoshop thinks you want to start with. What's wrong?

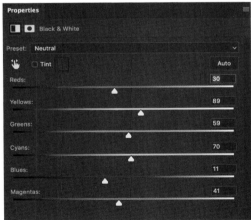

The default conversion results in red and blue getting a little lighter, and green getting darker. In other words, this is not a direct, neutral conversion of luminosity values. Using this setup, start by adjusting the Reds, Greens, and Blues sliders so those colors match the Reference layer. Then go back and adjust the secondary sliders. If you need more precision than dragging the controls provides, hold Option/Alt and then drag on the slider name, which slows down the movement of the control.

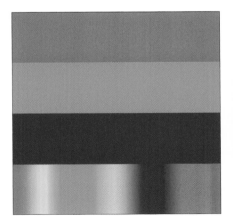

Once you have achieved a true neutral setting, save the preset for easy recall later (click the panel options menu in the upper-right corner of the Properties panel and choose Save Black & White Preset). I use this preset as a starting

point when applying a B&W adjustment layer for detailed contrast work, as in the B&W Control Freak technique from the "Color & Value" chapter of Part II, "Techniques."

How about an experiment that tells us something about how the Opacity setting works with color?

Turn off the Blend layer, and unlock the Reference layer. At the very top of the layer stack place a Posterize adjustment layer, leaving the default value setting of 4.

The solid color bars have not changed, but look at the gradients. The black-white gradient now has the expected four solid bands, but the spectrum is more complex. What's going on?

Posterize splits each channel into the specific number of levels, evenly distributed between black and white. That means each channel gets four levels in this case, which you can verify by looking at each channel individually. The reason there are not exactly 12 bars in the spectrum is because of overlap. In particular, pay attention to the Red channel being split because we created the spectrum such that RGB red occurs at both edges of the document. However, each of the channels has the same gray values, and the same amount of gray (you can measure the width and brightness of each gray bar on each channel if you like).

Back in the RGB Composite channel, slowly lower the Opacity setting of the Reference layer while watching the spectrum. At about 75%, there should be a distinct change in pattern, and the edges of the solid bars may change slightly. By 70%, the solid bars obviously are being affected, and additional banding shows up in the spectrum.

Remember that the Posterize adjustment is affecting the result of the blend, not just the content of the Reference layer. The angles that show up in the spectrum are due to the way the compositing equation handles the alpha component, and represent the dividing point between the luminosity values that Posterize has used for each channel. If that word salad doesn't mean much to you, don't worry about it. Just pay attention to the regular pattern, which means the opacity value is smooth across the entire range of colors.

RGB TRIANGLE

Of course, we are not limited to this rather simple design. Because there are three color channels, we can also build a triangle spectrum that shows a more logical mix of colors and allows us to explore interactions using patterns. This one is a little trickier and requires some precision while creating it.

To create the equilateral triangle, start with another square document (this time with a transparent background), and create a new guide layout of six columns and five rows, with zero gutter. Ensure that View > Snap is selected. With the Rectangular Marquee tool, drag out a selection as shown in this diagram.

With the selection still active, choose Select > Transform Selection. When the transform options appear, select Toggle Reference Point and drag the reference point from the center to the lower left of the selection. Moving the reference allows the selection to rotate from the corner.

In the options bar, enter **−60** for the rotation angle. With the transform still active, chose View > Rulers and drag a guide down from the top of your document to the corner indicated here. Leaving the transform active allows the guide to snap to the corner. Press Return/Enter a couple of times, then Command+D (macOS)/Ctrl+D (Windows) to deselect.

Use the Polygonal Lasso tool to connect the corners you just used, then fill with black and deselect. We're going to fill on the channels directly, and Photoshop will not add pixels to a blank channel. The black fill is there to "catch" the gradient we'll apply shortly.

We have one more trick, which is finding the midpoints of the triangle's sides. Again, drag a rectangular marquee of any width from the top of the triangle to the bottom, then drag a guide down until it snaps to the middle of the selected region—that is the half-way point of the height of the triangle, and one of the guides we previously created should intersect with it precisely on the edge of the triangle. Deselect the marquee.

And now you know a stupid Photoshop trick: how to create an equilateral triangle. That's an accomplishment!

Okay, remember how I said to create a preset of the 0% smooth black-white gradient? Select the Gradient tool and load that preset up. Open the Channels panel, and select the Red channel. Drag from the apex of the triangle to the center point of its base. It should be white on the top, black on the bottom.

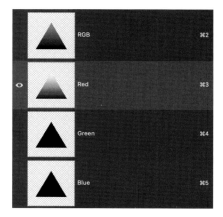

Repeat for the other two channels: Drag from the lower-right vertex to the left side's center point for Green, and from the lower-left vertex to the right side's center point for Blue. You may hide the guides now if you like. Click back on the RGB composite channel, then rename the triangle layer to **Base**. Your final triangle will show saturated channel colors in its angles and close to 35% gray in the exact center.

Add a Curves adjustment layer above that and set the Curves blending mode to Hard Mix.

Cool, huh?

Now tweak the curve and watch the pattern change (try the Solarize preset we created in the "Helper Layers" chapter of Part II, "Techniques"). Remember that setting a blending mode on an adjustment layer is effectively a self-blend of everything below the adjustment (or what the adjustment layer is clipped to).

Variations you can try with this setup:

- Duplicate the base triangle and use Cmd/Ctrl+I to invert the colors.

- Duplicate then rotate the triangle to see how different colors interact with various blending modes as well as Opacity and Fill settings.

- Add adjustment layers between the triangles or clipped to the top one.

- Use a Posterize adjustment in various places (keep the levels settings fairly low).

- Use this to explore color interactions, generate palettes of color chips, and so on.

HUE WHEEL

Another favorite of mine that probably looks more familiar is a hue circle. This takes advantage of the spectrum gradient we created. In another new document sized 2000 px by 2000 px, create a guide layout of two columns and two rows, so that you get an intersecting guide right in the middle of your canvas. Switch to the Elliptical Marquee tool, ensure snapping is on, then hold Option/Alt+Shift while you drag out from the center guide intersection so that most of the square canvas is taken up with the selection.

Select the Gradient tool, load the Spectrum - RyGcBmR preset we created earlier, and select Angle Gradient. On a blank layer, drag from the center to either the top or right of the selection area. The direction in which you drag places red along that axis. In HSB color space, RGB Red is considered 0°, while green is 120° and blue is 240°. For this version, I chose red to be at the top for consistency with the RGB triangle.

Name your new layer **Hue Wheel**.

With the selection still active, add a blank layer above your hue wheel, then use the B-W 0% Smooth preset with the radial fill gradient (select the Reverse option) and drag from the center to the edge of the selection. This should give you a gradient from white in the center to black at the circumference. Name this layer Luminosity.

Create another blank layer, then edit the gradient to replace the white color stop with fully saturated red (Hue: 0, Saturation: 100, Brightness: 100). Drag

again from the center to the circumference, creating a gradient with red in the center and black at the edge. Name this layer **Saturation**. Here's the layer stack so far.

Turn off the Saturation layer, and set the Luminosity layer blending mode to Luminosity.

With your fresh, new experiment file ready to go, group the Luminosity and Saturation layers, then start adding adjustment layers and blending mode changes as before. This particular version allows for incremental rotations so you can align virtually any combination of colors. Adding saturation and luminosity layers enables you to see new patterns based on those characteristics in addition to opacity, fill, blending, and so forth.

Honestly, this one is also just a lot of fun to play with. The layer names are just to keep track of the original settings, but please do try all the different blending modes! Duplicate the Hue Wheel layer and rotate it, add some Posterize and other adjustment layers, create flat copies and apply filters–go nuts! Part of the value of these exercises is just to have fun and see what happens. Sometimes the results will be quite boring, but other times they may spark a new idea or give you a creative boost.

SOLVING PROBLEMS

I tinker with these and many more experiments all the time, building little files to investigate certain questions. The methodology here is similar to any scientific endeavor in that I take time to think about what I want to explore, and ask myself questions about how best to reduce the variables. The experiments themselves are not meant to be pretty, but they *are* meant to let me see things in an unambiguous way. Sometimes that means making multiple experiments. Although the projects I've talked about here focus on the RGB display spectrum, I also dive into virtually everything I can find to play with in Photoshop, including filters, plug-ins, tools, and any other element that is exposed in the user interface.

Sometimes these experiments help me reverse engineer certain techniques, such as simulating classical realism style painting. Other times they show me the limits of some function or technique, which both sets a boundary and poses new questions: What if I want to go further than the technique allows?

The general process is to think about the challenge ahead and then to break it into smaller tasks. Often times, the value of an experiment—including a failed one—is how it helps shape your thinking about a problem, or expands your vocabulary regarding other situations.

We can obviously go far beyond tinkering with color and brightness, and use various filters. A classic example is using Difference blending mode with a slightly altered version of some layer content to grab the differences as a selection, as we did with in the "Hue/Saturation Selection" section of the "Selections & Masking" chapter in Part II. Instead of altering hue, what if we slightly blur a layer? The result is that high-contrast areas are now low-contrast, so we end up with a display of high-contrast edges that can be selected and used as a mask.

That mask is a great starting point for selective sharpening.

Moving deeper into filters, let's say you want to describe the distortion effects from using the Path Blur feature in Blur Gallery. Applying a path blur to a photo is a great place to start, but how do you know if you like it? How does the blur change as the paths are changed? What would you use to show the changes, and better yet, how would you teach yourself better control over those changes?

First, we know we want something that doesn't resemble our own art work so we can evaluate the effect and controls on their own without being influenced by whether we like the result. We also know we want to reduce the amount of

variables to only the essential. The variables we typically have to work with are color and brightness, so what minimizes both? A layer filled with 50% gray meets that description, right?

But performing a task that moves pixels around is boring and pointless if you can't see those pixels. We can add some visible pixels with the Noise filter (Filter > Noise > Add Noise). A modest amount will do, so let's fill the gray layer with 10% monochromatic and Gaussian distribution.

Next, we can apply some blur (Filter > Blur Gallery > Path Blur).

Now we have a baseline for seeing the exact effect, and we can build from there. Changing the path lets us see the scope of the effect and how certain controls behave. You now have another entry into your vocabulary—you understand something more about the Path Blur feature. You just discovered a new hidden power, but that power is *yours*. It does not belong to Photoshop.

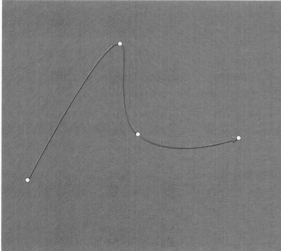

The experiment is useless without context, though. How do you fold this new power into your work? Would it be good for building textures? Can you control it well enough to imply complex motion?

NOW WHAT?

We're going to apply general problem-solving skills in the next few projects, building on the material provided in Part II, "Techniques." The purpose of going through experiments at this point is to provide you with a way to address challenges you will face in your editing and retouching, by giving you a way to reset your mind. As you identify the tasks at hand, you are likely to discover that the instructions for a given technique don't exactly solve the issue. You cannot simply type in values for certain dialog boxes or exactly follow provided steps when you're dealing with images that are vastly different than the examples provided.

Working on experiment files when you're not under a deadline or don't have an important project in front of you allows your familiarity with the features, techniques, and tools to grow. You'll recognize patterns and behaviors more quickly. You will start to see new possibilities simply because your mind is making connections. Experiments give us more points of reference, and more points mean more pathways to travel.

And sometimes we just need a break. Building experiments to solve problems is great, but we do need more. Build experiments to play, to kill time; the things you discover will leave little seeds in your imagination, and when the time is right those seeds will begin to sprout.

In the projects that follow, I will not be providing details on every single step because the point is to share how I think about approaching the images. All of the projects rely on techniques previously described in the book, but they also include additional tools and methods I have not talked about earlier. The reason for this is to show that the material provided is not meant to stand alone and solve all of your imaging problems; they were always meant to expand your Photoshop vocabulary, to empower you as the artist. That means it is on you to mix this new knowledge with whatever else you can find, what you already know, and what you will learn when you put this book down.

BASIC PORTRAIT RETOUCHING

The next three sections are all about seeing various techniques in action. We'll start with a basic portrait retouch that introduces frequency separation, then move to something a little more complicated with stylization and compositing. After that, we'll look at Frequency Separation as a technique and how we can augment it with blending modes and adjustment layers.

Let's revisit this portrait of a dancer friend of mine. You tried a basic application of dodge and burn back in the "Dodge & Burn Methods" section of the "Dodge & Burn" chapter in Part II. It's worth going into a little more detail here.

Before we do anything else, however, let's figure out the things we want to accomplish with this portrait. I find that either writing down a small list or making annotations on an image helps me keep focused and organized. In this case, I'm going to use both annotations and a list that breaks down the various tasks.

When first approaching an image, I may not have a final vision in mind, but I can identify some elements to address. Here's a list of what I can immediately think of for the dancer portrait:

- Darken the background.
- Clean up the stray hairs.
- Smooth out the brightness variations on her skin.
- Even out the skin color.
- Add some highlights to her eyes.
- Get rid of the odd shadows and textures on her neck.

Just putting a few things down should suggest some techniques right away, such as dodge and burn to deal with the eye highlights and skin variations, for example.

There is no required order for these tasks, but conventional wisdom says to start from big features to small details. For this project, however, I'm going to jump around a little because I want to show you the various techniques in play rather than giving you a workflow to follow.

The simple thing to take care of is the background, and I used Content Aware Fill on a new layer to take care of the gap left by the handheld backdrop. To darken the rest, I used a solid black color layer set to about 75% opacity. Both of these layers were grouped together, then I used Select Subject to create a loose mask of the model, and applied that to the group. To give her a little depth, I added to the group a Gradient Fill layer set to Linear Dodge (Add) at 20% Fill. Don't worry about the gradient colors used; I just tried a few combinations until I found something I liked. All I wanted was a tiny bit of subtle texture behind her.

AM I CHEATING?

You see I'm using some automated tools rather than the manual approaches I talk about earlier in the book. I'm not being lazy; I'm using the tools to their best effect. For the background correction, there was no need for detail or intricacy, so the result from Select Subject was just fine. Remember that the information I'm sharing is not to show supremacy of certain techniques; it's to increase your breadth of experience and faculty for Photoshop. If an automated tool gets you 90% of what you need—or 100%—you absolutely should use it. It's not cheating; it's getting your tools to work for you!

Looking next at the skin and hair, I added a single pass of Frequency Separation (which you'll explore in its own project later in this chapter). Frequency Separation is a method of isolating color information from detail information, allowing you to work on these elements individually. On the high-frequency layer, the most usual approach is to use the Clone Stamp or Healing Brush to remove small blemishes. Take a look at the high-frequency layer before and after (I turned off the background changes to make things more visible).

Notice the small details, such as some hair strands and a few skin details, have been removed. I tend to use the Spot Healing Brush; in this case, I used a brush size that is just a little larger than the features I need to address (say, a skin blemish or speck of makeup). But I also like to use the Luminosity blending mode when possible. For this kind of scenario, tiny features stand out because of contrast that includes differences in brightness. Replacing or smoothing the brightness changes makes some features much less noticeable without obscuring or removing the feature itself.

The regular Healing brush is also very effective, but does require the extra step of choosing a sample region. However, this gives more control and I prefer to use it for strongly directional texture such as hair. Looking at the stray hairs, most are lighter than their surroundings, which suggests using the Darken blending mode. This preserves more of the base texture while removing the brighter regions. I turned off the adjusted background to make the changes to flyaway hairs more visible.

This blending mode approach is also well suited to dealing with the flyaway hairs that invade the background.

REMBRANDT PORTRAIT

Back in Part II within the "Dodge & Burn Methods" section of the "Dodge & Burn" chapter, we looked at a few different approaches to adjusting contrast in an image manually. In this project, we're going to choose various techniques to achieve different goals. For this project, I wanted to let the final result be influenced by Dutch painting master, Rembrandt van Rijn. His work is typified by rich, warm colors, a spartan background, and a sense of realism in portraying his subjects. The mechanics of his look were frequently accomplished by limiting the color range, using a single light source, and implying detail rather than painting it directly.

My starting image is a portrait I shot specifically for this effect. Because I can visualize the end result reasonably well, I am left with choosing techniques to support that goal. Here's a brief list of tasks to accomplish:

- Reduce the overall brightness.

- Apply a strong, warm overall tone.

- Draw focus to the center of the face.

- Clean up various details and skin blemishes.

- Replace the background.

- Apply a texture.

Because I would be replacing the background, I wanted to start with a mask. My initial attempt at using the Select Subject option of the Quick Select tool was really good, but missed some of the hat and made the edges a little rough. Using the Gradient Map Luminosity trick from the "Gradient Map Luminosity Selection" section of the "Selections & Masking" chapter in Part II allowed the tool to make a much more complete selection. The secret is to ensure the adjustment layer is active so the AI has something to look at.

NOTE As this book went to press, Adobe updated the Select Subject tools with Sensei AI, and they are amazing and magical! That notwithstanding, the techniques here are sound and useful because even magic sometimes fails.

With the mask applied, I just needed to add a black layer for the background until I was ready to composite the model with my final scene.

From here, I wanted to apply some rough shading around the entire model. The fast way to do this is with a new layer set to Overlay (ensuring the brush is in Normal blending mode). I was not worried too much about introducing color artifacts, so I had some liberty to really darken things quite a bit. If I had wanted to take more care in preserving color and avoiding harsh transitions, I would have used the two Curves adjustment layer method discussed in "Dodge & Burn Methods". My soft round brush was set to around 8% flow and is about 1/4 the size of the face, which still required some care to prevent building up too much dark density. In just a few broad strokes I had the overall shape I wanted.

For the next pass, I wanted to shape the face and clean up some of the skin variations. This required another Overlay layer, but also a helper layer to show only Luminosity ("Helper Layers" chapter in Part II, "Techniques"). The Luminosity layer gets toggled on and off during the process, so make sure you are always painting on the correct layer—remember to use good layer naming conventions!

For final contrast details, I used a Soft Light layer and just went around making little highlights and shadows, in particular along fabric seams and around the eyes. Soft Light gives just a little different effect than Overlay, providing a touch more contrast to work with.

This is about as far as I wanted to go with the model alone, so after a little spot healing to clean up some dust and stray pixels it was time to group the

correction layers together and copy the mask from the subject to the group. I planned to copy a flattened layer to my background composite, so I wanted to ensure that stray corrections would not be caught up. The subject was completely isolated on the merged layer, but all the changes were in place. I was ready to easily paste this layer into my new scene.

I prepared the basic scene, which is a composite of two images with a single, admittedly sloppy mask to blend them. The subject covered most of the elements that I didn't want in the final work, such as the plates and coffee pots that don't really seem to fit in a portrait from the late 1600s.

Since the plan is to darken the background quite a bit, there's no need to fuss over details here. I added a dark tobacco color via a Solid Color fill layer set to Normal and 70% opacity to set the color tone, then I added a Levels adjustment to make everything darker.

With some context for lighting and overall feel in place, I refined the model. I added some color first by creating a Solid Color fill adjustment layer and clipping it to the cut-out model. Sampling a color from the edge of the fire gave me a great tone to start with.

Vivid light will be a great choice for blending this kind of atmospheric color because it combines Color Dodge with Color Burn. The initial result is going to be odd and harsh, as you can see.

There are two key controls to deal with this. First, adjusting the color itself gives a better preview of the final result. Open the Color Picker and first adjust the Saturation (S) and Brightness (B) controls. This is very much a subjective adjustment, because predicting an exact color to use is going to be nearly impossible. Selecting a color from the edge of the fire is only meant to be a starting point.

Color Dodge and Color Burn are among the Special 8 blending modes that respond differently to the Fill slider than they do the Opacity slider. Vivid Light is a combination of the two, so it is also part of the Special 8. Lowering the Fill value is the second major control that helps the model look more like he fits into the environment. Here, Fill is reduced to about 50%.

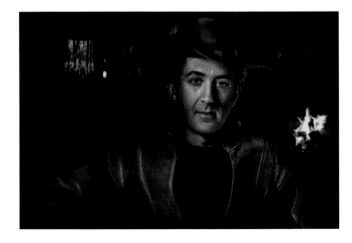

The model needs a little glow from the ambient light, and that calls for Color Dodge. Each shoulder gets a little splash of color, also sampled from the fire, but because the lighting intensity is different on each side, I chose to use separate layers for each side. I also created a mask from the cutout model's outline, and then inverted it to constrain the color to only the model. Each shoulder gets a slightly different Fill and Opacity value, but uses the same color.

To finish up the composition, a scratched copper texture set to Overlay blending provided some extra grit, but it has its own color that pushed everything too dark. I wanted the texture, but not the color. I removed the hue easily by clipping a Hue/Saturation adjustment layer to the texture layer, and then dragging the saturation slider all the way to the left.

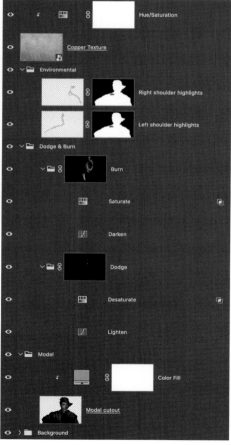

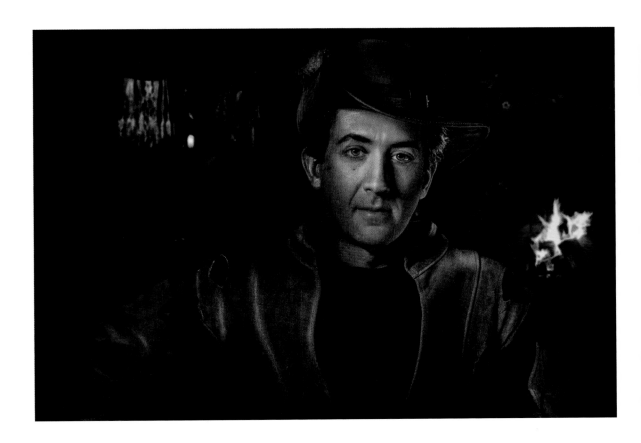

FREQUENCY SEPARATION

Frequency Separation is an extremely popular and powerful technique, having grown out of a need to isolate different characteristics for more targeted editing. While it's been around for years in professional (and let's face it, geek) circles, it is mostly seen as a tool for working on facial skin in portraits. The idea is pretty straightforward to describe: By splitting high and low frequencies in an image, it is easier to work on each independently without affecting the other. This enables faster, more precise editing, and in some ways is more flexible than working on the base image by itself.

However, most people are left wondering what frequencies are in the first place, and once that is cleared up, how do you choose the range of frequencies you need to work on?

I want to give you some background on the name of the technique, and then use that working definition as a way to expand into a somewhat novel approach. *Frequency* is a term that relates the idea of an event or occurrence happening repeatedly through time. A ticking clock, the sun rising and setting, and even heartbeats are all examples of frequency when you measure how often they happen over the course of a year, a day, or a second. Frequencies also measure very tiny things like sound waves and light, and we observe the effects as pitch and color.

When we talk about frequency in the visual domain, we are talking about patterns and scale of things we can see. This applies to objects as well as textures and small features in photographs. As noted above, skin has a so-called high frequency we can examine because of pores, small blemishes, and even fine hair; so, *high* is about texture and detail, while *low* is about color and shading.

What makes it high is not the size of the feature in the real world, but the relative changes in color and brightness that allow us to see details in an image. Because digital images are made up of pixels, the number of pixels involved in a transition from bright to dark is a basic way of describing frequency.

High frequency implies the change from bright to dark occurs over a very small number of pixels. So a *low frequency* feature is one that occurs over lots of pixels. An example of high frequency would be the transition from white to black being a hard edge or boundary. Low frequency is a gradient transition. With a combination of filtering and blending modes, Photoshop lets us treat these frequencies differently.

This is incredibly useful because it often happens that frequencies overlap. Again, the pores (high frequency) in a model's skin (low frequency) pretty much always go together. Note that highlights and skin blemishes can be either high or low frequency depending on size and edges, so when considering how to set up your tools, think about the size of the boundary or transition.

Ok, enough background! Let's get to the techniques and how to make them work for you.

Let's start with the most popular example of skin retouching. Take a moment to think about the size of the features you want to correct. In this example, the pores are only a few pixels across, so keep that in mind as you choose your settings. Once we have the elements in place, I'll explain the technique a bit more.

Also, it's worth pointing out that there are many variations on this technique. I'm going to start by showing you a common, basic version with the addition of my choice to use tool blending modes while working with some of the tools.

Start by duplicating your background image two times. Name the top copy **High** and the other copy **Low**. We are going to first create a version of the image that has no high frequency detail.

Turn off the High copy, select Low, and choose Filter > Blur > Gaussian Blur. The goal is to apply just exactly enough blur to remove the details you want to edit. Typically, the blur radius you select should be 0.5 to 3 times the size of the feature, so a pore that takes up 4 pixels would require a blur radius of anywhere from 2 to 12. When the feature is low contrast, you can rely on smaller radius values, but increase a little if the features have more contrast. There are some caveats to be aware of, which I'll discuss a little later on.

Next, select the High layer, make it visible, and then change the blending mode to Linear Light.

With the High layer still active, choose Image > Apply Image and choose Low from the Layer menu. Use the following recipe:

- Blending Mode: Subtract
- Invert: Deselected
- Scale: 2
- Offset: 128
- Preserve Transparency: Deselected
- Mask: Deselected

In plain language, Apply Image takes the current image (an unaltered copy of the original) and removes the blurred version, including hue, saturation, and brightness. Photoshop then divides the result of the initial blend by the Scale factor, and then adds the Offset value (in units of grayscale brightness) to that output. In simpler terms, Photoshop subtracts the Low layer from the High layer, divides that result by two, and then adds back 50% gray. Dividing by two reduces the color contributions, but also darkens the image significantly. Adding 50% gray back increases the brightness without adding color.

What's left is something that looks similar to using the High Pass filter, which is commonly used for sharpening.

The result is that you have two separate layers that combine to give you your original image back. The High layer contains only detail information. If you switch its blending mode back to Normal, you'll see that you've isolated the details and lost both color and brightness values. I like to add the blur pixel value to the High frequency layer name in case I need to use another frequency separation pass.

Next, duplicate both High and Low frequency layers, and clip each to its original. Set the clipped layer blending modes to Normal, then lock the original High and Low layers to prevent editing. Group all four layers and name the group Frequency Separation.

These clipped layers allow you to work non-destructively, giving you the option to reduce opacity or mask some of the corrections later on.

Now the question is whether you should work first on the high- or low-frequency layers. Honestly, I go back and forth depending on the image. For this example, I started with the Low layer to try and distinguish between natural skin variations and blemish colors. My goal in such cases is not to make perfect skin, but to make the model look natural and realistic. Starting by evening out the color helps me decide which skin features to retain, which to minimize, and which to remove.

For a long time, my preferred approach was to select areas with the Lasso tool, then run Gaussian Blur on the selection, using a low value but repeating it several times. More recently, I've switched to using the Mixer Brush to blend colors because it feels more intuitive, and prevents some odd boundaries you get from the edge of the lasso selection. There is a caveat, however: It becomes extremely easy to mix everything to the point that you destroy the character and produce a plastic sheen or other bizarre texture. The rule of thumb is to ease into the blending! Go slow, use your power with restraint.

For blending, I use a round, soft Mixer Brush with the following settings:

- Load Brush: Deselected
- Clean Brush After Stroke: Selected
- Wet: 20%
- Load: 20%
- Mix: 10%
- Flow: 10%
- Sample All Layers: Deselected

Remember to work on only the copies of your High and Low layers!

The brush size should be a little on the large side at first. For portraits, I like to use the model's eyeball as a rough gauge. My first pass around the image is done very lightly to address harsh transitions and edges, then working smaller to discolorations, and finally blemishes. I find working large to small sometimes reduces the effect of blemishes, and when working towards a natural result you may not have to do much more than smooth over the color variations.

The discoloration from blemishes is pretty much gone by this point, leaving small defects in the skin to deal with.

Now you can work on the High copy layer with any number of tools. An easy one to start with is the Spot Healing Brush with a 100% hard edge, sized to just a little larger than the feature you want to heal. That means you will be constantly adjusting the size. Just remember that the "feature" may not be an entire blemish; the brush should only have to deal with small details. Work as small as reasonable.

I also prefer to start with the Spot Healing Brush set to Luminosity blending. In many situations this won't be very noticeable because the layer is already mostly gray, but it does help prevent stray color pixels from showing up if you use a large radius for the blurring step. However, there are two other blending modes that are really helpful for fine details. When there is a dark feature surrounded by lighter colored details, try Lighten blending mode on the Healing tools.

Notice that the darker patches are now gone, but the lighter hairs are still present on the skin. Similarly, using Darken when a light feature is surrounded by darker areas works well to preserve the local texture.

You can also use the regular Healing Brush, Patch tool, or Clone Stamp. Each has its own pros and cons, and the Clone Stamp has all the normal tool blending modes available. There is no real right and wrong here, so try each of them out to see when you might use each.

A word of caution, though: Ensure you are always working on the correct layer, and check the tool options so that tool is not sampling from all layers. If something looks horribly wrong, check the Sampling and Blending Mode options as well as your working layer!

VARIATIONS

There are lots of variations available with this technique. Using the Mixer Brush on the low-frequency layer tends to change all the elements of color, including moving brightness around. This can cause unwanted changes in the shape of facial features. You can correct this with subsequent use of dodge and burn, or you can avoid some of it by separating out the color and luminosity layers. If you want to try this out, you can isolate Color and Luminosity layers as described in the "Helper Layers" chapter in Part II, "Techniques." You will want to treat the Luminosity layer with dodge and burn techniques rather than the Mixer Brush or blurring tools. Just be warned that this approach takes a lot more attention to detail and patience, because you are working on three different layers.

Another option is to try different kinds of blur. A popular method that seeks to preserve edges uses the Median Blur filter. This is really great for dealing with architectural and textile photos where you need to move large blocks of color around within the bounded areas.

There is something to consider when choosing your blur size, too. Different types of textures or detail may not be completely isolated from the color layer, so you should get in the habit of checking out the results of your blurred color layer. If some of the detail is left behind because the edge is larger than the radius you set for the blur, you risk damaging that texture by blending or giving it additional blur. On the other end, if you use too large of a blur radius, you don't have much wiggle room when trying to correct smaller defects. And at some point the blur is so large that it will not line up properly with the detail layer.

That's why I suggest you get comfortable with the idea of using multiple frequency separation passes for different textures and amounts of detail. This will be more common when dealing with images where you have closeups of both skin and fabric, or multiple textiles that need to be retouched.

PART IV
REFERENCES

Not every blending mode or adjustment layer listed here is found somewhere in this book. After all, you need to do some exploring and discovery on your own. As you look over these entries, try things out and keep some notes—and share what you find!

ADJUSTMENT LAYERS

If images in Photoshop are just well organized data, then adjustment layers are the knobs, dials, and sliders you use to adjust that data. Adjustment layers take in image information, apply some math, and kick out the results on the other side. The controls on an adjustment layer let you change some parameters of that math to some extent, and can affect both individual pixels as well as how those pixels relate to each other.

There are 25 unique layer adjustments in Photoshop, 16 of which are also available as adjustment layers that you can add to your layer stack directly. Another three are fill layers, and the remaining six are "destructive" adjustments that you run like filters on a layer.

Adding an adjustment layer is simple, but of course with Photoshop there are multiple options. At the bottom of the Layers panel, notice the small circle icon that is half filled; this icon marks the "Create new fill or adjustment layer" button, and it does exactly what it describes. Click the button to open a text-based menu from which you may choose one of the 16 adjustment layers. When you add the layer, you may be presented with a dialog box that lets you choose settings, or the Properties panel will change if you have it open (Window > Properties).

For added fun, there is a dedicated panel under Window > Adjustments where you can see all of the adjustment layers as icons. You will also find the adjustment layers under the Layer > New Adjustment Layer menu. There is no difference in choosing from this menu or the Layers panel.

With all three options, you may hold Option (macOS)/Alt (Windows) while making your choice to bring up the New Layer dialog box before adding the layer. Here, you can set the layer name, indicate whether the new layer should be clipped to the layer immediately below it, and set the layer's color, blending mode, and opacity. Choose this method when you are recording actions!

Layer adjustments (notice the ordering of the words? It matters!) are located under the Image > Adjustments menu (see?). When using this approach, you will apply the effects of the adjustment destructively to the selected layer or layers. You will also find the six additional adjustments in this menu. Several layer adjustments have shortcuts by default, including my favorites, Curves Command (macOS)/Ctrl (Windows)+M and Levels (Cmd/Ctrl+L).

You may wonder why there are so many different options when in reality they all deal with brightness and color in some way. The answer is this:

Each adjustment gives you a different way of manipulating image data.

Imagine the differences between a computer mouse, touch pad, and drawing tablet. Each of them lets you move a cursor around and click on elements in an interface. But each has a unique way of letting you accomplish those tasks,

with more or less control. Where the mouse lets you move and click, a touch pad adds gesture controls to give more complex interactions. And a tablet can enable pressure and rotation through a stylus. It's not just a question of control, however; it's also about perception.

Consider Curves and Levels. Both let you reassign input values to new output values. Levels does this linearly across the value range, while Curves gives you more discrete control. Everything you can do with Levels can be replicated with Curves, but not the other way around. So why would you use Levels at all? Because the interface is more direct and obvious, for one thing. For some, it's simply a matter of preference. I almost never use Levels outside of working on masks, for example, but there's no real technical reason for the choice—it's simply a habit at this point.

ALL THE BUTTONS!

Well, not *all* the buttons, but you should be aware of these buttons in the Properties panel that accompanies each Adjustment layer. Along the bottom of the panel are five icons:

- Clipping toggle
- Reset To Previous State
- Reset To Default
- Visibility
- Trash

Note that these are not the official Adobe names, because the popup descriptions are *looooong*. The purpose of each of these is fairly obvious, but they're often overlooked by people working with Adjustment Layers. They are really helpful, however, and I do recommend you get familiar with them and use them in your workflow.

In the upper left corner of the Properties panel for Curves, Hue/Saturation, and Black & White you'll find the Targeted Adjustment Tool (TAT). This is an on-canvas tool that allows you to manipulate the selected adjustment value by dragging directly on the canvas. For example, when you select the tool with a Curves adjustment layer active, dragging on the image produces a control point on the curve that represents the luminosity under your cursor. Clicking adds the control point to the curve, and then dragging up or down adjusts the point.

In the Hue/Saturation layer, dragging left or right with the tool adjusts the Saturation slider. Similarly, dragging horizontally on a Black & White layer adjusts the slider for the principal color under the pointer. Easy!

Other adjustments do give you quite a bit more control, though, and while some of them may look redundant, they all have a place in the Photoshop universe. I highly recommend giving each one a try with a few different images, especially anything you've not used before. While the distinctions between several of the adjustments may not seem that useful at first, the important thing is to build your experience with different ways to accomplish your goals in Photoshop.

Each of the following entries gives you some basics about the adjustment, a practical use, whether it can be used as a Smart Filter, and more. Where applicable, additional options and considerations are included, such as limits on bit depth or color mode, and tips on combining different tools. This section is not meant to be exhaustive and authoritative, but instead to be practical and useful for photographers.

BRIGHTNESS/CONTRAST

- Available both as an adjustment layer and under Image > Adjustments.

- Can be used as a Smart Filter.

The Brightness slider expands the highlights in your photo when moved to the right, and expands the shadows when moved to the left. Contrast is similar to Levels in that it expands or contracts the total range of values. When moved to the left, tones in your image become more muted and tend towards neutral values; when moved to the right, those tones become more saturated and dynamic.

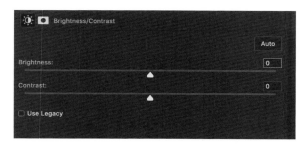

In standard mode (with Use Legacy deselected), the controls are proportional to the existing brightness and contrast in the image, similar to Levels and Curves. That is, the sliders are nonlinear and operate based on relative values available in the image. This is better for photographs and gives you more

latitude in making fine adjustments, as well as helps avoid clipping highlights and shadows.

Legacy mode is linear and uses absolute values, which is more useful for working with masks (or preparing an image to create a mask). In Legacy mode, all pixel values are equally shifted and this can easily result in clipping.

The Auto function attempts to evaluate your image and apply settings to maximize dynamic range while preventing over-saturation and compression in the shadows and highlights. Brightness/Contrast has no presets or other controls aside from an Auto button, making it less useful in a commercial setting where repeatability is critical. While there is nothing wrong with this adjustment, I tend to prefer Curves or Levels simply because they are accessible with standard keyboard shortcuts and offer more flexibility with presets.

LEVELS

- Available both as an adjustment layer and under Image > Adjustments.

- Can be used as a Smart Filter.

Levels is one of the two critical adjustment tools for contrast, giving you access to manage luminosity range and value, and to some extent color balance. The Properties panel shows a histogram and two sets of sliders. The top controls manage Input, effectively allowing you to remap the black and white points in your image to the values set in the Output section. Typically, Output will stay at 0 and 255, meaning the Input sliders will map specifically to black and white. In some cases, you may wish to change this range either for stylistic reasons, or to adjust ink density for printing.

The midpoint slider manages the transition from black to white by moving the middle gray assignment value. The readout for this slider is given as a gamma value, ranging from 0.01 to 9.99, with 1.00 as the middle between the inputs. This slider is dynamic in that it will maintain its relative position between the end points as you move them.

For the mathematically inclined nerds, the *gamma* readout (customarily represented by the Greek letter γ) is an exponent, given in the following equation:

$$V_{out} = (V_{in})^{\gamma}$$

V is the luminosity, so this says the output luminosity is equal to the input luminosity raised to the power of the γ value. The reason the midpoint slider

uses this kind of value display is to avoid confusion with the discrete end points which read actual luminosity values, while the γ reading is a relative value. Adding to the fun is that the γ value is nonlinear, so the rate of change in the slider value is faster to the right, and slower to the left. You don't have to know how the number translates to luminosity, only that values less than 1 darken your image, and values greater than 1 make it brighter (a value of 1 leaves the image unchanged).

Levels comes with a handful of presets that are cleverly named things like Brighter, Darker, and Increase Contrast. If you are also clever, you'll figure out what they do. You can save and load presets from the panel menu in the upper-right corner of the Properties panel.

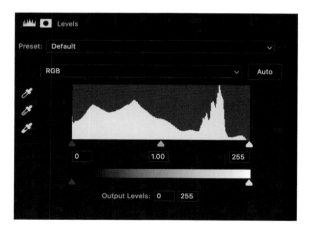

On the same menu, there is an option to Show Clipping For Black/White Points. Setting this option enables the clipping display whenever you move an input slider. Instead of setting this option, though, I strongly recommend using the temporary modifier of holding the Option/Alt key while dragging. This way you get the best of both worlds.

On the left of the Properties panel are three eyedroppers for setting the shadow, midtone, and highlight values. Selecting one of these tools then clicking a point in the image tells Photoshop to use the point you chose as the value for that input slider. For example, to set the black point in your image, click the black eyedropper and then sample the darkest point in your image. Hold Option/Alt while clicking to preview the clipping results. The black and white point sliders will not show a change in the Layers panel, but the histogram may

show signs of being expanded by displaying gaps between luminosity values. In order to move the clipping points out, you will need to resample or reset Levels using the Reset button at the bottom of the panel.

There is also an Auto button that will apply certain settings automatically. Holding Option/Alt while clicking the button opens the Auto Color Correction Options dialog box. This is the same box you'll find with the Curves adjustment layer, and has several features. Keep the Levels histogram visible as you work with these options to see how it behaves.

NOTE When using the Auto Color Options dialog box, you must have previously selected the adjustment icon and not the layer mask! The layer mask is selected by default whenever you select an adjustment layer, but with the mask selected the Color Picker will sample from the mask, not the image. If you try to use the Color Picker and things turn all white (or are otherwise unexpected), cancel out of the dialog box and click the icon to highlight it, then start over holding Option/Alt while clicking Auto.

- **Enhance Monochromatic Contrast:** All color channels are composited for luminosity and an optimum setting is applied to all color channels equally. This option is intended to increase contrast without shifting color at all. This is the same as Image > Auto Contrast.

- **Enhance Per Channel Contrast:** Each channel is considered independently, with the black and white points set based on that channel's histogram. This option is likely to cause color shifting, so is typically best applied either after your image has been neutrally balanced or when you know there's a slight overall color shift. You are likely to need additional color corrections with per channel options. This is the same as Image > Auto Tone.

- **Find Dark & Light Colors:** The composite values for darkest and brightest colors are used for maximum color contrast. This is different than luminosity, which simply looks at the total histogram as opposed to evaluating the actual color luminosity. This option is the same as Image > Auto Color.

- **Enhance Brightness & Contrast:** This AI-driven option uses content-aware evaluation of bright and dark areas. It's a good choice for images that already have a good luminosity histogram but may need some color boosting. It is now the default option for Auto in both Levels and Curves.

- **Snap Neutral Midtones:** Select this to allow Photoshop to set the midtone using a neutral color from your image rather than the default 50% gray. This option is available for the first three Auto methods and lets you select the value by clicking the Midtone swatch under Target Colors & Clipping.

- **Target Colors & Clipping:** These three swatches are available when you select one of the first three algorithms. Clicking these opens up the Color Picker dialog box, which then allows you to choose a color from the image or the dialog box. Setting the shadow, midtone, and highlight values yourself gives you additional freedom to control the process, even while enabling the automation tools to do their job.

Clipping values are essentially the black and white point sliders, but within Levels, they actually expand the histogram without moving the control points when using the first three algorithms. This means you can't go back and move the points outward unless you reset the adjustment layer.

For each of the first three Auto methods, the histogram is expanded in the Levels Properties panel. You can see gaps in discrete values if the adjustment is extreme enough, especially with 8-bit images.

CURVES

- Available both as an adjustment layer and under Image > Adjustments.

- Can be used as a Smart Filter.

This is the main workhorse adjustment, found in virtually every professional workflow and probably the single most useful tool available in your Photoshop arsenal. Curves is able to accomplish most of what can be done with other adjustments; the limiting factor is your patience to discover the tool's various tricks and techniques. I think it's safe to say that most intermediate to advanced users drop Curves into a layer stack almost by reflex.

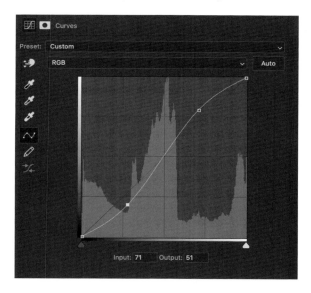

In essence, Curves behaves like Levels in that it allows you to map input values to output values, and the most general use for this is to adjust contrast and

brightness. Levels, however, is a graphical set of adjustments with a single control for gamma (midpoint) tweaking, whereas Curves is a parametric view of the luminosity that allows for very detailed adjustments all along the range of available values.

The default view of Curves is a straight line with a slope of 1, overlaid on a histogram of the input luminosity (that is, the luminosity "visible" to the Curves adjustment from a composite of the underlying layers).

The value readouts in the Curves Properties panel are in luminosity values ranging from 0 to 255. It is possible to type values directly into these boxes when a control point is selected. If you have a hardware controller, such as the Monogram Creative Controller, Loupedeck, or PFixer MIDI controllers, then you can set a knob, dial, or slider to adjust these values while you work—just something to keep in mind if you are of a more production-oriented bent!

For a detailed discussion about practical applications and a demonstration of exactly how Curves behaves, visit "Seeing Images as Data" in the "Welcome" chapter in Part I.

EXPOSURE

- Available both as an adjustment layer and under Image > Adjustments.

- Can be used as a Smart Filter.

Used to adjust the dynamic range and gamma of the image, Exposure is often ignored in favor of other tools. The three sliders comprise Exposure, Offset, and Gamma Correction. While similar functions may be available in other adjustments, the purpose here is mostly familiarity of controls. Exposure expands the image histogram (visible when the Histogram panel is open) when moved to the right and compresses it when moved to the left. It has a greater impact on highlights than shadows.

Offset tends to behave in the opposite way; it compresses the histogram when moved to the right and expands it moving to the left. Offset also tends to adjust the shadows more than highlights.

Gamma Correction, similar to its behavior in Levels, reassigns the midtone values and shifts the entire histogram. However, Gamma Correction is non-linear, and it compresses the histogram in either direction if you move the slider too far.

Overall, Exposure is a great way to use more traditional approaches to histogram adjustments, though the capability is almost identical to Levels. The main reason to use Exposure is for alternative interface controls rather than any inherent advantage over image adjustments.

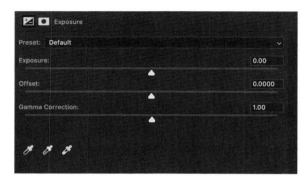

VIBRANCE

- Available both as an adjustment layer and under Image > Adjustments.

- Can be used as a Smart Filter.

Vibrance is similar to Hue/Saturation (which I'll describe in a moment), but its sliders are relative and vary according to color ranges. Saturation in this adjustment layer behaves differently according to color value, and gives preference to the Green channel, then the Red, and finally the Blue. Vibrance gives equal weight to the Green and Blue channels, but less to Red. Unlike the Hue/Saturation controls, these sliders are far less likely to cause clipping or oversaturated colors because the values are scaled. Both sliders will remove saturation from all channels equally, but each slider does so at slightly different rates.

This adjustment layer is a great fine-tuning tool for preserving medium to light skin tones in environmental portraits, and because it is more restrained than Hue/Saturation, it's much more forgiving of large changes.

Vibrance is one of a few adjustment layers that has no presets.

HUE/SATURATION

- Available both as an adjustment layer and under Image > Adjustments.

- Can be used as a Smart Filter.

Hue/Saturation has three controls to adjust Hue, Saturation, and Lightness—the elements of the HSL color space. Although this adjustment uses the HSL model concept for display, it operates just fine on images in RGB, CMYK, and LAB color spaces. In many representations of color theory, Hue is displayed as a color wheel where the angle of rotation in degrees (0–360) is a specific hue, and distance from the center point is considered saturation.

The Hue slider ranges from –180 to +180, and is centered on 0. These are not actual Hue values, but represent the shift from your starting color, so the slider is a relative change, not absolute assignment of hue.

Likewise, Saturation ranges from –100 to +100 and starts from 0 in the center, but it linearly increases or decreases the contrast of each channel identically when Master is chosen from the "color" menu (the nameless menu just above the Hue slider). Decreasing the slider effectively reduces colors to neutral gray, while increasing the slider results in full saturation. You can adjust each of the six major hues independently as well, which is covered below.

Lightness affects the total brightness of each channel, ranging from complete black to white.

At the bottom of the Properties panel is a pair of hue ramps. The top ramp is the baseline representing the full range of hues. The bottom ramp is the result of shifting the Hue slider, and represents a kind of map relating the top input hue to the bottom output hue.

The output range is a set of controls on the output ramp that relates to the options available in the color menu. When you choose a color from the menu, a default input range slider appears at the chosen color range as well as a numeric readout of the actual values. The values are tied to the range sliders; outer sliders are the ends of the falloff, while inner sliders are the "width" of the hue being adjusted. You can drag in the center of the range sliders to drag the entire set where you need it, shifting the chosen fundamental hue. If you move the range sufficiently, the color menu selection changes to reflect the new color (or the closest primary/secondary color).

Hue/Saturation also features a Targeted Adjustment tool (TAT). Enable the TAT then drag on the image to adjust the saturation of the selected color globally. Hold Cmd/Ctrl while clicking to adjust the hue of that color globally. If you find you use the TAT frequently, open the panel menu and choose Auto-Select Targeted Adjustment Tool. That way it's ready to go whenever you add the Hue/Saturation adjustment layer.

A Colorize option removes saturation and applies an overall tone using what-ever hue you choose. This is great for applying an overall tone to an image, whether or not it starts as black and white.

Common uses for Hue/Saturation are to apply global shifts to offset a color cast, to apply creative color shifts, and to fine-tune images for gamut cor-rection when outputting for print. It can also be used for more discreet color balance operations, because it allows saturation adjustments at the same time. Color Balance is more global. And as seen in the "Selections & Masking" chap-ter, it can be used for making fine selections based on color.

Hue/Saturation offers a selection of presets, and you can save your own.

COLOR BALANCE

- Available both as an adjustment layer and under Image > Adjustments.

- Can be used as a Smart Filter.

Color Balance is used for making global corrections in each of three tonal ranges: shadows, midtones, and highlights (make a choice from the Tones menu of the Properties panel). The color sliders are broken out for each pri-mary/secondary hue range, allowing for a mix between complementary colors, hence a "balance" between the two. Conceptually, the sliders let you replace one hue by substituting in its complement.

In the chapter "Color & Value," you used a brute force method of removing color cast by generating an average complementary color that acts to negate an overall shift in all hues. Color Balance can accomplish the same task by addressing individual hues, so this is a more precise approach to correction, with more subtlety and control.

Color Balance has a Preserve Luminosity checkbox that is meant to preserve the mix of gray (that is, value) by compensating for perceptual loss of brightness with certain color changes. This should be left on by default, but you may encounter situations where it causes highlight blowouts due to over saturation, especially when shifting towards the secondary colors. If this happens, consider turning off Preserve Luminosity and using a Curves adjustment layer set to Luminosity blending mode instead of turning on Preserve Luminosity.

Alternatively, set the Color Balance blending mode to Saturation instead of Normal to adjust relative saturation levels without worrying about luminosity shifts. This is a neat trick to manage color contrast a little more directly than some other methods.

BLACK & WHITE

- Available both as an adjustment layer and under Image > Adjustments.

- Can be used as a Smart Filter.

Allows you to mix the conversion of each primary and complementary color to gray. When you first apply it, the Black & White filter automatically returns a basic grayscale version of your image using a default setting. Photoshop accomplishes the conversion by extracting the tonal contribution from each color to gray, effectively desaturating the existing color. Sliders allow you to adjust the tone of each hue to affect the final gray value.

The Auto button maximizes the distribution of gray values, resulting in a typical high-contrast conversion where possible. This is a good option if you're looking for a starting point for dynamic range. Auto does not have additional options like you find with Curves and Levels.

Black & White also features a Targeted Adjustment tool (TAT), allowing you to drag directly on the image to make specific changes. Remember, however, that this tool affects all regions in your image with the same fundamental hue, so be sure to watch the entire canvas while using TAT.

Tint allows for a monochrome result, applying any hue you like in a similar fashion to using a color overlay.

The presets available with Black & White are actually really good at simulating certain filters. One of my favorites is the Infrared preset, which gives beautiful results for landscape images. Pair this preset with a Curves adjustment for more control.

When set to Luminosity blending mode, Black & White is a wonderful tool for adjusting tone in specific ranges. In fact, I almost never use it for actual grayscale conversions, preferring to use Gradient Maps and my "B&W Control Freak" method from "Color & Value." If you like the results you get from the Black & White layer conversion, but need a tiny bit more control, add a Color Balance layer below it to control the relative mix of incoming colors.

PHOTO FILTER

- Available both as an adjustment layer and under Image > Adjustments.

- Can be used as a Smart Filter.

Applies a semi-transparent color overlay to images, good for both correction and effects, but easily replicated with Solid Color overlay, typically with more flexibility. The major use for Photo Filter is to apply common toning presets quickly, and it's a great choice for replicating some traditional color filter effects. There are a number of presets, but you cannot save your own.

A Density slider behaves in a similar way to the Opacity slider, and you can use the Color Picker to dial in specific values. However, the best use of Photo Filter is to quickly apply the presets without any additional fuss or to preview several tonal variations as a visualization for your image before making a more detailed adjustment.

Other options for similar effects include the Solid Color fill mentioned, Color Lookup Tables, a Gradient Map, or a Gradient fill.

CHANNEL MIXER

- Available both as an adjustment layer and under Image > Adjustments.

- Can be used as a Smart Filter.

Traditionally used for black-and-white conversions, Channel Mixer enables you to shift the contributions of a given channel to a different output color. Offering some nice presets, it operates by letting you control the mix of input channels directly, to the point of entirely swapping them around. It does not affect color directly, only the blending of channel information.

Think of the mixer as if you were blending grayscale channel information to create color plates. When your RGB image comes into Photoshop, each channel is discrete. Using the input sliders, you can combine the channel information for a given output color, so the sliders are relative input values. At the bottom right of the Properties panel is a summation value that tells you the total combined contribution from each slider. Keeping that value at 100 retains the exposure of your image overall, so it's a good way to gauge whether you've changed the brightness of your photo.

At the bottom of the Properties panel is a Constant slider that acts like a rough exposure slider. Use it to compensate for any changes you've made to the color sliders.

For creative color effects, just start playing with the sliders for each channel in the Output menu. There's really no guide for this, though you can do some minor repair work for a noisy channel by replacing it with a little from the other two channels. This inevitably results in a color shift, however, so reserve that for dealing with deep shadows or white highlights.

A more moderate use is to create a hand-tinted look by toggling the Monochrome option. Select the checkbox, then deselect it and move the sliders. I honestly don't know why it works this way, but that's how it was designed. By selecting Monochrome, you are assigning the same slider values to each of the channels and directing everything to a single gray output channel. When you toggle it off, the sliders stay the same, allowing you to add color on each channel individually.

Where this becomes more useful is when you choose a particular preset before turning off Monochrome. Each of the presets sets the input sliders to a different combination of values, and turning off Monochrome leaves the sliders the same for every output channel. In this way you can choose the grayscale contrast level like you would with the Black & White adjustment layer, but then switch back and fold in hues any way you like.

Leaving Monochrome selected simply combines the output channels so they're all the same, and the input sliders behave just like the Black & White adjustment sliders, but limited to RGB. In addition to choosing presets, you can save presets as well.

COLOR LOOKUP

- Available both as an adjustment layer and under Image > Adjustments.

- Can be used as a Smart Filter.

Color Lookup uses a set of tables to translate incoming colors from your image to new output colors. Most often, these are subtle replacements and help ensure a consistent set of hues and values across a range of images. So long as the starting images use the same range of colors and have similar exposure, the output will maintain a consistent look.

While there are several presets for Color Lookup, the real value is in creating your own tables. For details on this process, see "Color Grading" section in the "Color & Value" chapter.

This adjustment layer uses several standard color table formats, but some are more flexible than others. There are no adjustment controls, so like Photo Filter, you are limited to blending modes, masking, and layer opacity/fill.

INVERT

- Available both as an adjustment layer and under Image > Adjustments.

- Can be used as a Smart Filter.

Literally inverts the colors and luminosity in your image, providing the same results as the Image > Adjustments > Invert command (Cmd/Ctrl+I). This adjustment is most frequently associated with visualization helpers, but there are some specialized uses for film negative scans and photo restoration techniques which are not covered in this book. There are no options or presets. You get what you get. On or off. Ah… simplicity!

POSTERIZE

- Available both as an adjustment layer and under Image > Adjustments.

- Can be used as a Smart Filter.

Groups similar gray values in each channel into solid, averaged bands. The only control is how many bands the range is divided into, which is used for each channel. In other words, if you choose the default 4, that means each channel gets divided into 4 tonal ranges. For an RGB image, that gives 16 total levels.

Posterize is typically used for creating graphic illustration effects or for special effects within photographs. However, I use it primarily for simplifying gradients to show how other adjustments affect hue and value.

THRESHOLD

- Available both as an adjustment layer and under Image > Adjustments.

- Can be used as a Smart Filter.

Creates a hard boundary between discrete luminosity values, filling everything below the selected value with black and everything above with white. The slider lets you choose the boundary value.

Again, the utility of this adjustment is kind of limited, but it turns out to be helpful for investigating how adjustment layers and blending works. I also use it to help create base effects that are used in other illustration techniques, such as this brushed linocut effect (seen in the "Stamped Portrait" section of the "Effects" chapter).

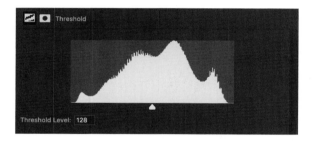

SELECTIVE COLOR

- Available both as an adjustment layer and under Image > Adjustments.

- Can be used as a Smart Filter.

Selective Color treats hues as a mix of printing dyes to give more subtle control over color balance. Each primary and complementary color is represented as a mix of cyan, magenta, yellow, and black. Sliders allow you to adjust the mix for each of the colors individually, as well as highlights, midtones, and shadows.

This adjustment is frequently used to balance images for printing output, and is used commonly with gamut visualization turned on. The "Color Matching"

section in the "Color & Value" chapter demonstrates using Selective Color for matching colors in composites, and it can also be used as an input for the "B&W Control Freak" technique (again, see the "Color & Value" chapter), as well as a visualization aid.

At the bottom of the Property panel are two radio buttons: Relative and Absolute. Relative adjusts the mixes based on the existing color and applies changes more subtly as a percentage of color already in your image. Absolute applies larger changes without regard to the starting values, and so can easily oversaturate colors that are already strongly present.

Each slider presumes a starting contribution to whatever has been selected in the Colors menu, and then either adds to or subtracts from the starting mix. For example, choosing Greens from the menu and adjusting the Cyan slider is not likely to have much effect, but adjusting Magenta will, simply because of the nature of complementary colors. While each printed color is some mix of the Cyan, Magenta, and Yellow, the impact of each depends on how much each is used in a given color.

The Black slider adjusts tint (lighter) and shade (darker), just as if moving all of the sliders together will uniformly shift the selected color range brighter or darker.

The following fill layers have some interesting properties when used with the Presets panel. In the latest versions of Photoshop, you are able to drag presets to each of the fill layers directly from the Presets panel, and in some cases you can change the fill type. This can be a real time-saver for testing out presets or when working with library items and templates.

GRADIENT MAP

- Available both as an adjustment layer and under Image > Adjustments.

- Can be used as a Smart Filter.

Remaps the colors and values in an image to whatever is designated on the Gradient Map. Think of this as a one-dimensional color lookup table. Gradient Maps are used widely for retouching color corrections and black-and-white conversions. I also use them as a selection tool. For an example using Gradient Maps, see the "Gradient Zone Control" section in the "Color & Value" chapter.

There are tons of presets available for Gradient Maps, and the ability to create your own, which is highly recommended. The gradient ramp represents the range of values available from black to white (recall that RGB color in Photoshop can be converted to a single gray color) and any color on the ramp is mapped to that same value in your image. If the value does not exist in your image, the gradient color does not get applied.

To configure your own gradient, click the ramp to open the Gradient Editor. You can add color stops to the bottom of the ramp and move them around to change the mapping. Each stop can have any color allowed in the working color space. The top of the ramp is for transparency, which is only used for gradients and gradient fills, but is ignored for Gradient Maps (bummer, right?).

Between the color stops are midpoint sliders. These control the transition between color stops and are great for adding little tweaks to gradients. These can help you create harder edges between colors, though if you want a nearly solid transition you should use two color stops almost on top of each other.

For each of the color and opacity stops, you can enter specific values for location in the bottom input boxes, or scrub on the word "Location" to adjust values like a slider.

Above the solid gradient ramp is a Smoothness slider. This affects the transition between colors, and appears largely based on perceptual models for luminosity. At 0%, the transitions are linear, which can be seen in a stepwise black-to-white ramp. The default of 100% results in a smoother perceptual blend, but has a slightly curved luminosity response.

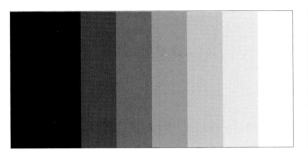 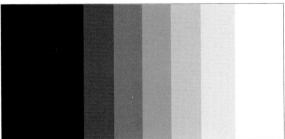

Note that the second gradient is slightly compressed towards the middle. In Part I, there is a discussion on Levels and Curves that shows a smoothed curve and how to use those adjustments to flatten the gradient. In practical use, most people leave the Smoothing value set to 100% by default, but there may be instances where you want a sharper transition or the non-linear results.

A neat feature not covered elsewhere in this book is noise gradients. From the Gradient Type menu, choose Noise and check out the gradient ramp. Instead of a set of transitions between colors you choose, Noise assigns a random gray value to each brightness value from 0–255 in each channel. Color sliders let you limit the mix of each channel, and you can choose from three different color models: RGB, HSB, LAB. Checkboxes let you Add Transparency and Restrict Colors to avoid over saturation.

The Roughness slider blends the values so the result doesn't look like random lines as much as a highly variegated and complex gradient.

Just play with it. Click the Randomize button and mess with the sliders, save the ones you like because—hey!—it's random!

SOLID FILL

- Available both as an adjustment layer and under Image > Adjustments.

- Can be used as a Smart Filter.

Applies a Solid Color Fill layer. Solid Fill is typically used in graphic and illustration elements along with shapes and masks. However, it is used in photography with a variety of blending modes and opacity to apply color changes to image elements. It can also be used with visualization helper layers.

The advantage to Solid Fill over a simple raster filled layer is that you can much more easily change and refine the colors used. Consider using a Solid Fill layer any time you would normally just fill a regular layer with color.

GRADIENT FILL

- Available both as an adjustment layer and under Image > Adjustments.

- Can be used as a Smart Filter.

Applies a scalable gradient fill layer. The gradient can be dragged around when the Properties panel is open, which also allows for scaling, rotating, and choosing the gradient used. This is often a better choice than simply dragging out a gradient when an entire layer needs to be filled, because the scaling does not end at the canvas boundaries like a standard gradient would. Even better is that you can change the gradient without dragging out a new one—simply open the property panel and make your changes.

As mentioned above regarding the Gradient Map, you have a full range of presets available, including noise gradients. The only down side to using a Gradient Fill layer is that you cannot transform it like a rendered gradient. While you do have control over orientation and the gradient type, you cannot squish or stretch it like a regular layer item. If these features are required, you'll have to first rasterize the layer or create a stamped copy, which then loses the editability of the gradient.

PATTERN

- Available both as an adjustment layer and under Image > Adjustments.

- Can be used as a Smart Filter.

Applies a scalable, rotatable pattern fill layer. Just like with Gradient and Solid Color, this fill layer applies a scalable pattern without boundaries, and can be edited as much as you like.

BLENDING MODES

Blending modes (frequently referred to as just "blend modes") continue to be somewhat mysterious to lots of users. The trick is simply to become familiar with them through use, but gaining that familiarity can be somewhat daunting. Most people rely on a classic group of four: Multiply, Screen, Overlay, Soft Light. These four will indeed accomplish quite a bit (in addition to the basic Normal mode), but there are so many more possibilities with just a little insight as to how the other modes work.

Remember that Photoshop gives you a view of your work on the canvas as a composite of individual layers. You can see lower layers through higher layers, like a stack of glass. Also like stacked glass, the upper layers in the stack can subtly affect the look of the layers below them. Blending modes determine how individual pixels interact with each other between layers, and they do it with equations. The inputs for the equation are the pixel values on each layer, and the output is the combination of those values displayed on Photoshop's canvas. In a simple two-layer stack, the top layer is where you would change the blending mode; it is commonly called the *blend* layer. The layer immediately below it is referred to as the *base* layer, but in a more general sense anything below the blend layer can also be called the *backdrop*. It is important not to get too literal, however. Any layer can be both a blend layer and a base layer, depending on its position in the stack (that is, the naming convention is relative to a layer's function in context of other layers). For simplicity, the references will stick with two-layer examples.

Each blending mode has a unique equation, ranging from simple math functions like add, subtract, multiply, and divide, to more complex and somewhat mysterious ones like Overlay and Exclusion. A few of them actually compare pixels and make a choice about what to display. And the Dissolve blending mode involves some random calculations that can be difficult to find useful.

For each entry, I've provided a notional (and sometimes simplified) equation, along with some key words that tell you a little more about the technical elements of each blending mode.

Fortunately, you don't have to understand or even be aware of the math to use blending modes effectively. This section is for those who are interested in how Photoshop accomplishes this particular bit of magic. It's also for the curious who may be looking for new ways to think about experimenting in Photoshop.

There are a few descriptive characteristics for blending modes that help break down their behaviors. You can consider these to be groupings or categories; they're meant to help you understand how each of the blending modes works so you can explore more deeply.

- **Commutative/Non-commutative:** *Commutative* means the layer order does not matter between the base and blend. *Non-commutative* means layer order does matter and swapping the layers' positions will give different results. Non-commutative blending modes typically have some kind of

division operation or use explicit layer characteristics that are exchanged—such as Hue from the blend layer and Luminosity from the base layer. Clearly, swapping those layers would give different results.

- **Special 8:** Blend modes that behave differently with Fill versus Opacity are identified with this key word. See the section "Opacity & Fill" below for details.

- **Neutral color:** Many blending modes have a neutral color that becomes transparent in the blend layer. An example is Overlay that ignores gray, but allows for dodge and burn tools to be used on the gray pixels. To determine whether a blend mode has a neutral color, and what that color is, hold Option (macOS)/Alt (Windows) while clicking the New Layer icon at the bottom of the Layers panel. The dialog box that opens has a checkbox at the bottom that becomes active when you choose a blending mode that has a neutral color. The option lists the neutral color and allows you to fill the layer with that color. For example, if you choose Screen from the Mode menu, the option is labeled Fill With Screen-Neutral Color (Black).

OPACITY & FILL

There are eight "special" blending modes that behave differently when you adjust the Fill of the blend layer compared to when you adjust the Opacity. The Opacity setting of a layer controls how much of the current layer allows lower layers to show through, like a transparency film. Opacity acts on the output side of layer operations, in that all layer styles and masked areas are uniformly adjusted as the slider is moved.

Fill acts on the input side, and does not affect applied layer styles. Use Fill to retain layer effects while fading or making transparent the regular layer content. In other words, you could apply a drop shadow to some layer content, then lower Fill to make the content completely transparent, leaving only the drop shadow behind. Fill assigns an alpha (transparency) value to layer content before layer styles are composited; the pixels are still there, you just can't see them.

When it comes to the Special 8 blending modes, Fill is "premultiplied" in the layer content, so the alpha information is part of the compositing equation. I do not have insight to why Adobe chose to apply this only to a handful of blending modes, but you'll see the Special label applied to the modes that behave differently.

I have never gotten an official answer from Adobe, but I have a theory: The difference between Fill and Opacity is in the order of operations. Opacity operates on the entire layer after everything else has been rendered, including the blending mode and any layer style effects. This blending is managed by the layer's compositing equation (how the layer interacts with the backdrop of layers beneath it). Fill operates on the layer content, but before the blending modes and layer styles. In particular, Fill affects something called *alpha blending*. Each blending mode has an alpha component as part of its equation, and my guess is that Fill is showing up in certain blending modes (the Special 8) where alpha is calculated as part of the blending mode itself, rather than as part of the compositing equation.

Put another way, the value of the Fill slider writes the alpha information to the layer content before layer styles and blending modes are applied, and the Opacity slider considers all of that to be a single, rendered piece of content.

This starts to make sense when you realize that the transparency of layer content is different than the opacity of the layer itself. If you start with a blank layer with Opacity set to 100%, the layer is 100% opaque, but the content is 100% transparent. For our purposes, think of "alpha" as the transparency of layer content, rather than of the layer itself.

As you reduce the Fill slider value, Photoshop uses less of the blend layer content in its blending mode calculation.

Confused? I sure am. I hope I'm close, or when the Photoshop engineering team officially calls me out, I'm buying everyone ice cream sandwiches (you just have to come pick them up from my house on a Tuesday that falls on the 4th of July).

Of course, the explanation is meaningless without something visual. In this setup, there is a horizontal spectrum gradient, and above that is a vertical black-white gradient set to Hard Mix blending mode (the layer named B-W, Hard Mix). The black-white gradient does not go to the top and bottom of the canvas so we can compare the original spectrum with the blend result.

When I reduce the Opacity slider of the B-W layer to 50%, the edges of the color triangles are still hard and visible. The spectrum is starting to show through as expected.

Now I've set the Opacity value back to 100%, and instead lowered the Fill value to 75%.

Those edges are now soft, demonstrating that the blending occurs before the Hard Mix results are rendered to the screen. As Fill is lowered, the edges of the triangles become more vertical and diffuse, until eventually they match the background at 0% Fill as expected. Here is the result of 20% Fill, where the edges are almost vertical.

In other words, Fill acts to adjust how the alpha content of the blend layer and backdrop combine, while Opacity kicks in after all other content has been calculated and rendered.

BLENDING MODE MATH

Blending modes are executed using math, of course, but the equations don't generally use the same numbers that you might recognize as RGB values. Instead, the RGB values are scaled to decimal values between 0 and 1. These are effectively percentages of the gray value of each channel. In other words, when we say "50% gray," it really means the mid-point between full black at 0 and full white at 255. Math nerds would call this normalizing the range, because the same concept is applied to other bit depths so that whether you're dealing with 8-, 16-, or 32-bit images, the math is always reduced to dealing with percentages.

Consider the red-orange color of RGB: 213, 101, 44. Each channel can be represented as a percent of gray. To get the percent value, divide the measured gray value by the largest possible value, 255:

$$213 / 255 = 0.835$$
$$101 / 255 = 0.396$$
$$44 / 255 = 0.173$$

Then in terms of blend mode math, the red-orange color would be expressed as 83.5%, 39.6%, 17.3%. But this highlights a problem: RGB values are represented in terms of whole numbers only. That means we have to round each of the values, making our actual red-orange RGB: 84%, 40%, 17%.

Why does this matter? If we run the conversion backwards, we get 0.84 × 255 = 214.2, but 8-bit RGB does not allow partial (decimal) values of gray. It is again rounded to 214. Notice that is 1 higher than our original value of 213 for the Red channel. If things were always rounded, we would potentially change colors every time we did any kind of layer operation. Fortunately, Photoshop preserves a higher precision number for each color when it does the math, then returns, or calculates, the "correct" color in most cases.

In most operations, this isn't a problem, but it does confuse some things such as the concept of 50% gray. That number doesn't actually exist in 8-bit RGB space because the result is 127.5. So Photoshop defines 50% gray as 127 by convention. The 16-bit and 32-bit color spaces do have enough precision to have exact values for 50% gray. This topic comes up in discussions of Frequency Separation, where we use blending modes to isolate information based on distance from 50% gray, but the variations are almost entirely academic. Your eye is not likely to detect any difference at all in practice.

Now that you've seen the conversion process and we've talked about precision, let's consider how some of this applies to actual blending mode equations to give you a feel for how it all works. We'll start with the humble and relatively simple Multiply blending mode. I've placed a cyan (RGB: 0, 172, 236) square on a layer above the previous red-orange swatch, and changed the blending mode of the cyan layer to Multiply.

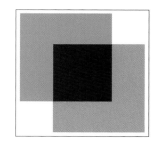

If we were to run the values from the RGB channels directly, we'd get an absurd result:

$$0 \times 213 = 0$$
$$172 \times 101 = 17{,}372$$
$$236 \times 44 = 10{,}384$$

Instead, using the percent values we end up with:

$$0.84 \times 0.00 = 0$$
$$0.40 \times 0.67 = 0.27$$
$$0.17 \times 0.93 = 0.16$$

Converting back to RGB by multiplying the result by 255 translates to RGB: 0, 68, 41, which is indeed the dark greenish. This also explains why Multiply always results in a darker color: Multiplying decimals results in a smaller value, and smaller gray values are closer to 0, or black.

Some of the blending modes get a little trickier. When you see an equation that uses the form "1 – Base," (meaning, "one minus the color on the Base layer") that is actually the inverse of the gray value for each channel, or the inverse of the RGB color. This first comes up with the Color Burn blending mode, which chooses the minimum between two values (incidentally, the format "min (A, B)" means "given the choice between A and B, take the smaller value"). It may not be directly intuitive to think about color inversion, so consider it this way: Imagine the range of gray values from 0 to 255 as a vertical stack, and that you want to show 40% gray. 40% of 255 is 102, so the stack stops at 102, and anything above that is sliced off and set aside.

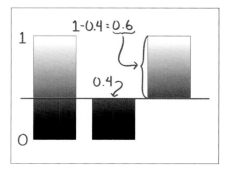

Because the range is normalized to exist between 0 and 1, then adding the two stacks together gets us back to 1, right? Now we can say 1 minus either stack is the value of the other stack. Using the illustration, 1 – 0.4 = 0.6, or 60% gray. 60% of 255 is 153. We can test our equation by adding 153 to 102 and getting 255.

Inversion in this case simply means swapping the stacks, and does not relate to any physical element of how electromagnetic waves of light interact. In our example of "1 – Base" we are saying "The inverse of the color on the base layer."

To complicate things even further, some blending modes do not convert to percent values, but to luminosity values, which I discussed in the introduction to the book. This is the case with Darker Color and Lighter Color. Then of course there are the compositing modes at the end of the list, where RGB is not used at all, but color values are instead converted to HSB (Hue, Saturation, Brightness).

My reason for explaining all of this is not so that you feel the need to bust out a calculator every time you use a blending mode, but so that you have a starting point for understanding unexpected results. For those who are curious about how this all works, now you know.

THE REFERENCE IMAGES

Along with example images for each blending mode, I have included reference graphics to provide a more consistent view of how each mode behaves. Each graphic consists of a group of six triangles in two rows and shows the result of blending a Base layer with a Blend layer.

The Base layer is the same RGB triangle repeated six times.

The Blend layer is above the Base. It consists of the same triangles rotated 0, 60, and 120 degrees on the top row. The bottom row is treated to the same rotations, but the colors are inverted.

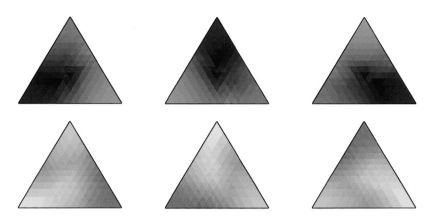

Although this does not give you a view of every possible combination of color and value, it serves as a way to gain some intuition about the behaviors of blending modes. As with the rest of the tutorials in this book, my goal is to give you some kind of anchor for exploring intelligently on your own. There are lots of great ways to explore how blending modes interact, and I strongly encourage you to create additional experiments that more closely reflect your work.

In particular, you should build experiment files that include gradients. Using gradients gives you a continuously changing variable, such as saturation or opacity. A simple case would be comparing two independent variables (the input values to the blending equation) by having a Solid Color Fill layer as the base, and a Gradient Fill layer as the blend, where the gradient allows only one characteristic of color to change. Let's say you want to explore the effects of Pin Light blending on saturation; you might create a base layer that has a medium red fill (HSB: 0, 50, 100), and a gradient that starts with a fully saturated red (HSB: 0, 100, 100) and ends completely unsaturated (HSB: 0, 0, 100) retaining the same hue all the way across.

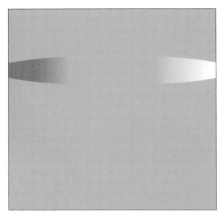

Leave some area of the Base layer visible without any blending (by adding a mask to the Blend layer, for example) so you can compare the effects with and without layer content. In this setup, you can easily change any of the variables. For a more complex result, use orthogonal gradients; replace the solid color fill with a vertical gradient, leaving the Blend as horizontal. Now you can compare ranges of variables.

One fun variation on this setup is to have two spectrum gradients as your inputs, and check out the patterns that show up. Here is a spectrum gradient, one horizontal and one vertical, still set to Pin Light blending.

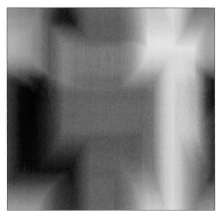

Notice in the first setup you can clearly see that middle saturation values blend completely with the base color when the hue matches up, but in the second setup you can see how various colors blend to create both bright and dark regions with a range of saturation results. The explanation for this is left up to you, dear reader, with this hint: Start by identifying exactly which colors are overlapping where, and think about the result color. Did it change hue, saturation, or brightness? Some combination?

If you want to simplify the results, add a Posterize adjustment layer clipped to each Gradient Fill layer. This reduces the colors to blocks (see the entry for Posterize in the "Adjustment Layers" chapter of Part IV, "References").

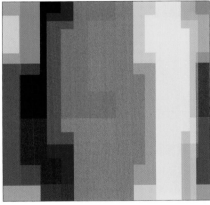

These experiments can help ingrain blending effects in your mind, and hopefully allow you to work more intuitively with them. Also, remember that I built the examples shown here in RGB, but converted them to CMYK for printing purposes, so your results will be somewhat different if (when!) you build your own.

NORMAL

Normal blending mode is the basis for all standard editing. It's how you might view a printed picture lying on a table. Changing either the opacity or fill sliders has the expected effect of reducing the opacity of the layer. There is nothing tricky about this blending mode; it simply allows layers below to show through when opacity is reduced.

DISSOLVE

Dissolve blend mode has some interesting aspects to it. It uses a random seed (that is, a random starting value) that is generated whenever you open Photoshop. Each pixel location is assigned a random value between 1 and 99 so that each value is approximately equally represented. I say "approximately" because it's not exactly balanced. The idea is that the opacity level gives you about that percentage of visible pixels on the layer. So if you set the Opacity slider to 50%, about 50% of the pixels will remain. The Fill slider behaves the same way.

Here's a 10 px by 10 px image with four layers; the top three layers are set to Dissolve mode. Red is set to 25%, Green to 50%, Blue to 75%, and the white background is 100%.

Setting both the Blue and Green to 50%, you can see that the same pixel locations are visible on each layer, irrespective of their channel color.

That tells you the randomization is applied to the grid of pixels and not their color or channel information. In fact, creating another document without closing and re-opening Photoshop gives the same result. I don't know if that fact is useful or even entertaining. But now it's a thing you know.

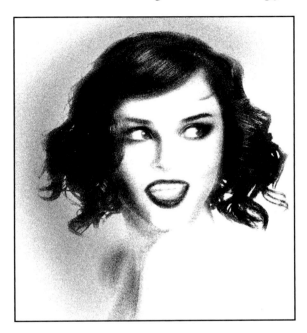

My favorite use for Dissolve is to create a kind of halftone or grainy effect for illustrations. You can see it put to use in the "Dissolve Portrait" section of the "Effects" chapter in Part II.

DARKEN

Each mode in the Darken collection behaves slightly differently, but all result in a darker image. Of these, probably the most popular is the Multiply blending mode.

DARKEN

Output = min(Base, Blend) *(for each channel)*

- Commutative
- Ignores White on the Base Layer
- Operates per Channel

Darken blending mode compares the pixels on the blend layer with the base layer and displays the darker of the two. This blending mode works on a per-channel basis, so each channel is evaluated independently to find the darkest pixel between two layers. That means Darken can result in a different color being displayed.

If the blend layer has an RGB color of 251, 175, 93 and it is compared using Darken with a base layer of RGB: 125, 167, 217, the result is simply the darkest value from each channel: RGB: 125, 167, 93.

Darken is useful for burning or shading where you want some color changes, as you might when painting or doing creative image collage, especially with compositing work. Use the effect with hand painting or layer styles like Drop Shadow to produce a more realistic effect than Multiply for environmental shadows.

If all channels on one layer are darker than all other channels, then Darken behaves exactly like Darker Color.

MULTIPLY

Output = Base × Blend

- Commutative
- Ignores White on the Blend Layer
- Operates per Channel

Multiply blending mode is most often used for drop shadows, especially as a layer style. This mode affects layer content based on total brightness, and so ignores white.

COLOR BURN

Output = 1 − min(1, (1 − Base)/Blend)

- Non-commutative
- Ignores White on the Base Layer
- Operates per Channel
- Special 8

Color Burn works by dividing the inverse of the base color by the blend color, and then inverting the result. The effect is darker than Multiply, although it still works individually on each channel and does have an effect on white.

This mode behaves differently between the Fill and Opacity sliders, making it the first one of our blend modes to fall within the category called the Special 8. Check out the use of Color Burn in the "Graduated Neutral Density Filter" section in the "Dodge & Burn" chapter in Part II.

100% Fill, 100% Opacity

50% Fill, 100% Opacity

100% Fill, 50% Opacity

LINEAR BURN

Output = (Base + Blend) − 1

- Commutative
- Ignores White on the Base Layer
- Operates per Channel
- Special 8

While still darker than Multiply or Color Burn, Linear Burn is not as saturated as Color Burn. This mode looks like color subtraction and, indeed, white is subtracted from the result of adding the two layers together.

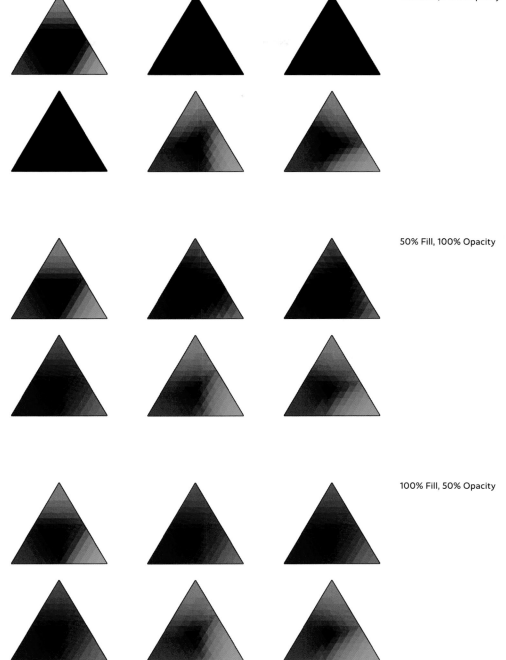

100% Fill, 100% Opacity

50% Fill, 100% Opacity

100% Fill, 50% Opacity

DARKER COLOR

Output = min(Base, Blend)

- Commutative
- Ignores White on the Base Layer
- Operates on Composite

Darker Color literally chooses between the darker values of two layers, but it uses a composite result from all three channels combined.

Of course the Darker Color blending mode has no effect on self-blends. Darker Color is actually a pretty cool way to blend composite images, and along with Lighter Color, it is a nifty tool for eradicating edge halos caused by processing or compression artifacts.

LIGHTEN

The blending modes in the Lighten collection behave exactly the opposite of the Darken blending modes, as you might expect.

LIGHTEN

Output = max(Base, Blend)

- Commutative
- Ignores Black
- Operates per Channel

Of course, Lighten is exactly the opposite of Darken. It selects the lightest value from each of the three color channels. Because this operates per channel, it can result in new colors.

SCREEN

Output = 1 − [(1 − Base) × (1 − Blend)]

- Commutative
- Ignores Black
- Operates per Channel

Screen is the counterpart to Multiply; it ignores black instead of white. Screen is a popular choice for dodging operations, but it can blow out lighter colors to white pretty quickly. However, it also results in some nice pastel colors.

Screen is not available in 32-bit mode.

COLOR DODGE

Output = Base/(1 – Blend)

- Non-commutative
- Ignores Black
- Operates per Channel
- Special 8

Color Dodge increases saturation by dividing the base color by the inverse of the blend color. This typically results in lots of contrast, and most lighter areas can get blown out. A self blend (blending a layer with itself) produces additional saturation, while an inverted version of the layer blended with itself moves everything to white.

This blending mode is useful for adding highlights as special effects that blend more naturally with bright areas of a photograph. Paint with a bright color (or even solid white) where a highlight in the image should be made to look as if it is glowing, then lower the Fill slider to achieve a blended effect.

Color Dodge is not available in LAB space or in 32-bit mode.

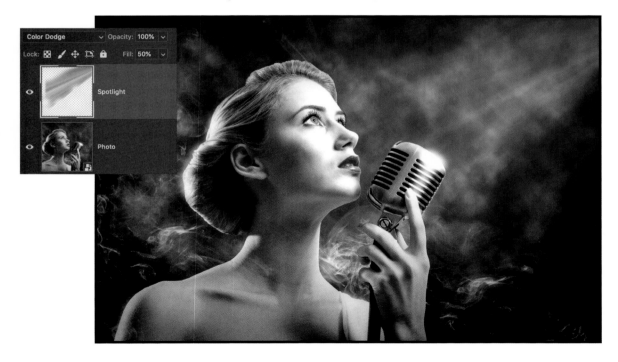

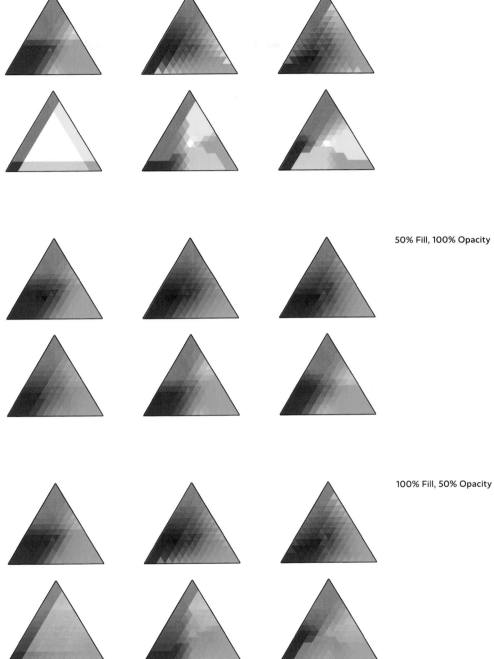

100% Fill, 100% Opacity

50% Fill, 100% Opacity

100% Fill, 50% Opacity

LINEAR DODGE (ADD)

Output = Base + Blend

- Commutative
- Ignores Black
- Operates per Channel
- Special 8

Linear Dodge blending mode is a simple addition of luminosity of each channel, hence the use of (Add) behind its name in the menu. While it can result in blown-out highlights, Linear Dodge is a good choice for lightening areas with painted color when used with low Flow and a low Fill setting. Because it adds each channel individually, you can easily shift colors. Use it for colored highlights in hair or other shiny, textured surfaces.

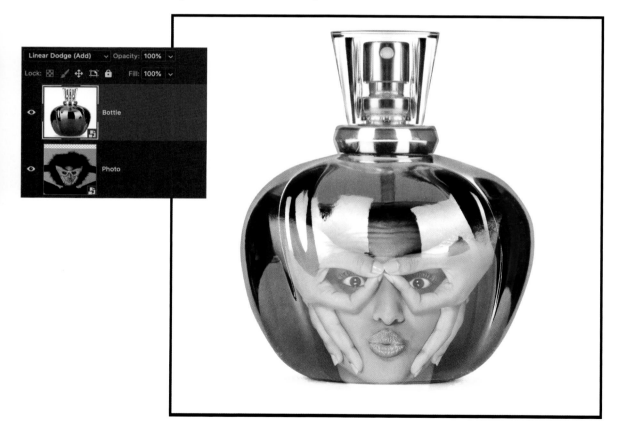

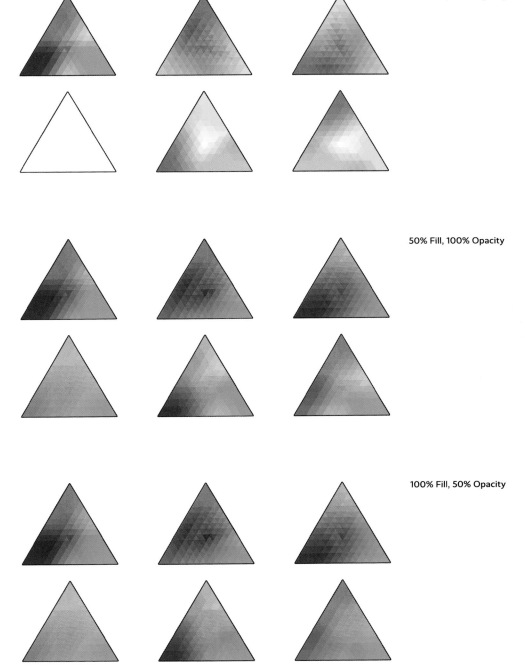

100% Fill, 100% Opacity

50% Fill, 100% Opacity

100% Fill, 50% Opacity

LIGHTER COLOR

Output = max(Base, Blend)

- Commutative
- Ignores Black
- Operates on Composite

You might've guessed by now that Lighter Color is the opposite of Darker Color. And just like its counterpart, Lighter Color works on the composite of all the channels. Lighter Color, like all comparison modes, leaves self blends unchanged. Inverted and complementary blends yield hard transitions across the 50% brightness mark. This is a good choice for compositing images that you want to blend smoothly.

Lighter Color is not available in Grayscale mode.

CONTRAST

The Contrast modes, as their name might suggest, typically act to increase contrast in various ways. However, not all of the blending modes are entirely predictable. This is especially true with Hard Mix.

OVERLAY

If Base > 50%, then Output = $1 - [1 - 2 \times (Base - 0.5)] \times (1 - Blend)$ *(applies Screen mode)*

If Base ≤ 50%, then Output = $(2 \times Base) \times Blend$ *(applies Multiply mode)*

- Non-commutative
- Ignores 50% Gray
- Operates per Channel

Overlay first determines whether a color is brighter or darker than 50% gray, then applies Multiply to darker colors and Screen to lighter. This mode is related to Hard Light in an unusual way. Applying Overlay to the top image gives the same result as if you swapped the layer order and instead applied Hard Light to the top layer (the bottom would now be set to Normal).

Overlay is especially popular for layer-based dodge and burn techniques. Typically, you paint with shades of gray to dodge or burn on the top layer, but it works well with colors, too. Another technique uses Overlay on a on a layer that has had the High Pass filter applied for sharpening and local contrast enhancement.

Overlay is also an excellent choice to pair with a Curves adjustment layer to dramatically boost contrast.

Essentially, Overlay and Hard Light differ by the layer each uses as inputs and outputs. This mode increases saturation for self blends, but reduces it for inverted blends.

Overlay is not available in 32-bit mode.

SOFT LIGHT

If Blend > 50%, then Output = Base + (2 × Blend − 1) × [F(Base) − Blend]

If Blend ≤ 50%, then Output = Base − (1 − 2 × Blend) × Base × (1 − Base)

If x ≤ 25%, then F(Base) = [(16 × x − 12) × (x + 4) × x)]

F(Base) = √x when x > 25%

Wacky, huh?

- Non-commutative
- Ignores 50% Gray
- Operates per Channel

Soft Light behaves similarly to Overlay, but it has less contrast. The end result produces softer transitions across brightness and colors, and what appears to be translucent blending in shadows and highlights.

Use Soft Light blending mode in place of Overlay when you want a smoother transition, or when you want to dodge and burn with pastel colors instead of gray.

Soft Light is not available in 32-bit mode.

HARD LIGHT

Output = $1 - [1 - 2 \times (\text{Blend} - 0.5)] \times (1 - \text{Base})$ when Base > 50% *(applies Screen mode)*

Output = $(2 \times \text{Blend}) \times \text{Base}$ when Base ≤ 50% *(applies Multiply mode)*

- Non-commutative
- Ignores 50% Gray
- Operates per Channel

Hard Light is really a combination of Multiply and Screen blending modes split at the 50% gray level. As noted previously, it's related to Overlay.

When applied to a self blend, contrast is increased and middle tones become desaturated. But for an inverted blend, the result is brighter and less saturated than with Soft Light.

Hard Light is not available in 32-bit mode.

VIVID LIGHT

Output = 1 − (1 − Base) / [2 × (Blend − 0.5)] when Blend > 50% *(applies Color Dodge mode)*

Output = Base / (1 − 2 × Blend) when Blend ≤ 50% *(applies Color Burn mode)*

- Non-commutative
- Ignores 50% Gray
- Operates per Channel
- Special 8

Vivid Light pushes contrast to the point of full saturation in self blends, but results in 50% gray when used with inverted colors. Notice that the self blend triangle very quickly goes from black to full saturation. It accomplishes this by applying Color Dodge to the lighter pixels and Color Burn to the darker ones.

Vivid Light is not available in 32-bit mode.

100% Fill, 100% Opacity

50% Fill, 100% Opacity

100% Fill, 50% Opacity

LINEAR LIGHT

If Blend > 50%, then Output = Base + 2 × (Blend − 0.5) *(applies Linear Dodge mode)*

If Blend ≤ 50%, then Output = Base + 2 × Blend − 1 *(applies Linear Burn mode)*

- Non-commutative
- Ignores 50% Gray
- Operates per Channel
- Special 8

This mode uses Linear Burn and Linear Dodge in much the same way that Vivid Light uses the Color Dodge and Color Burn. This creates heavy contrast and saturation, which is more typically used in retouching than in composite or texture work.

Linear Light is not available in 32-bit mode.

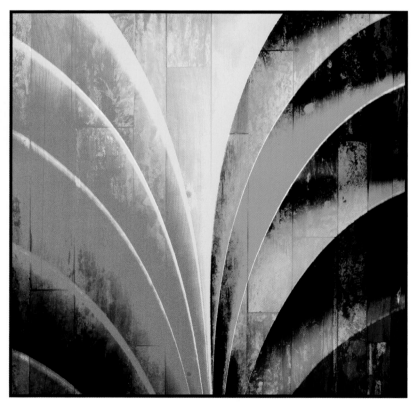

100% Fill, 100% Opacity

50% Fill, 100% Opacity

100% Fill, 50% Opacity

PIN LIGHT

If Blend > 50%, then Output = max[Base, 2 × (Blend – 0.5)]

If Blend ≤ 50%, then Output = min[Base, 2 × (Blend)]

- Non-commutative
- Ignores 50% Gray
- Operates per Channel

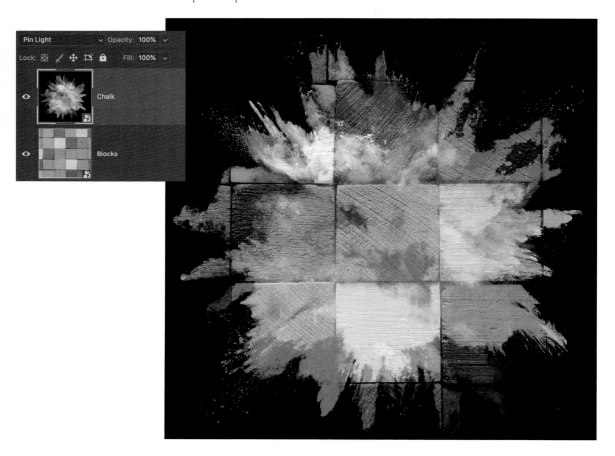

Pin Light can result in changed colors that seem incongruous or at least unexpected. To best understand this, look at the inverted blend triangle. Note that the overall brightness is relatively stable, while there are odd sections of slightly unexpected colors. This is because Pin Light is comparing blend colors based on their total luminosity value and selectively replacing them. If the blend color is brighter than 50% gray, pixels in the base layer are compared with those in the blend layer (see the equation above) and the brighter of the two is displayed. The opposite happens if the blend color is darker than 50% gray, and the darker of the compared pixels is displayed. This can sometimes also result in slightly different colors.

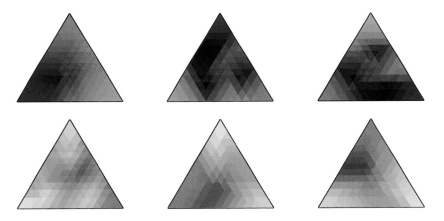

HARD MIX

Ceiling = (Base + Blend) when Sum ≥ 255 *(for each channel)*

Floor = (Base + Blend) when Sum < 255 *(for each channel)*

- Commutative
- Ignores 50% Gray
- Operates per Channel
- Special 8

Hard Mix is the one mode that does not scale values before performing its math. The base color and blend colors are added linearly, and anything that equals 255 or higher gets clipped to 255. Anything less than 255 gets dropped to 0. Because this happens on every channel for every pixel, the results are combinations of full or zero brightness on each channel: Red, Yellow, Green, Cyan, Blue, Magenta, White, and Black.

Interestingly, Hard Mix is a special blending mode, so lowering the Fill value causes a smooth transition from the clipped effect to simple translucency. Lowering Opacity simply makes the result more transparent.

Because the colors are solid, the boundaries between colors tend to be hard edged. This leads to some usefulness in creating geometric patterns and shapes. Try dragging out a spectrum gradient then duplicating it and setting the Duplicate to Hard Mix. You'll get solid bands of color in the gradient's primary shape.

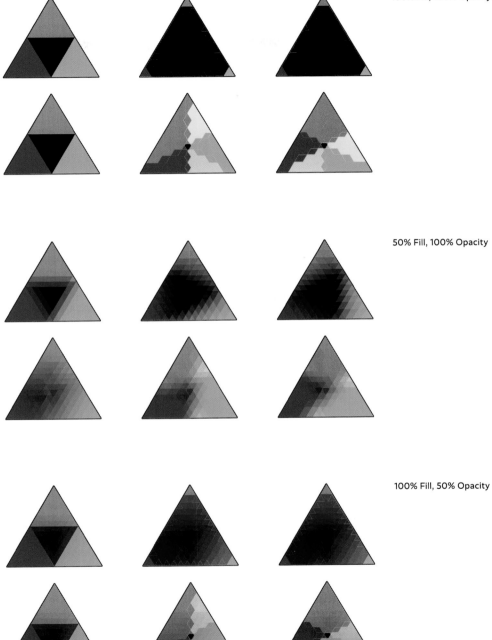

100% Fill, 100% Opacity

50% Fill, 100% Opacity

100% Fill, 50% Opacity

INVERSION

Inversion blending modes: They invert color and luminosity.

DIFFERENCE

Output = ABS(Base − Blend)

- Commutative
- Ignores Black
- Operates per Channel
- Special 8

If you read the help files carefully, you'll see that the Difference blending mode is really doing a simple subtraction, but keeps the result as an absolute value. The output can never be negative, which wouldn't make sense anyway. Self blends result in black, but most other blends generate new colors. Difference mode is used to great effect when comparing or aligning image layers, and it can be used for visualizing edges by duplicating a layer and applying a slight blur to the duplicate. Creatively, it creates some visual interest when there are a combination of colors and neutral grays to blend with.

*ABS means "absolute value"

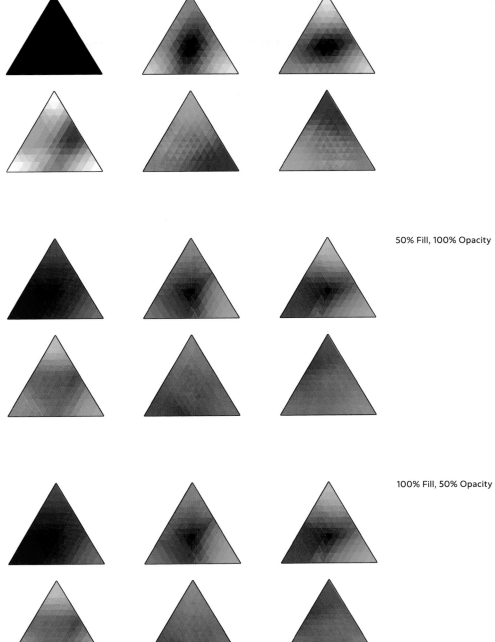

100% Fill, 100% Opacity

50% Fill, 100% Opacity

100% Fill, 50% Opacity

EXCLUSION

Output = Base + Blend – 2 × (Base × Blend)

- Commutative
- Ignores Black
- Operates per Channel

Exclusion results in low-contrast, muted colors that resemble results from Difference blending. However, Exclusion does not appear to include the luminosity conversion that other blending modes do; instead, it simply uses the percent fraction of each color channel. Rather than a luminosity value of .30 for pure red (RGB: 255, 0, 0), it uses 255 / 255 = 1.

Looking at the equation, you can see that as the values get further apart, the brightness increases, just not as quickly as with Difference. Filling an Exclusion blended layer with solid white results in a standard inversion. If either the base or blend colors are 50% gray, the result is 50% gray.

Exclusion is not available in LAB color space or 32-bit mode.

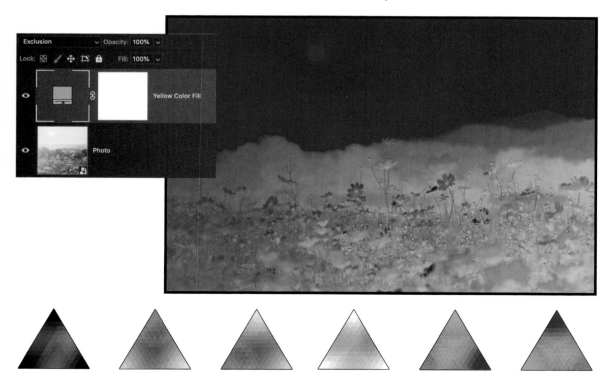

SUBTRACT

Output = Base – Blend

- Not Commutative
- Ignores Black
- Operates per Channel

There's not much more to say about this blending mode. It does what it says, and can easily result in lots of black areas. Note that it subtracts the top layer from the underlying layer, so layer order does matter.

Subtract is not available in LAB color space.

DIVIDE

Output = Blend / Base

- Not Commutative
- Operates per Channel

Divide is easier to understand when you remember that the channel gray values are normalized or converted to a percentage. Self blends result in solid white because any number divided by itself is one, or 100%. Similarly, blending with black (0%) gives you black. This mode is identical to inverting the top image and setting the blending mode color to Color Dodge.

While this mode has creative uses, Divide is mainly intended for use with cali-brated technical images, such as those found in astrophotography and micros-copy. Dividing by 0 in this case does not cause Photoshop to implode or even hiccup. So your plans for world domination won't find outlet here.

Divide is not available in LAB color space.

COMPONENT

Component blending modes replace elements between layers, removing the component from the Base layer and substituting the same component from the Blend layer.

HUE

Output = Blend Hue + Base Saturation + Base Luminosity

- Non-commutative
- Operates on Composite

Hue blending combines the hue of the current layer with the saturation and brightness of the base layer. This tends to give a more subtle effect than Color blending mode. Hue will not apply to any desaturated areas, and it tends to preserve luminosity.

SATURATION

Output = Blend Saturation + Base Hue + Base Luminosity

- Non-commutative
- Operates on Composite

Saturation combines the saturation of the current layer with the brightness and hue of the base layer. Saturation is useful as a visualization tool when used with a 50% gray filled layer, as it will remove the color of underlying layers, allowing you to see the luminosity. Another visualization method is to use a fully saturated Color Fill layer to look for inconsistent saturation across an image.

COLOR

Output = Blend Hue + Blend Saturation + Base Luminosity

- Non-commutative
- Operates on Composite

Color blending mode is a favorite of photo restorers because it doesn't affect the apparent brightness of an image. The results can be quite natural when handled carefully. It is related to Luminosity in the same way that Overlay is to Hard Light; that is, applying Color to the top layer gives the same output as if you applied Luminosity to the bottom layer, then swapped the stacking order and changed the base layer's blending mode to Normal. Self blends have no effect, but inverse blends are somewhat muted and result in new colors.

LUMINOSITY

Output = Blend Luminosity + Base Hue + Base Saturation

- Non-commutative
- Operates on Composite

Self blends with luminosity have no effect, but inverted blends yield some nice pastel colors with increased brightness. Luminosity is also used in several techniques to keep colors from shifting when an adjustment is made. You saw this technique earlier in the book when we set a Curves adjustment layer to Luminosity blending or we used a Black & White adjustment layer with Luminosity to manage the conversion of specific colors into grayscale.

INDEX

B

B&W Control Freak method, 167–171
backdrop, 39, 286
background fixes, 236
backslash key (\), 72
base layer, 39, 136, 286, 292
Berlier, Rocky, 163
bit depth, 251
Black & White adjustment layer, 271–272
 color to grayscale conversion and, 31–33, 167, 168
 Gradient Map used with, 130–131
 Luminosity blending mode and, 33, 221, 272
 stamped portrait effect and, 202
 Targeted Adjustment Tool and, 261, 272
black-and-white images
 Color blending mode applied to, 127
 converting color images to, 31–33, 167–171
black-to-white gradient, 29, 161, 163, 167
blemish reduction, 253
Blend If feature, 40–47
 color adjustments, 41–45
 comparisons made with, 46
 crossing the sliders, 98
 duotone effect and, 127
 how it works, 40–41
 image enhancements, 94, 96–97
 trapping transparency using, 46–47
 vignette removal, 117
blend layer, 39, 286, 293
blending modes, 16, 285–295
 adjustment layers and, 39, 95–96
 Blend If sliders and, 40–47
 categories of, 286–287
 controls and options for, 40
 Fill and Opacity adjustments, 39, 287–289
 group options for, 74, 78–80
 image enhancement using, 93–97
 math used for, 290–292
 multiple layers required for, 15
 painting with, 80–83
blending modes reference, 285–337
 Color, 336
 Color Burn, 302–303

 Color Dodge, 310–311
 Darken, 298–299
 Darker Color, 306–307
 Difference, 328–329
 Dissolve, 296–297
 Divide, 332–333
 Exclusion, 330
 Hard Light, 318–319
 Hard Mix, 326–327
 Hue, 333–334
 Lighten, 308
 Lighter Color, 314–315
 Linear Dodge, 312–313
 Linear Light, 322–323
 Luminosity, 337
 Multiply, 299–300
 Normal, 296
 Overlay, 315–316
 Pin Light, 324–325
 reference images, 292–295
 Saturation, 334–335
 Screen, 309
 Soft Light, 317–318
 Subtract, 331
 Vivid Light, 320–321
 See also specific blending modes
blending process, 39
blocking process, 168
blur filters
 Average Blur, 147, 148, 150
 Median Blur, 255
 Motion Blur, 194, 195
 Path Blur, 229, 230
 See also Gaussian blur
Blur tool, 76
Boolean selections, 57, 65, 137
brightening eyes, 119–122
brightness, 13
 lightness vs., 143
 luminosity vs., 14
Brightness slider, 262
Brightness/Contrast adjustment layer, 262–263
bristle brushes, 205, 206

CREDITS

PART I INTRODUCTION

Arlene Waller/Shutterstock Figure CO-01-01

Nejron Photo/Shutterstock UNFIG01-01-15

andreiuc88/Shutterstock PO-01-02, UNFIG01-02-23, UNFIG01-02-24

saraporn/Shutterstock UNFIG01-02-02

Ferli/123RF UNFIG01-02-22, UNFIG01-02-26

PART II TECHNIQUES

Arlene Waller/Shutterstock CO-02-01, UNFIG02-03-47, UNFIG02-03-50, UNFIG02-03-52

Gilles Baechler/Shutterstock PO-02-01, UNFIG02-02-49, UNFIG02-02-49, UNFIG02-02-51, UNFIG02-02-52

Cookie Studio/Shutterstock UNFIG02-01-02, UNFIG02-01-03, UNFIG02-01-04, UNFIG02-01-05, UNFIG02-04-03

Olga Kudryashova/Shutterstock UNFIG02-01-14, UNFIG02-01-14, UNFIG02-01-17, UNFIG02-01-19, UNFIG02-02-59, UNFIG02-02-65, UNFIG02-02-67, UNFIG02-03-68, UNFIG02-03-70, UNFIG02-03-71, UNFIG02-03-72

Liliia Rudchenko/123RF UNFIG02-01-35, UNFIG02-01-43

RAUSHAN MURSHID/Shutterstock UNFIG02-01-45, UNFIG02-01-46, UNFIG02-01-68, UNFIG02-01-70, UNFIG02-01-71, UNFIG02-05-01, UNFIG02-05-12

sheeler/123RF UNFIG02-02-15, UNFIG02-02-16, UNFIG02-02-17, UNFIG02-02-18, UNFIG02-02-19, UNFIG02-02-20, UNFIG02-02-22, UNFIG02-02-25

Screenshot of Adobe Photoshop © 2020 Adobe UNFIG02-02-27, CO-02-02

andreiuc88/Shutterstock UNFIG02-02-57, UNFIG02-02-58, UNFIG02-02-63, UNFIG02-02-64, UNFIG02-03-60, UNFIG02-03-61, UNFIG02-03-62, UNFIG02-03-63, UNFIG02-03-66, UNFIG02-03-67, UNFIG02-05-28

NinaMalyna/Shutterstock UNFIG02-02-85 UNFIG02-02-87, UNFIG02-02-88, UNFIG02-02-89, UNFIG02-02-90, UNFIG02-02-91, UNFIG02-02-92, UNFIG02-02-93, UNFIG02-02-96, UNFIG02-02-97, UNFIG02-02-98

Edvard Nalbantjan/Shutterstock UNFIG02-03-17, UNFIG02-03-18, UNFIG02-03-19, UNFIG02-03-20, UNFIG02-05-02, UNFIG02-05-03, UNFIG02-05-05, UNFIG02-05-06, UNFIG02-05-08, UNFIG02-05-09, UNFIG02-05-10

Blend Images/Shutterstock UNFIG02-03-25, UNFIG02-03-26, UNFIG02-03-27

Matusciac Alexandru/123RF UNFIG02-04-01

Christian Draghici/Shutterstock UNFIG02-05-13, UNFIG02-05-14

Stokkete/Shutterstock UNFIG02-05-20, UNFIG02-05-21, UNFIG02-05-22, UNFIG02-05-23, UNFIG02-05-25

faestock/Shutterstock UNFIG02-05-29

Olga Ekaterincheva/Shutterstock UNFIG02-05-30, UNFIG02-05-32, UNFIG02-05-33, UNFIG02-05-34, UNFIG02-05-35, UNFIG02-05-36, UNFIG02-05-37, UNFIG02-05-39

Dean Drobot/Shutterstock UNFIG02-05-40, UNFIG02-05-41, UNFIG02-05-42, UNFIG02-05-43

Khakimullin Aleksandr/Shutterstock CO-02-05

PART III PROJECTS

Vladimir salman/Shutterstock UNFIG03-01-30

Ysbrand Cosijn/Shutterstock UNFIG03-01-34

Maria Kazakova1/Shutterstock UNFIG03-01-54, UNFIG03-01-70, UNFIG03-01-71, UNFIG03-01-72, UNFIG03-01-73, UNFIG03-01-74

PART IV REFERENCES

Jag_cz/Shutterstock UNFIG04-02-01, UNFIG04-02-44, UNFIG04-02-59, UNFIG04-02-77, UNFIG04-02-88

komkrit Preechachanwate/Shutterstock UNFIG04-02-14, UNFIG04-02-66

Vandathai/Shutterstock UNFIG04-02-15

Vladimir salman/Shutterstock UNFIG04-02-18

Fred van Diem/Shutterstock UNFIG04-02-21

Jaromir Chalabala/Shutterstock UNFIG04-02-28

marina shin/Shutterstock UNFIG04-02-32

Khakimullin Aleksandr/Shutterstock UNFIG04-02-35, UNFIG04-02-43, UNFIG04-02-76

oneinchpunch/Shutterstock UNFIG04-02-38

Hekla/Shutterstock UNFIG04-02-39, UNFIG04-02-48

Hank Shiffman/Shutterstock UNFIG04-02-41

DATE DUE

APR 22 2021			